DAVID BAILEY

EYE

DAVID BAILEY

STEIDL

No great artist ever sees things as they really are;
if he did, he would cease to be an artist.

Oscar Wilde

David Bailey

by Tony Shafrazi

Just before the dawn of the '60s when London was still covered in the fog and dullness of a slow recovery from war, long before the internet or even color television, when English music was drifting from Frankie Vaughn and Lonnie Donegan to Tommy Steele and Cliff Richards, and in dreary theaters and movie houses scattered across the country giant images on screens flickered with light and movement offering hypnotic comfort and intimacy, excitement and escape to a world of dream – longing and limitless possibility, kids at school were suddenly exposed to a torrent, a tsunami of explosive rock'n'roll music blasting non-stop through radio stations like Luxembourg and Caroline. Pirate stations parked outside territorial waters flooded our ears with a constant stream of revolutionary American music – sounds even most Americans couldn't hear, corruption and bribery in the record and broadcasting industry with "payola" disc jockeys on the take, along with rampant racial discrimination, deprived them of the fantastic variety and wealth of talent that spewed forth from all over the USA. Youth in England hungrily consumed the rich rudiments of American culture in both sight and sound. Kids in the grey life of country roads and city streets scavenged through magazines, prowling for sexy images of pop culture, cinema and advertising and the latest sounds in jukeboxes and record stores everywhere.

Coming of age, most teenage boys and girls flocked to dark theaters across England to bathe in the light of giant beefy images of Robert Mitchum in *Heaven Knows, Mr. Allison, Fire Down Below,* and *Thunder Road*; the sexy rebel Marlon Brando in *On the Waterfront,* a bleach blonde haired Nazi youth in *The Young Lions*; the even younger, more mercurial and mythic, James Dean in *East of Eden*, *Rebel Without a Cause* and *Giant*; and young Paul Newman in *Somebody Up There Likes Me* and *The Left Handed Gun*. Restless adolescent boys full of lust and hunger, watched these movies and listened to the rocking groovy sounds of Chuck Berry, Elvis Presley, Buddy Holly, Gene Vincent, John Lee Hooker, Ray Charles and the wild Howlin' Wolf. Excited, wide-eyed and pumped up, we absorbed all the wild exposed beauty we could get, dreaming and longing to marvel at any image of a younger and more contemporary beauty, after goddesses like: Ava Gardner, Marilyn Monroe, Jane Russell, and Silvana Mangano. Like young alley cats, we rummaged through magazines and newsstands, devouring whatever caught our hungry eyes, and occasionally got to sew our oats with a young local girl.

Riding the very top crest of this wave was the young good-looking photographer, famous before the Beatles and the Rolling Stones in music, or Richard Hamilton and David Hockney in painting, there was David Bailey, always "there" where we longed to be – in the company of exquisite models, girls and beauties, preoccupied and shamelessly at play behind closed doors, taking delicious and vibrant photographs of all the beautiful women that I'd dreamt of and longed to have, and also working with groovy guys and legendary men, taking portraits and creating images of what was radically new, cool and relevant to the times, and doing it all with great style.

In spite of the perpetual cold-damp fungus-ridden plague of English weather, the provincial attitudes and the miserly grip of Dickensian poverty that still held strong in London and Paris, there suddenly arose from English youth a fury of sparks, an explosion of new trends in photography – fashion – music and art so radically different and original – igniting a blaze so fierce and bright, that it spread like wildfire, consuming and inflaming the world while defining the emblematic signs and standards for images and sounds of a new age, a period that would make the '50s appear archaic, impoverished and static. A revolution was forged that would become the cornerstone and foundation for our current post-modern global culture.

While the inspirational roots of this post-war revolution in England can partly be traced back to origins of American Jazz, Blues, and Rock'n'Roll, the English origins go back to the '20s, '30s, and '40s to the great literature of Somerset Maugham, Graham Greene and George Orwell; the radio recordings of the riotous and insane comedy of the Goon Show; as well as the raging anger and genius of new English theater; playwrights like John Osborne, *Look Back in Anger*, and Harold Pinter, *The Caretaker* and *The Servant*. The passion and explosive talent of actors like Charles Laughton, Lawrence Harvey, Richard Burton, Albert Finney, Alan Bates, and Richard Harris and later Michael Caine and Terence Stamp. The great director Alfred Hitchcock, and many expatriates from Europe and America including Alexander Korda, John Huston and Stanley Kubrick, brought forth expressive voices and dialects from regions across England, Scotland, Wales, and particularly the East End of London. Sometimes outpacing and outgunning their American counterparts, the English were advantageously better versed and inspired by the great rebellious literature and poetry of Ireland, existentialist voices in philosophy from France, and lived in fertile settlements for the displaced amongst expatriate great talents of literature and cinema from Germany, Poland, Russia, and America. Having lived through the devastation of two World Wars in forty years, voices, ideologies, images of protest and discontent, assertive with new-found cocky confidence, as well as wild humor and song, were second nature for English youth.

One of the distinguishing characteristics central and very noticeable in English art and what would later be loosely termed as the origin of "Pop Art", was its roots in graphic design and print, magazine layout and lettering, as well as in early images from German, Russian, and European propaganda and photo advertising. The recognition of graphic qualities in advertising magazine layout came partly from centuries of experience in the trade of cutting and tailoring, and was more concerned with shape and form, within the language of print – design

– fashion and mass communication. American artists were more pre-occupied with industry, the medium and process of production, and with art as a product of industry.

David Bailey, born in the East End of London just before the war in January of 1938, witnessed some of the bombing of London in 1941 as a child. His father, a cutter for English tailors and both his parents quite snappy and stylish dressed. He got most of his art education from going to the cinema and playing around with a box camera, at an early age Bailey was a readymade candidate for a future star.

Like many young men of his generation, in 1956 at the age of 18, he was drafted into the Royal Air Force and was sent to spend two years in Southeast Asia. It is there in the thriving exotic metropolises of Singapore and Malaysia, abundant with black market imported goods, magazines and by-products of American culture, that he got his first camera and began taking photographs. Bailey as an 18-year-old handsome young man looked more like the hero and star of an imagined English drama by Somerset Maugham or Graham Greene, who had both spent a lifetime in Indonesia and the Far East, much inspired to write of the drama of life and death in the tropics. Bailey, immersed in reading and literature, and mindful of the participatory nature of art, was already aware of the power of the photographic image as is clearly visible in his early self-portrait reclining, bare-chested in tropical heat underneath a reproduction of a Picasso painting of a bust, his arms folded reflecting a similar pose as the figure in the painting. It is a rare thing for a young man of 18 or 19 to pose for a self-portrait in the tropics and for inspiration especially choose to hang a Picasso reproduction as a "picture" at the head of his bed. It is clear that he had resolved to make a distinct image, and set out to become a photographer.

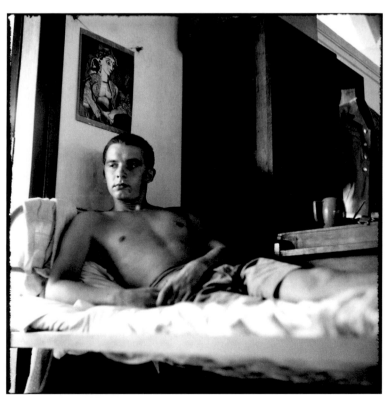

Self-portrait, 1957

By 1960, within a year of his return to London, he began his professional career as a fashion photographer and his photos were published in several magazines. Bailey looked more like a young movie star dressed in a leather jacket and Spanish high-heeled boots. Most women photographed for fashion magazines at the time, were at best graceful and elegant, but rather removed and inaccessible representing a distant world. Bailey discovered Jean Shrimpton, the great English Beauty in 1960. She modeled for Bailey the first time in April of 1961, and soon after he worked with her exclusively making some of the most innovative fashion images of the time. Shortly after that they were living together.

In his scholarly essay in *David Bailey: Black and White Memories*, Martin Harrison quotes Andy Warhol describing the New York summer of 1963 as "the last summer before the English Invasion" and gives a detailed account of his first meeting with David Bailey, at a dinner given by "Baby" Jane Holzer and how "David Bailey was there and he brought with him the lead singer of a rock'n'roll group called the Rolling Stones, his friend Mick Jagger that was then playing the northern cities of England."

I recently phoned my friend Jane Holzer to check out this story and she notably remembered that day with precise detail, and went on to elaborate with a delightful laugh, describing Bailey as a "great dish" asking me to tell him when I spoke with him next, "I hope he is as good a fuck now as he was then," which I did, and Bailey laughed on the phone and said, "Yeah, I am better now, with Viagra."

Surrounded by all the young beauties, seducing and amusing them to play, pose, come alive and get "switched on" as he called it, he would nail down and capture that final shot for print in all the magazines grabbing our wide-eyed attention, cringing with envy. We marveled at the whole new world and vocabulary of style, shape, and the form of beauty, while he single-handedly laid the foundation of what would come to be called the cool, mod look. I didn't know him then, I was a few years younger, an art student on the outside, and he was the good-looking guy from the East End, already famous in '62 and of rock or movie star status, who seemed to get all the hot birds. No wonder we'd often hear the famous cockney jingle, "David Bailey makes love daily."

Some years later in '65 or '66, I had the great fortune of dating and falling madly, head-over-heels in love with the famous model Prudence Pratt. Through her I learned the names of the three hot photographers who were great and straight and hence dangerous: Terence Donovan, Brian Duffy, and especially David Bailey. I remember getting sick to my stomach with youthful envy and jealousy; it was obvious that no one could hold a candle to the daring, innovative energy and naked spirit of his creative talent, no one could compete with David in stealing the company and affection of the greatest beauties.

At the same time he started as a professional fashion photographer, he was taking some of the most inspired portraits of the great talent of that time, portraits that had enormous iconic impact on everyone. Some of his first published photographs were the portraits of Somerset Maugham in 1960, Franco Zeffirelli in 1961, and Cecil Beaton in 1963.

Looking at these photos, what seems most original and powerful in the portraits David started in the early '60s, is the crisp sharpness of the image, the stark contrast of black against white, the radical abstractness of the shapes. His in-your-face animated stances with the characters coming out, almost leaving the frame, prove to be a completely accessible and rebellious way of making a connection with the viewer. All parts of the image are totally creative and super-charged. The dramatic, hip, mod stylization is superhyped, powered up, and turned on with youthful arrogance.

A clear example is the portrait of John Huston from 1965 (p. 12), a dramatic diagonal composition, a piercing look of the eye, the face, the head and hand of one of the greatest directors presented as a scorching slash of a character across the page.

One of the outstanding portraits by David Bailey is the cool, in-your-face Andy Warhol in simple graphic form (p. 34). A heart, echoed in the shape of his shoulders, the white shirt, and his lips – the most gentle, big beautiful eyes radiating tenderness as his head leans *into ours*, almost three-dimensional, with an open mouth directly placed in the absolute center of the picture.

A most memorable portrait of Man Ray (p. 56), so tight and close up that one equally reflects on the nose, hat, mouth, hand, glasses, and walking stick that frame the wise, piercing eyes of an American expatriate. A great artist and photographer brave enough to spend his life exiled in Europe.

A wonderful portrait also from 1965 of Cartier-Bresson (p. 70), a refinement of architecture of combed hair and even wrinkles on fore-head, near a clear eye, ear and neck. Clean white shirt collar and jack-et detail of herringbone weave, holding his camera in front of his mouth as if to say and show what he truly speaks through, the lens the eye of the camera is the mouth of the artist. Genius!

I well remember this portrait in London of Roman Polanski (p. 78), also shot in 1965, a legend of a picture and a true measure of the greatness of young Polanski and young Bailey. Timeless and noble. A young handsome Polish genius, what Polanski was to Joseph Conrad, Bailey was to Somerset Maugham and Graham Greene.

One of the greatest portraits of the twentieth century, a Roman champion of a man, Federico Fellini in 1965, with fists of gold, the mon-umental massive hand and Roman sculpture of a finger holding head, propped between nose and eye, with hooked eyebrow and piercing eyes deep into serious thought and dream (p. 102). This is a master-piece never to be topped.

All are remarkably dynamic portraits shot in the mid-60s of the greatest men with the greatest eyes and yet it is very clear that Bailey's drive moved on to continue the search, investigation, and discovery as he made great portraits in the '70s with one of the most penetrating, touching and warm portraits of young Yves Saint Laurent after the Paris revolution of 1968 (p. 44). What great talent and energy, here in the best, healthy and handsome portrait of him with great eyes framed behind large window-like glasses and in dynamic pose, one's heart goes out to him.

Yoko Ono in 1974, one of the most graphically dramatic and strik-ing portraits, a dream girl who, like Lash LaRue the legendary cowboy star from the '40s and early '50s, always wore black (p. 98). What beautiful model or actress could look as stunning as this? Look at those intense rubies of almond eyes framed in Indian-Japanese cheekbones. Here we can clearly see the beauty and strength, the dis-tinguished intelligence that John Lennon saw and respected and came to love!

Bailey continues into the '80s with what I believe to be one of his greatest, most insightful and noble portraits, a magnificent head, close-ly and flawlessly cropped in majestic dignity, bathed in wonderful light, of the great English sculptor Henry Moore shining through with thought-ful eyes (p. 24). What wisdom, what splendor and sorrow! An extraordi-nary homage of compassion and goodness radiating through those most expressive shimmering eyes of wonder and kindness.

The giant of a director, David Lean, from 1980, with his remarkable head, cheek, nose and mouth an architecture of form (p. 40). Lines on the face radiate from the eye and hook nose. Look and see the great image of an eagle, the falcon of *Lawrence of Arabia*!

The arresting portrait of Joseph Beuys from 1985, with bird-like eyes wide open in a haunted skull with a delicate mouth, passively and quietly looking as if into death and beyond (p. 62).

David Bailey's vision of a great man, Jean-Luc Godard, is a whole new achievement (p. 66). I love this man, this face, slightly unshaven, the rebel of a giant director with a tender smile and the kindest eyes looking at us through tinted glasses. Reflections of image on film and video at play. Suffering in privacy, I want to kiss him with thanks every day and forever. Bless you Godard.

The great studies continue with the most perceptive portrait of Francis Bacon from 1983 (p. 160). Oh Francis, that most daring, youth-ful boldness of the flame in your eyes! Looking at your face is like look-ing into the living fire and light of Turner. The enormous giant of a head leaning out with small body, resting, propped on hand, like his own great portraits, he is a twisted beauty of an accident of art and life!

It appears that in these later portraits, from the '70s and '80s through the present, Bailey's eye goes further, penetrating into the subject's face that now leans into the lens so the head appears to be moving, shifting and becoming monumental as he looks deep into the eyes.

What had started as the most innovative, cocky, in-your-face play-ful and animated graphic image of a portrait, some restlessly torn out of context, stark black-and-white shapes of figures leaning out of the frame, has gradually matured into a more thoughtful and fearless inquisitive curiosity and drive to look even deeper into the face of greatness and eyes of the subject. With a formidable sense of digni-fied respect, Bailey patiently holds a steady gaze, so it is now the eye of the camera, the eye of the photographer, and the eye of the viewer bravely leaning into the deep well, allowing it to reveal unimagined depth of feeling and expression through the eyes.

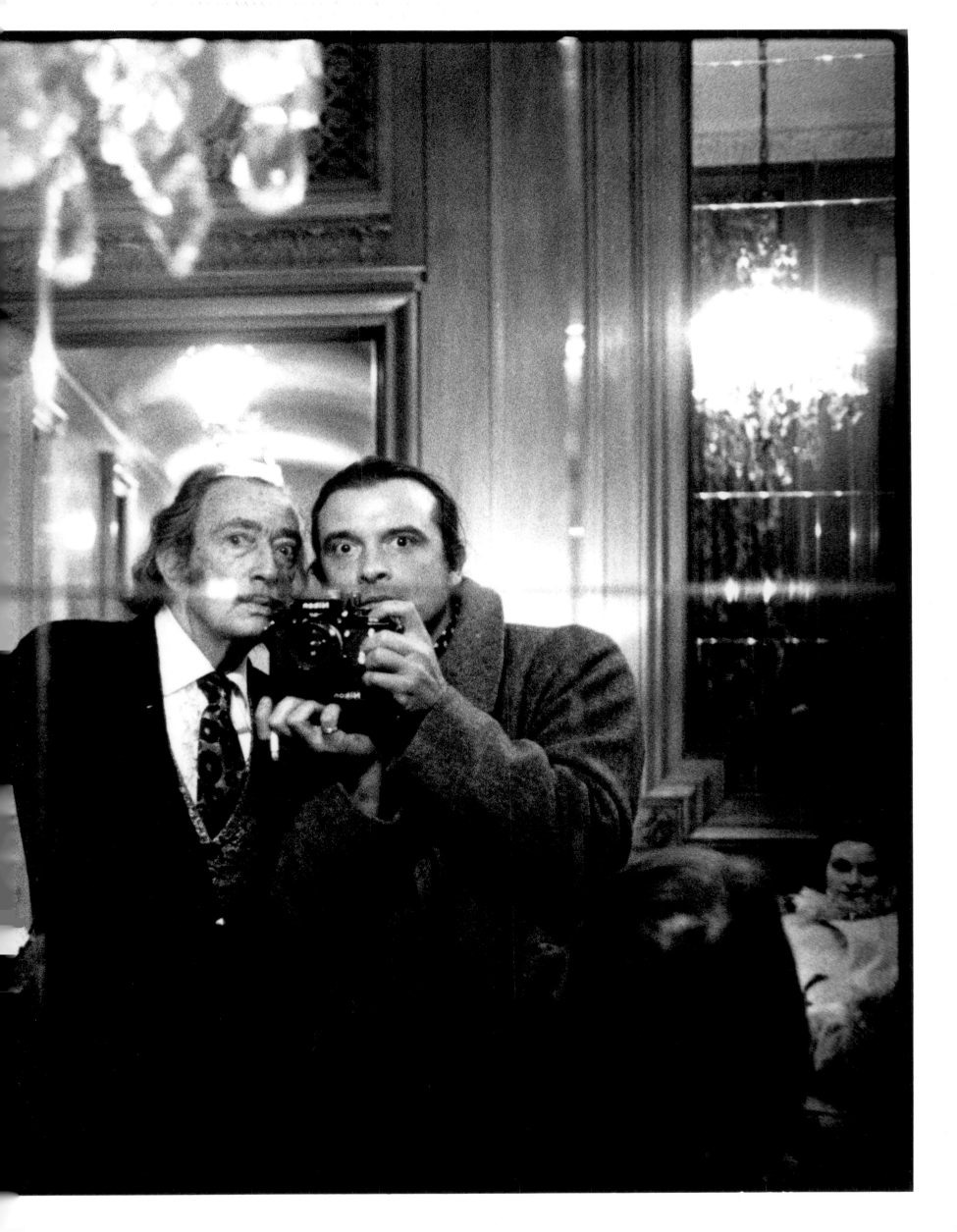

Salvador Dalí and David Bailey 1972 (previous page)

Eduardo Chillida 2000

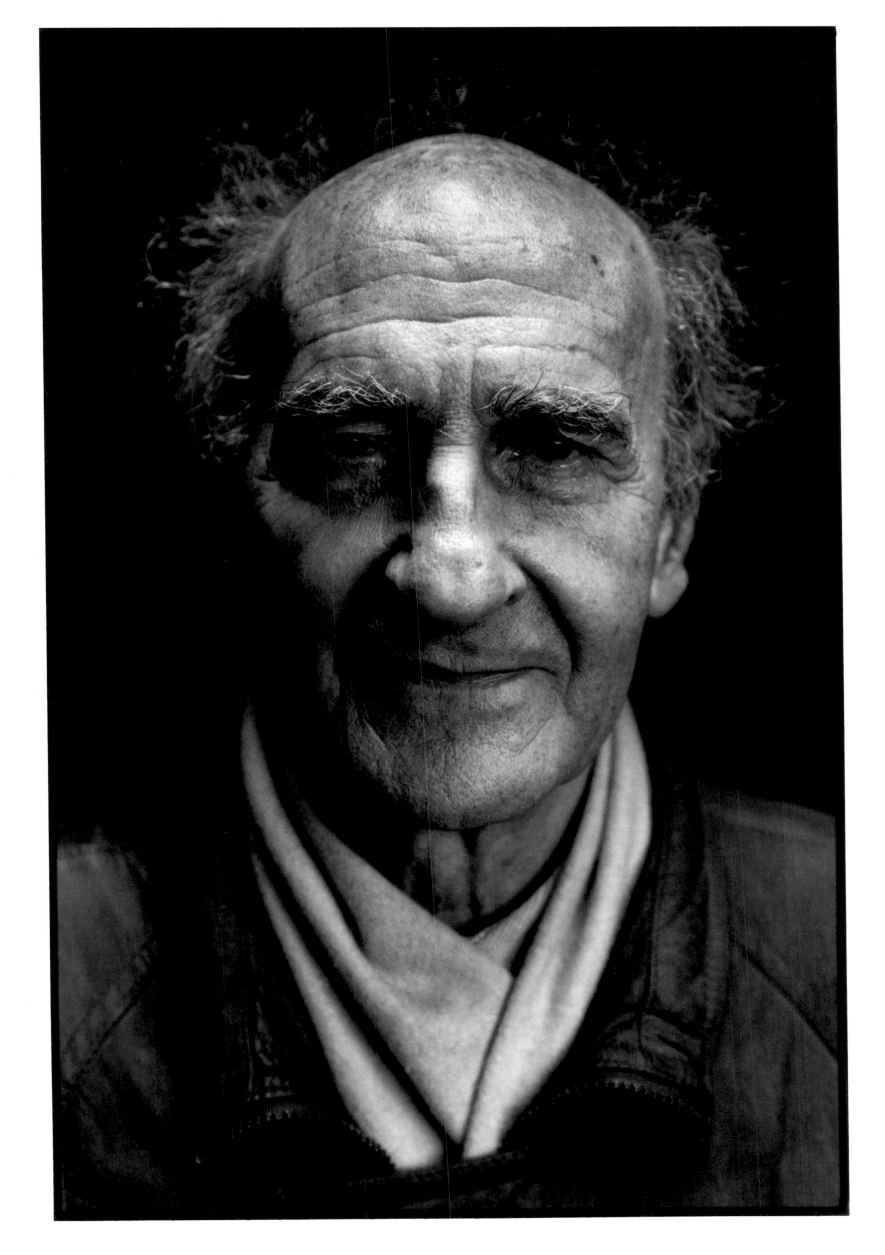

John Huston 1965

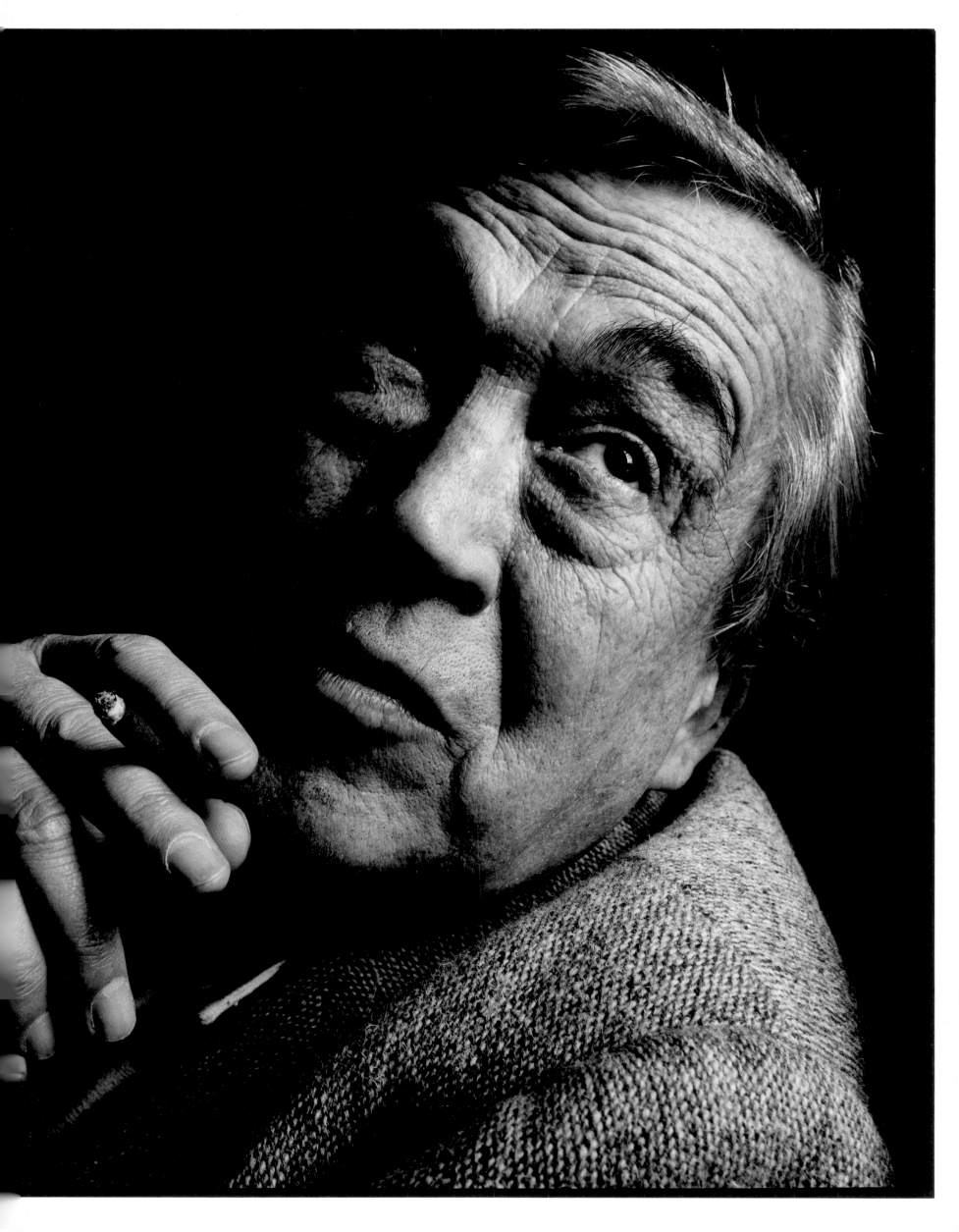

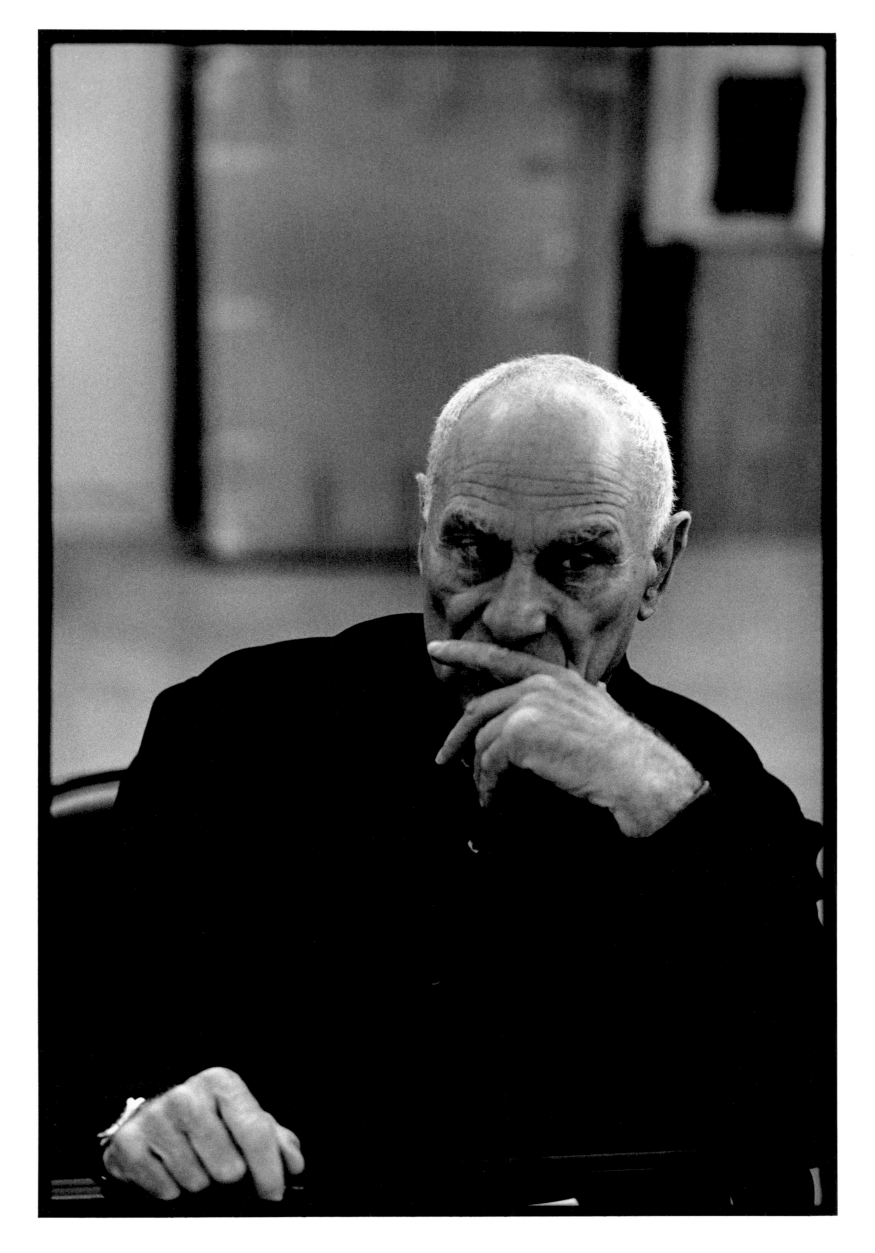

Jeff Koons 2007

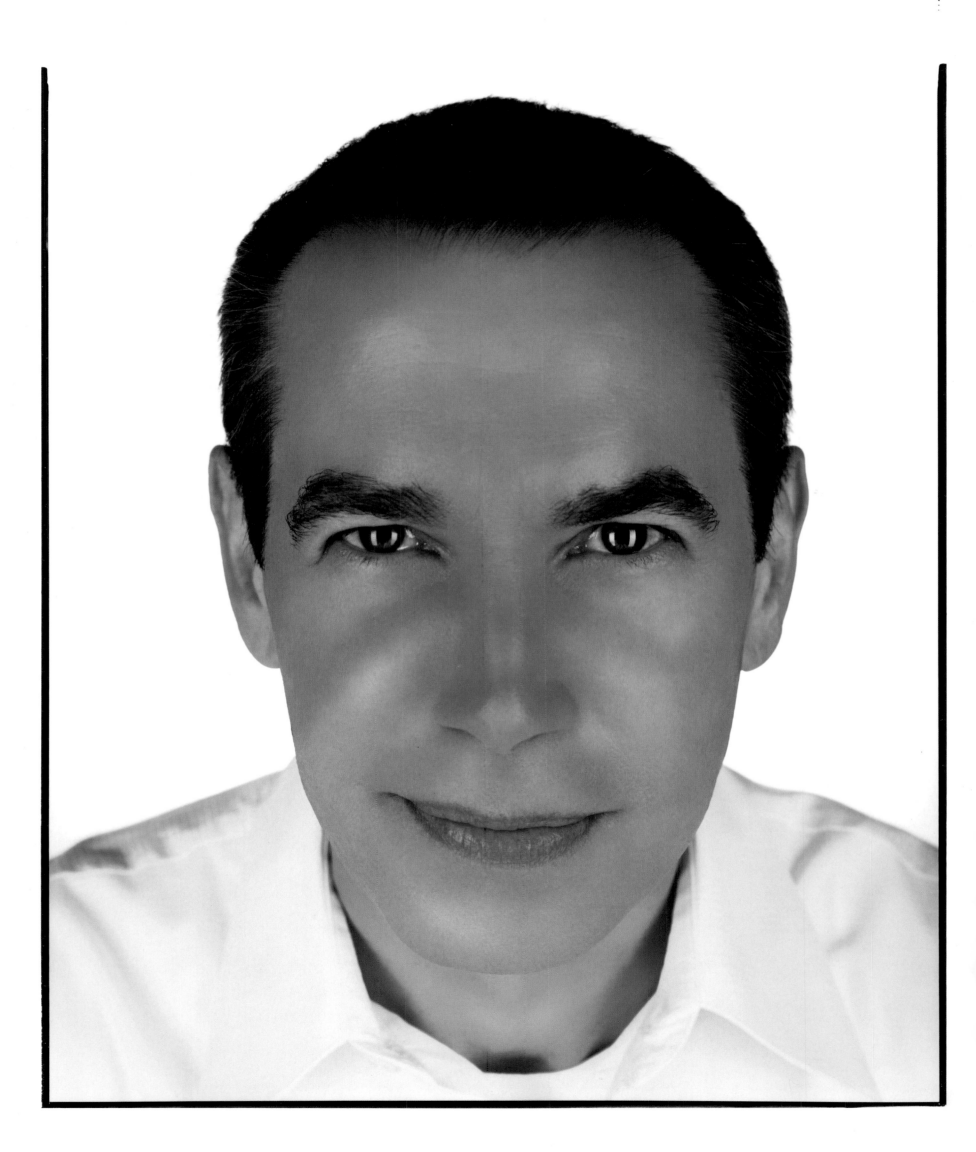

John Galliano 2003

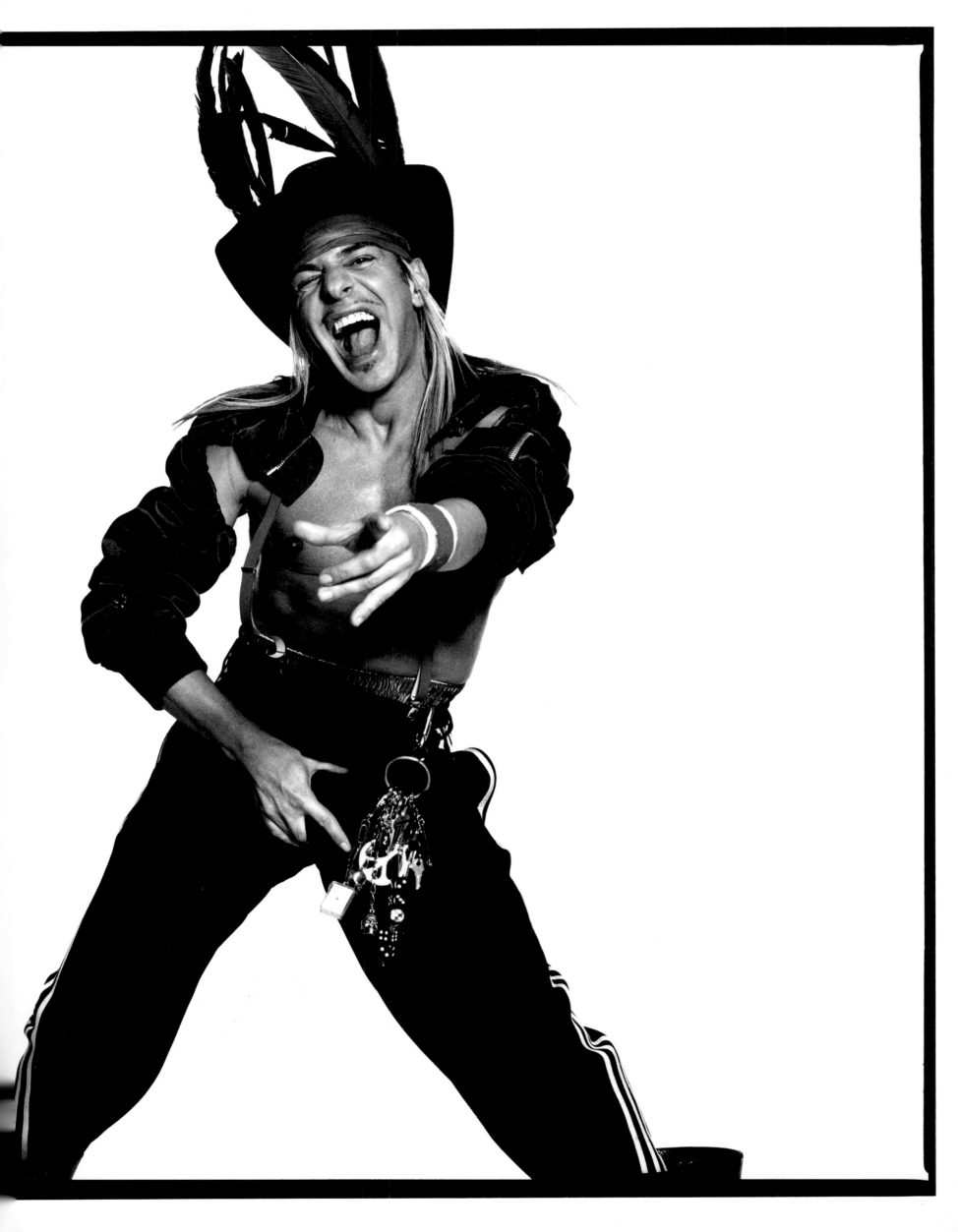

Chuck Close 2001

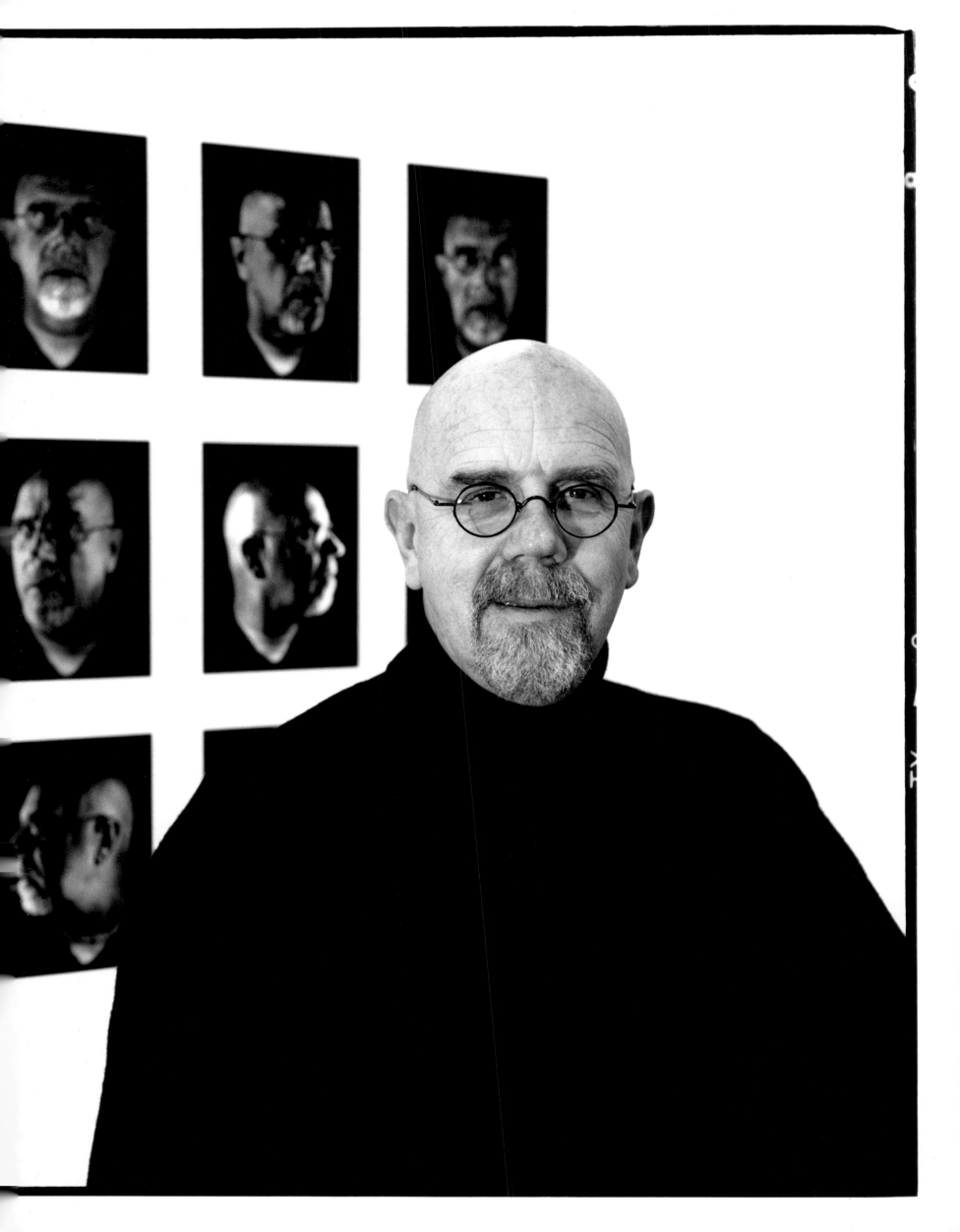

I. M. Pei 2000

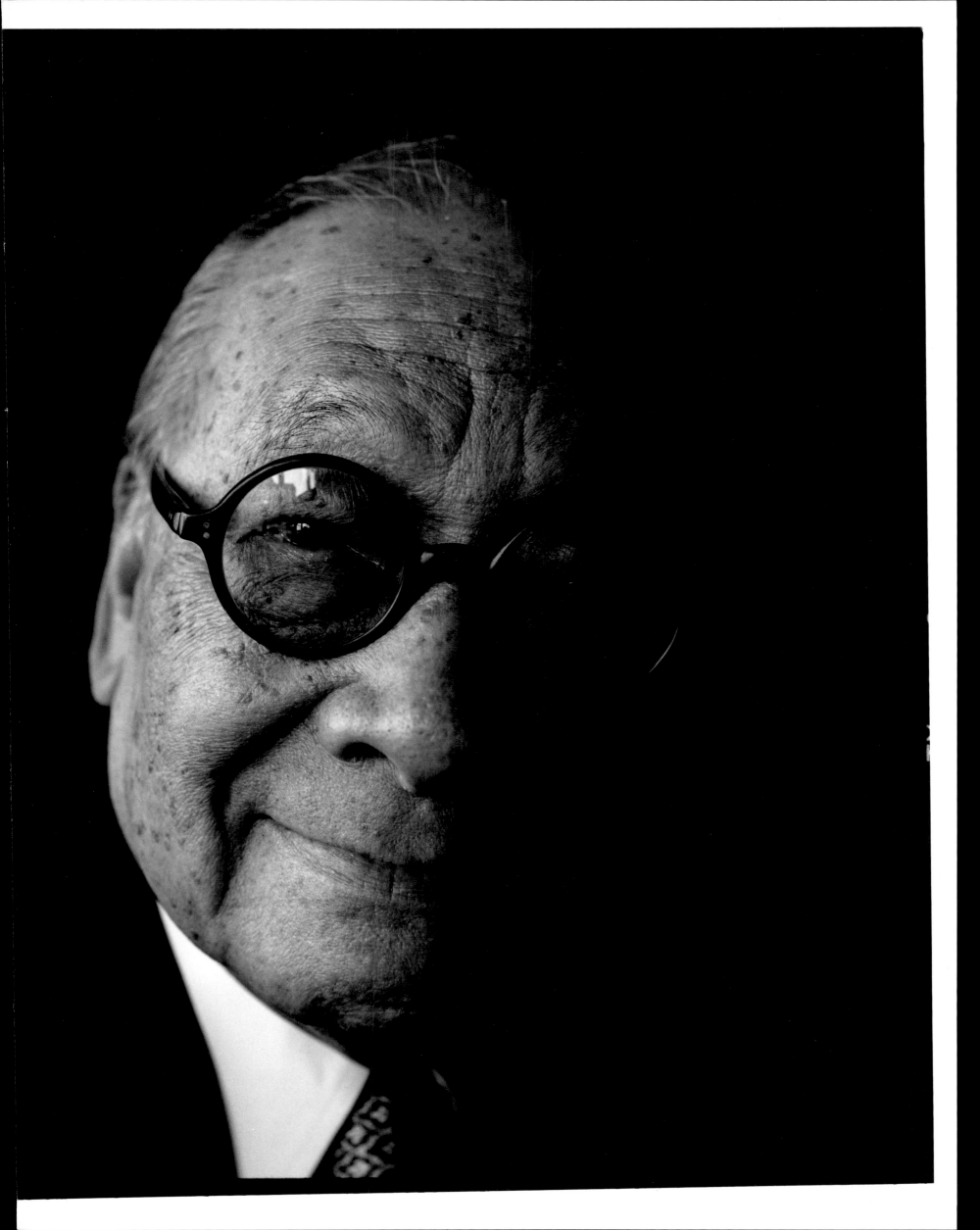

Henry Moore 1983

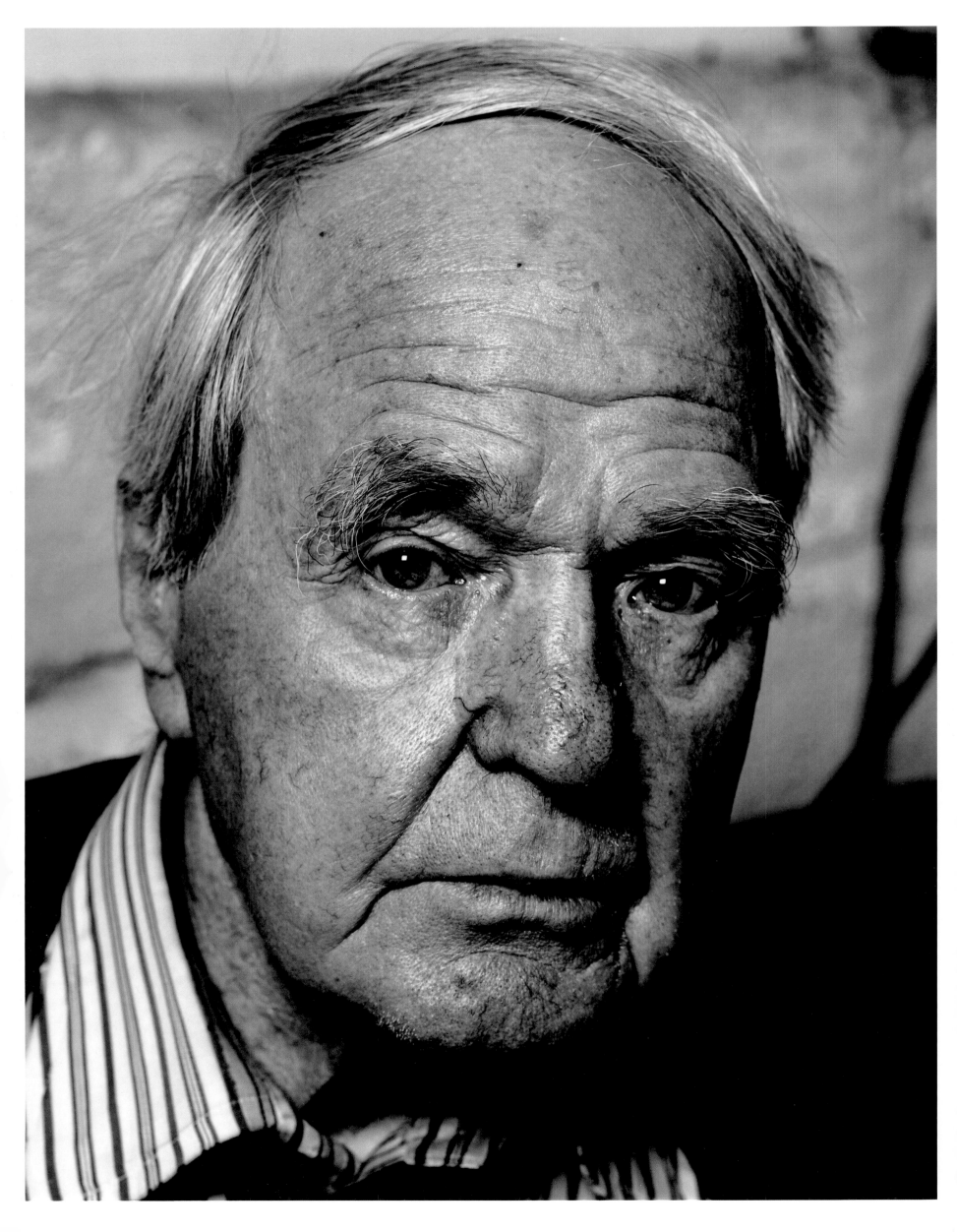

Marc Quinn 2007

Pedro Almodovar 2001

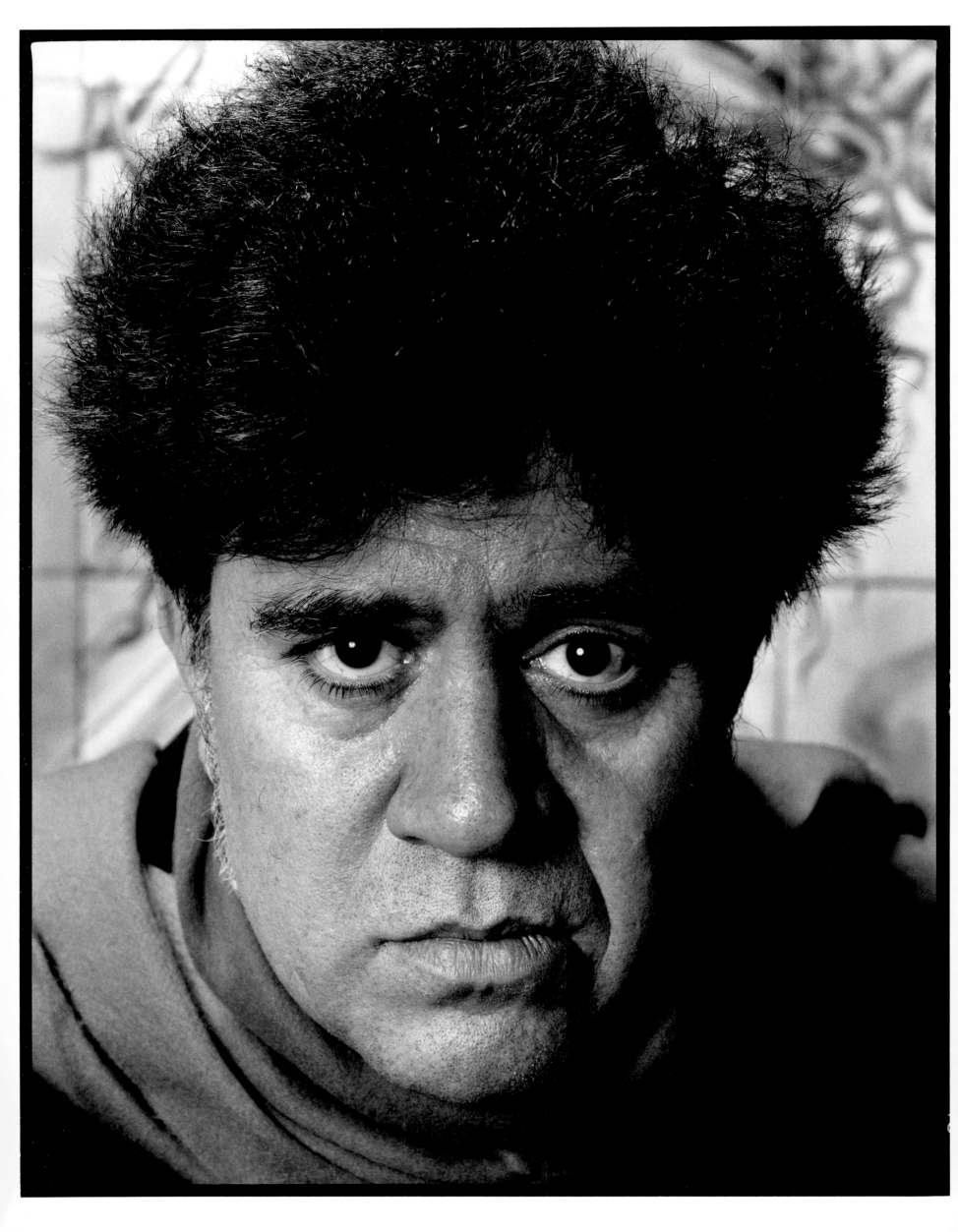

Ansel Adams 1983

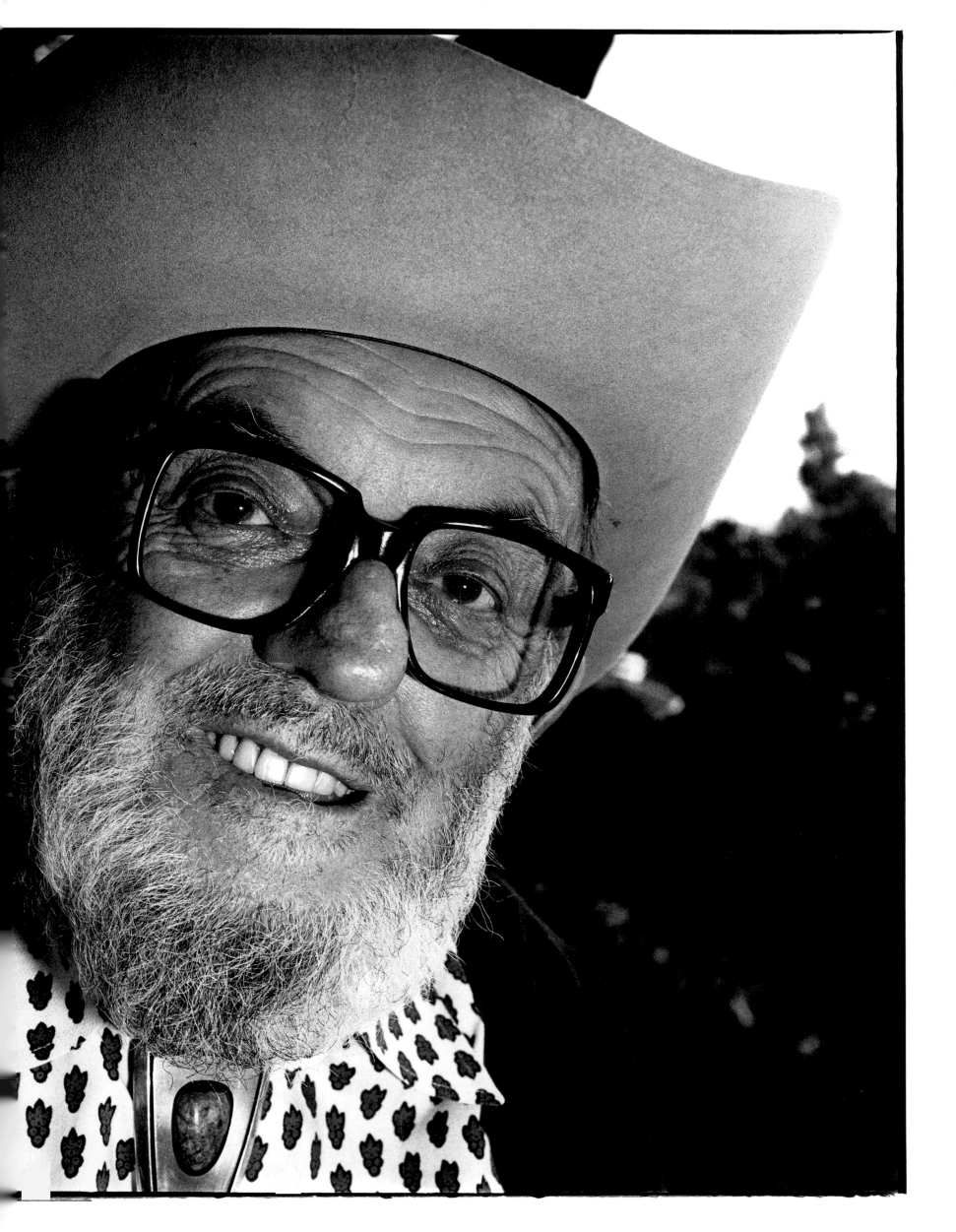

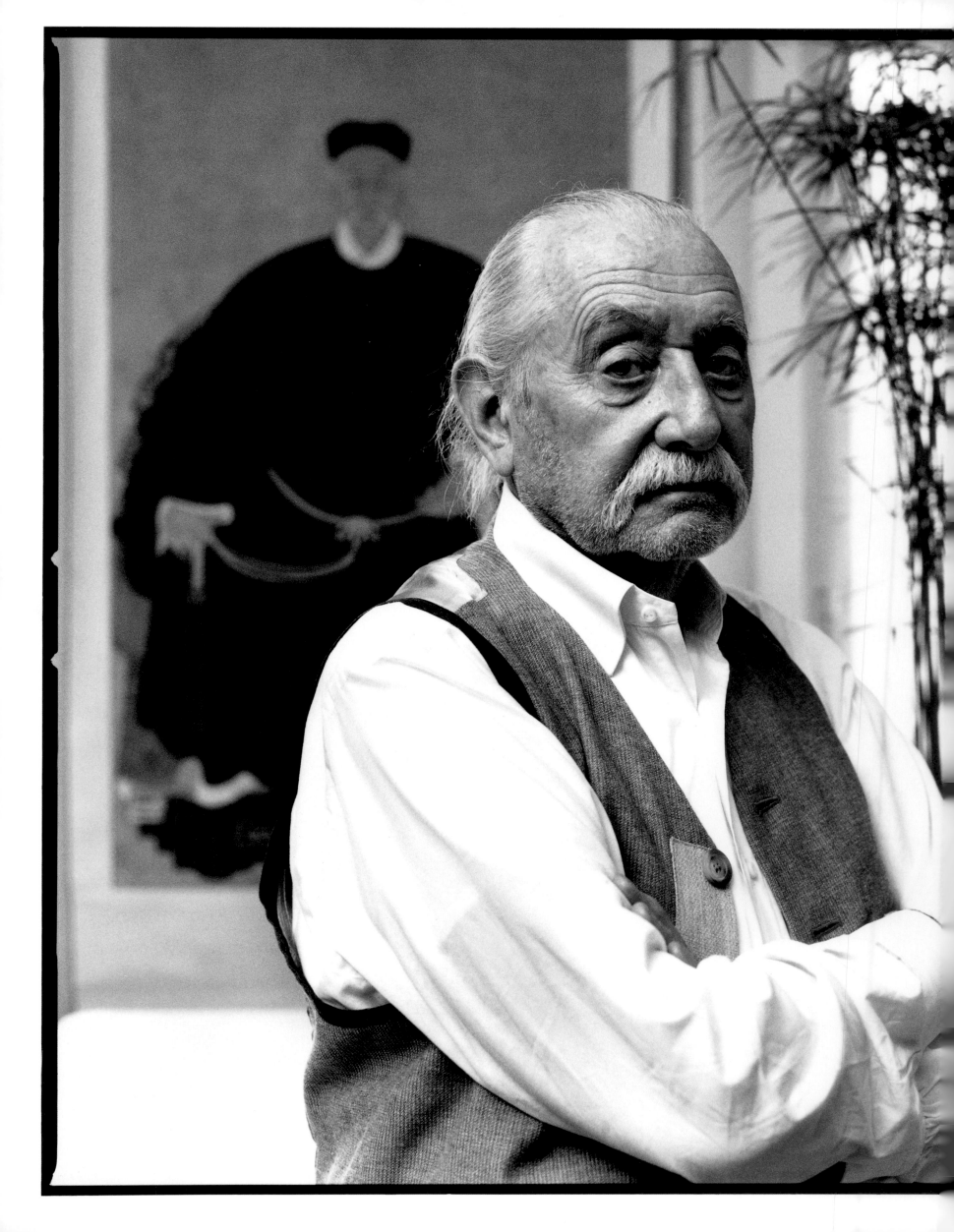

Ettore Sottsass 2003

Andy Warhol 1965

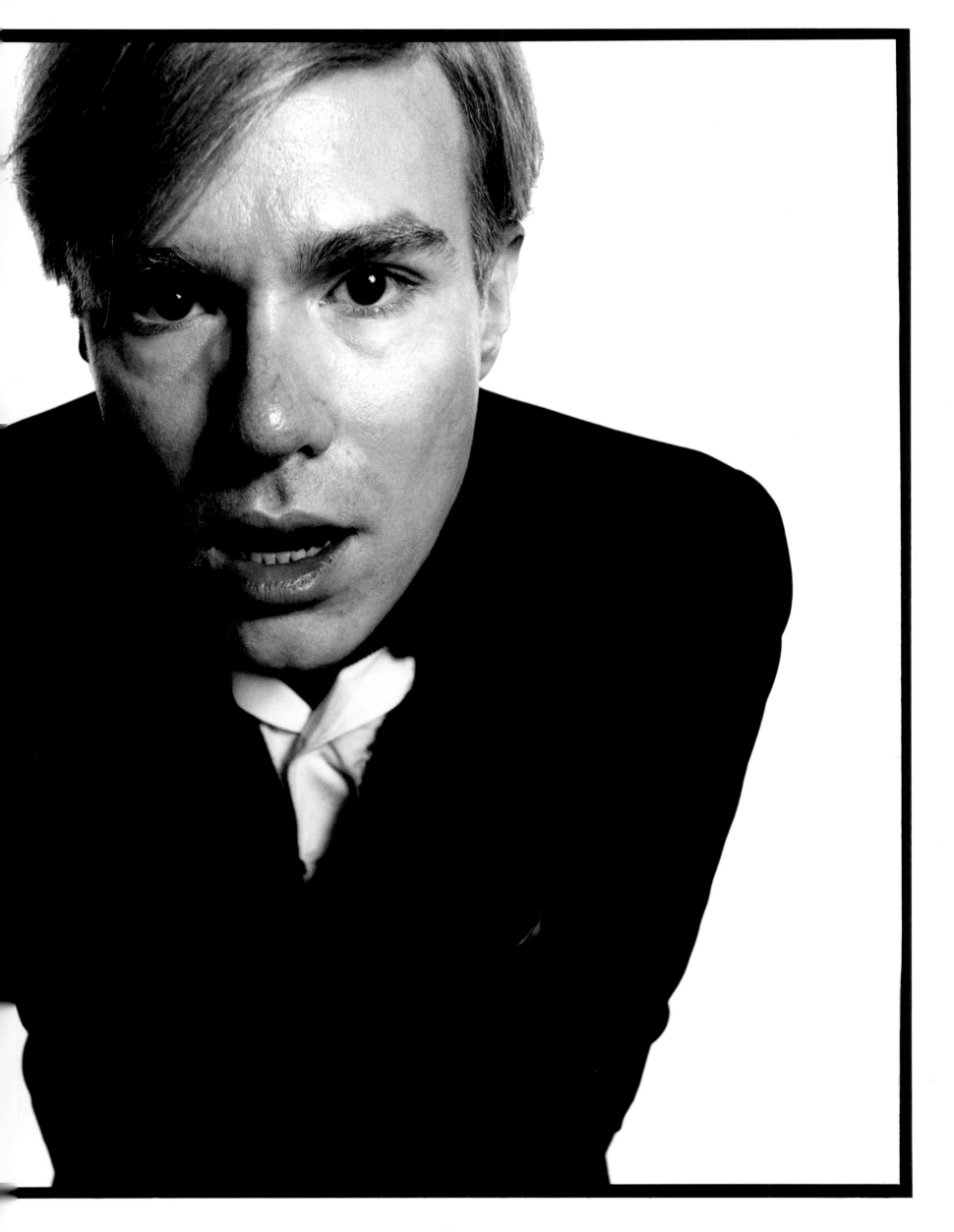

Nobuyoshi Araki 2005

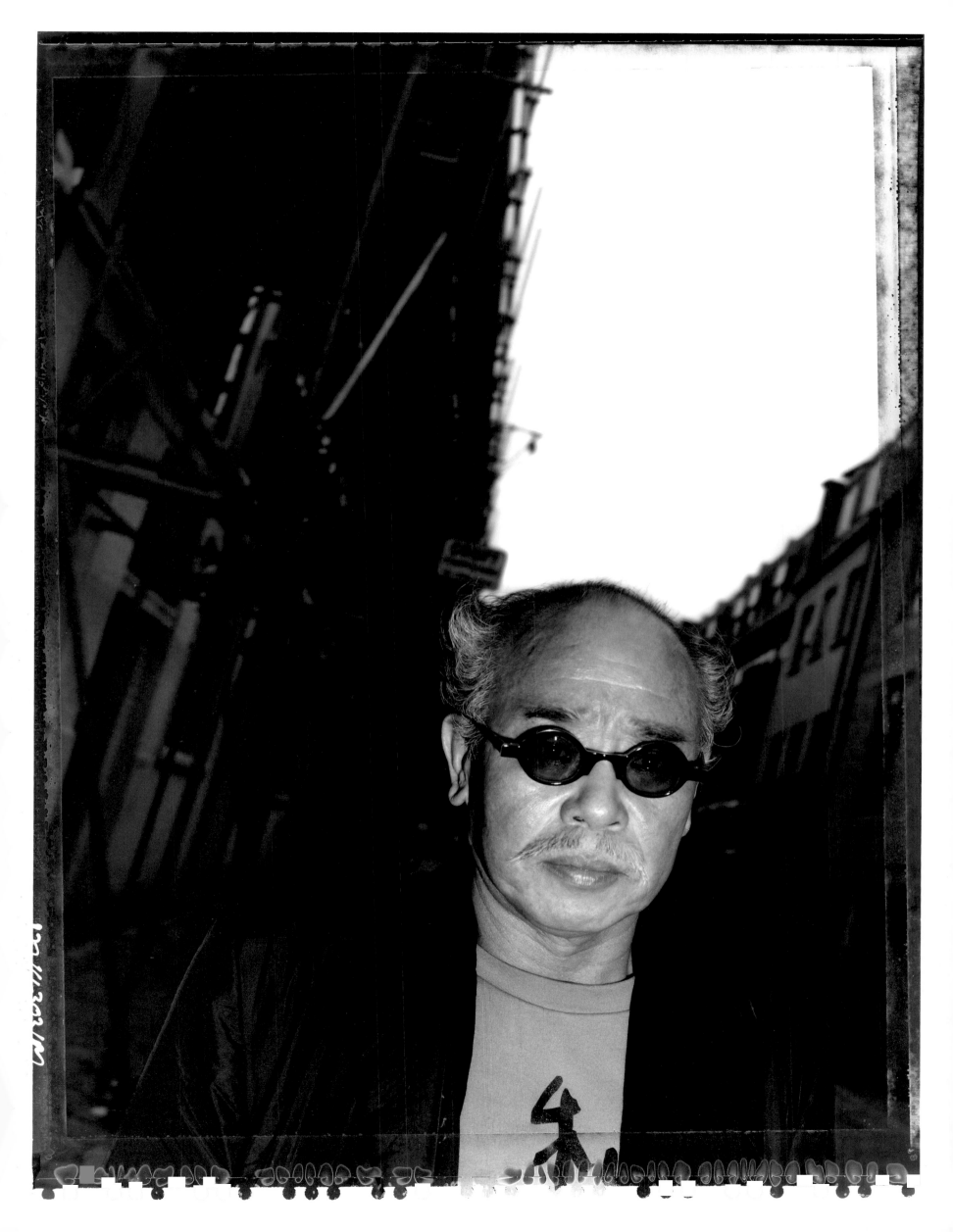

Jean-Michel Basquiat 1984

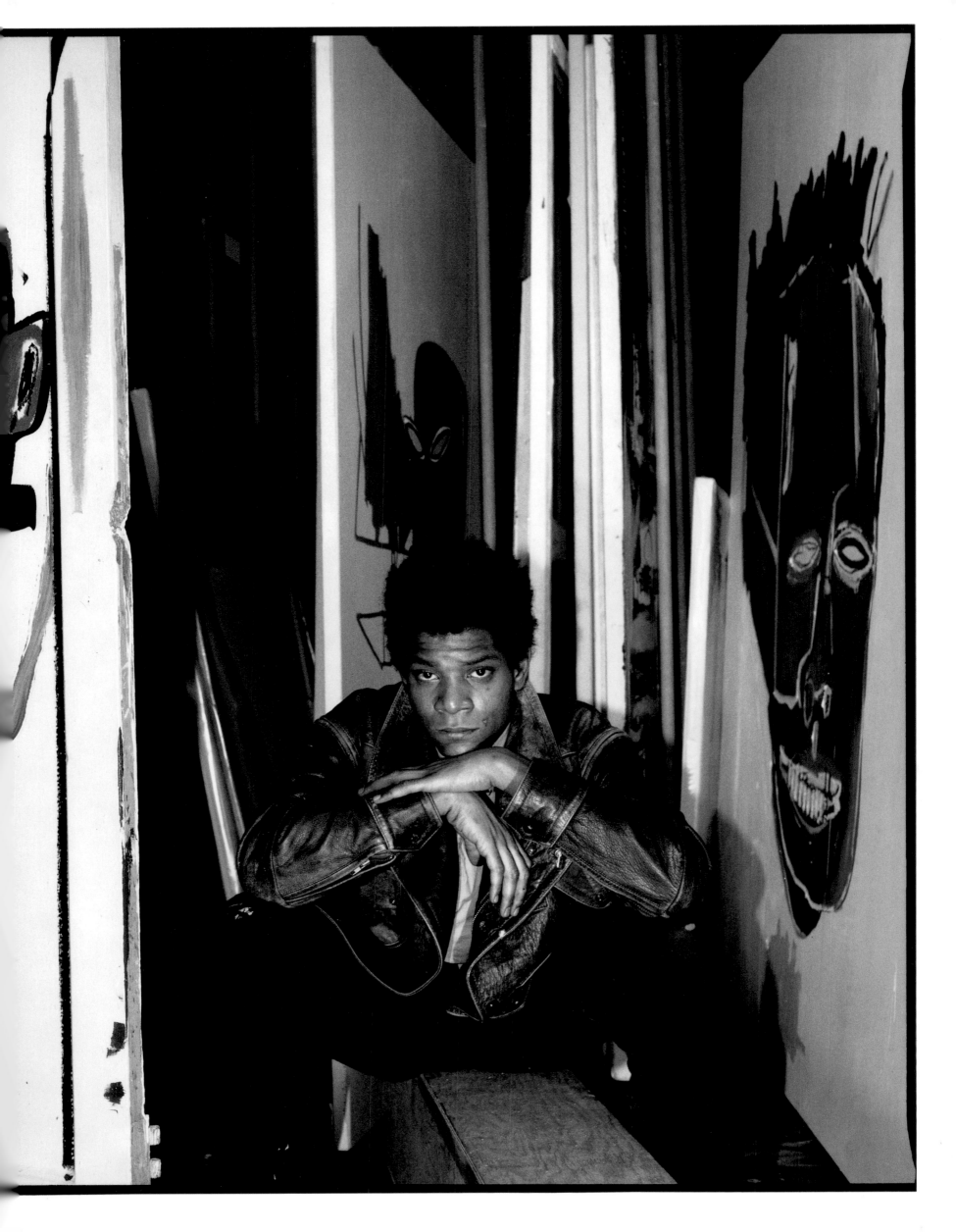

David Lean 1989

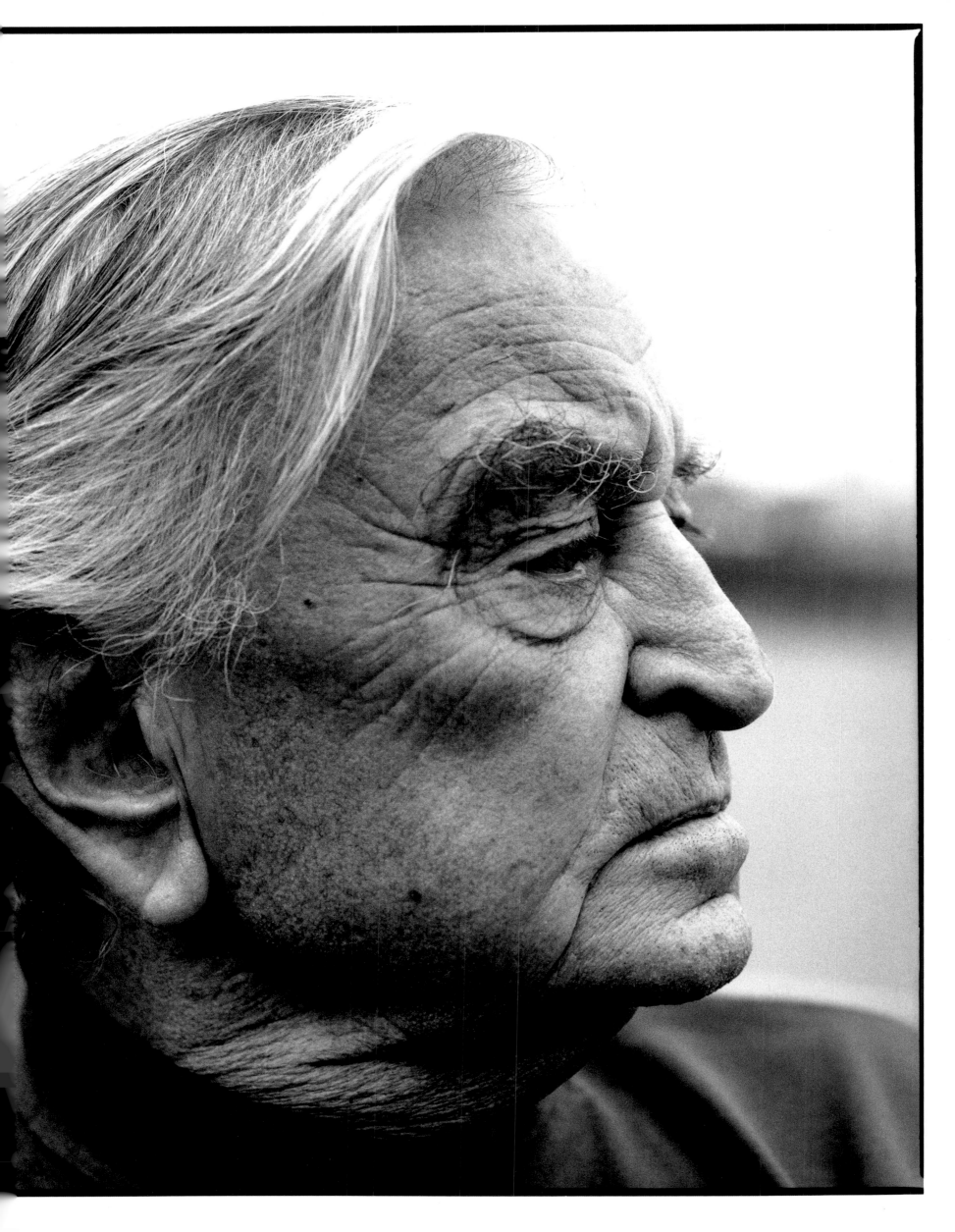

John Piper 1981

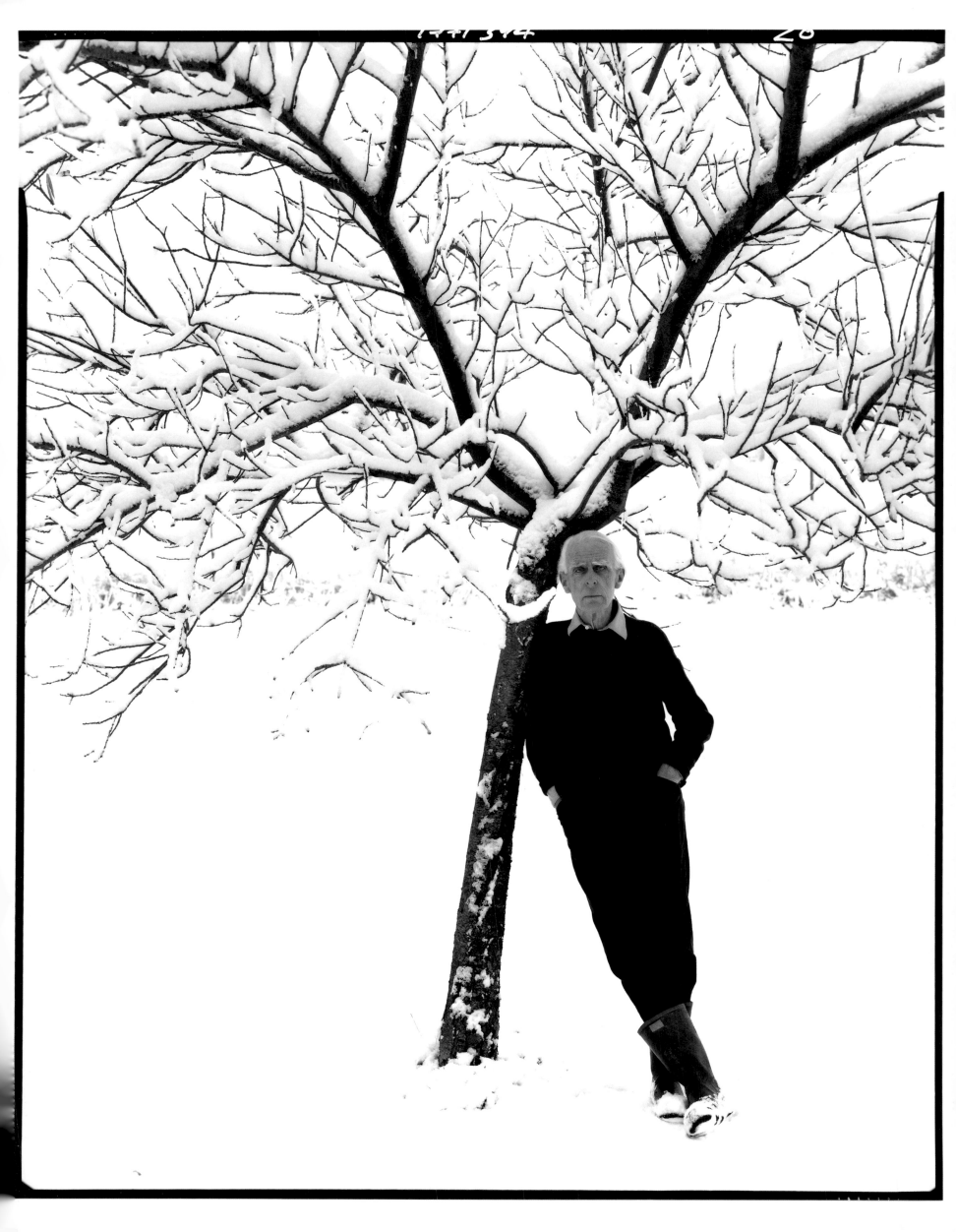

Yves Saint Laurent 1970

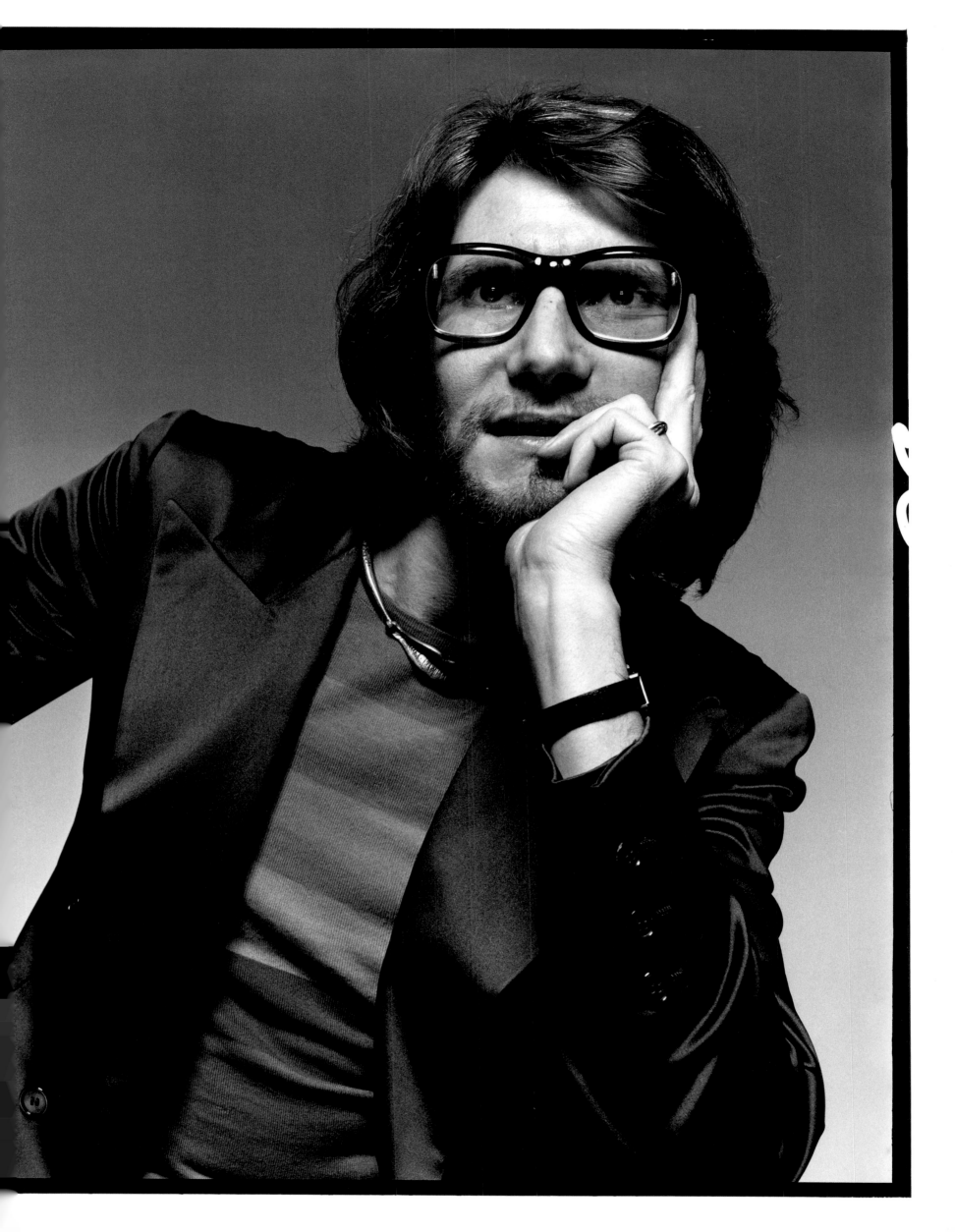

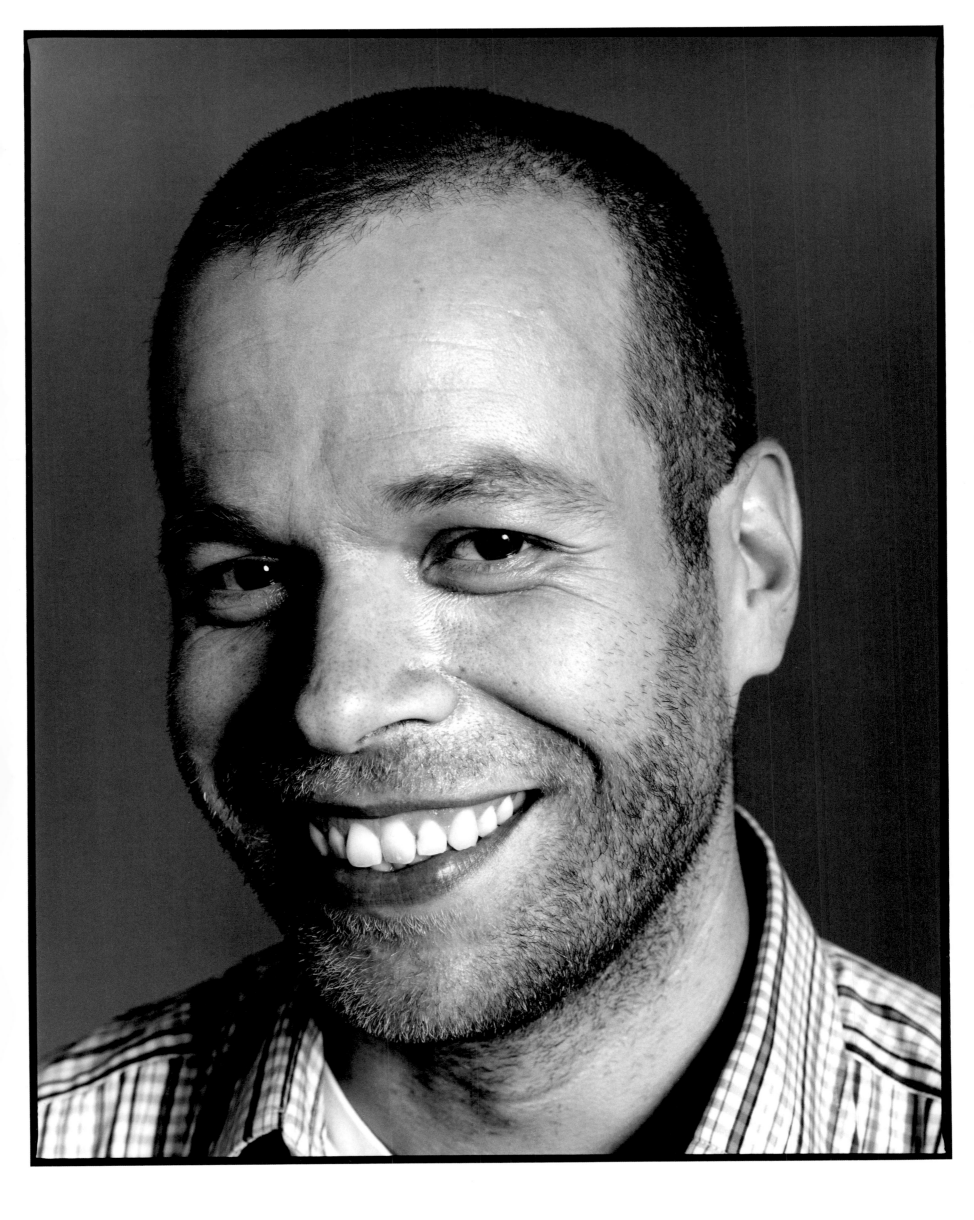

Antony Gormley 2008

Jacques-Henri Lartigue 1982

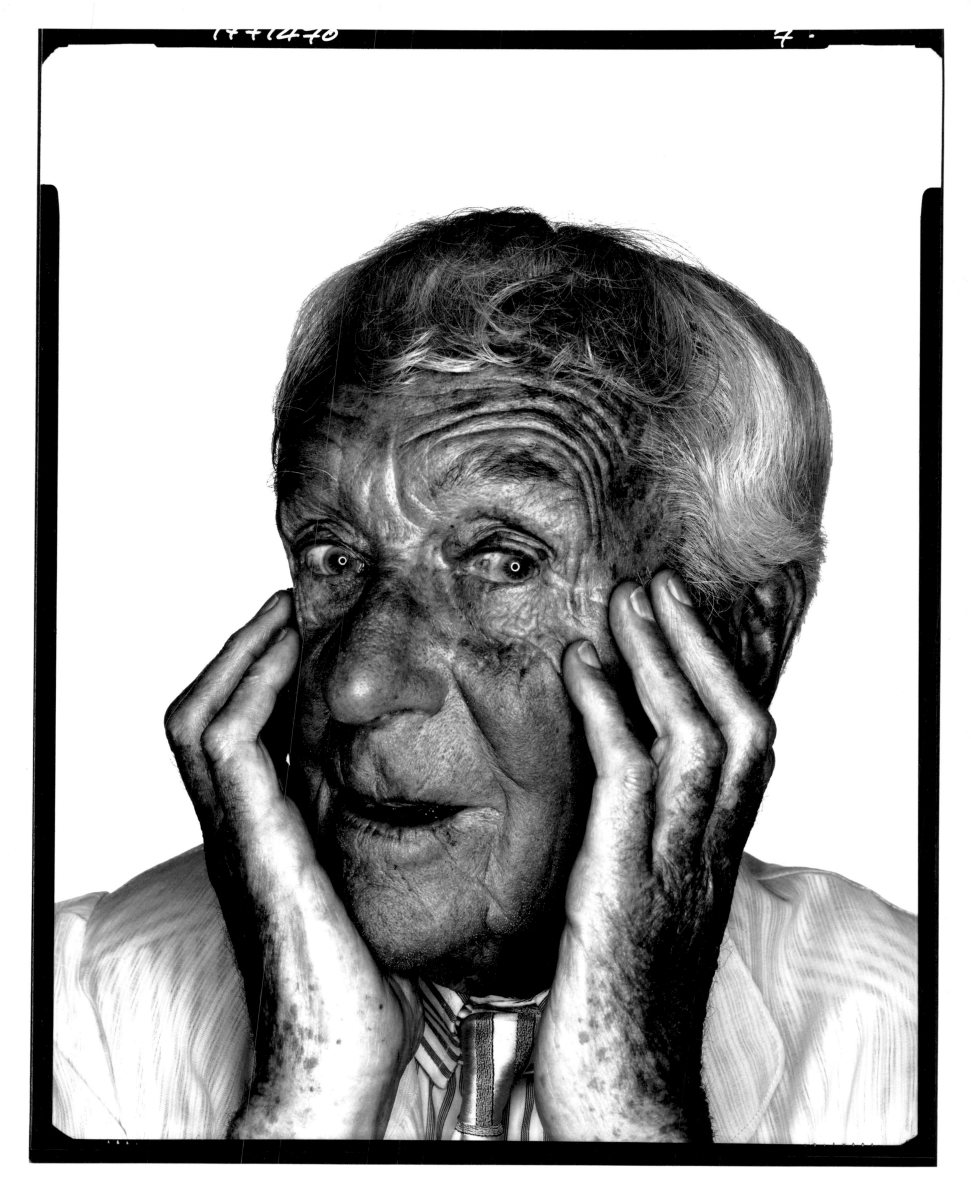

Michelangelo Antonioni 2002

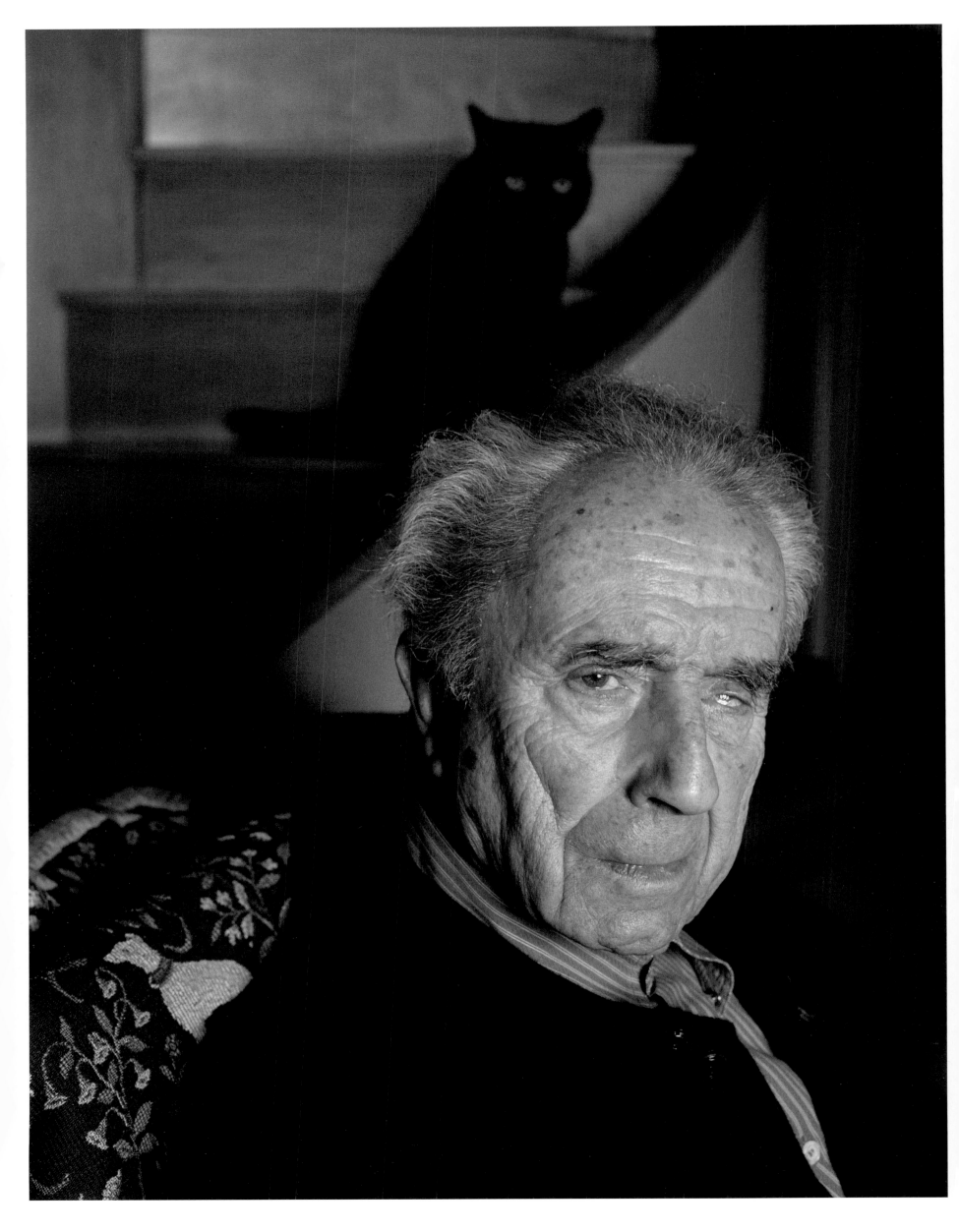

Peter Blake 2007

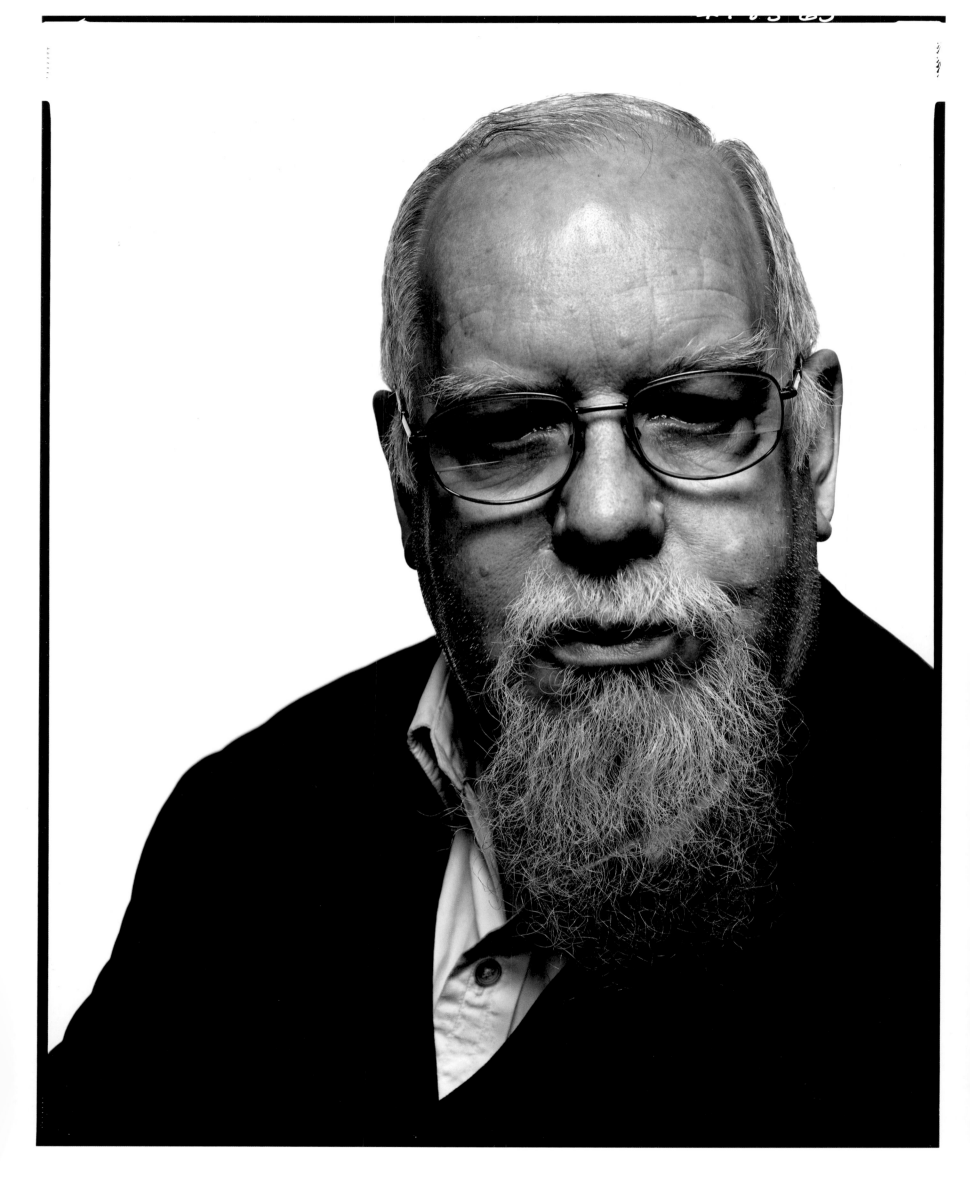

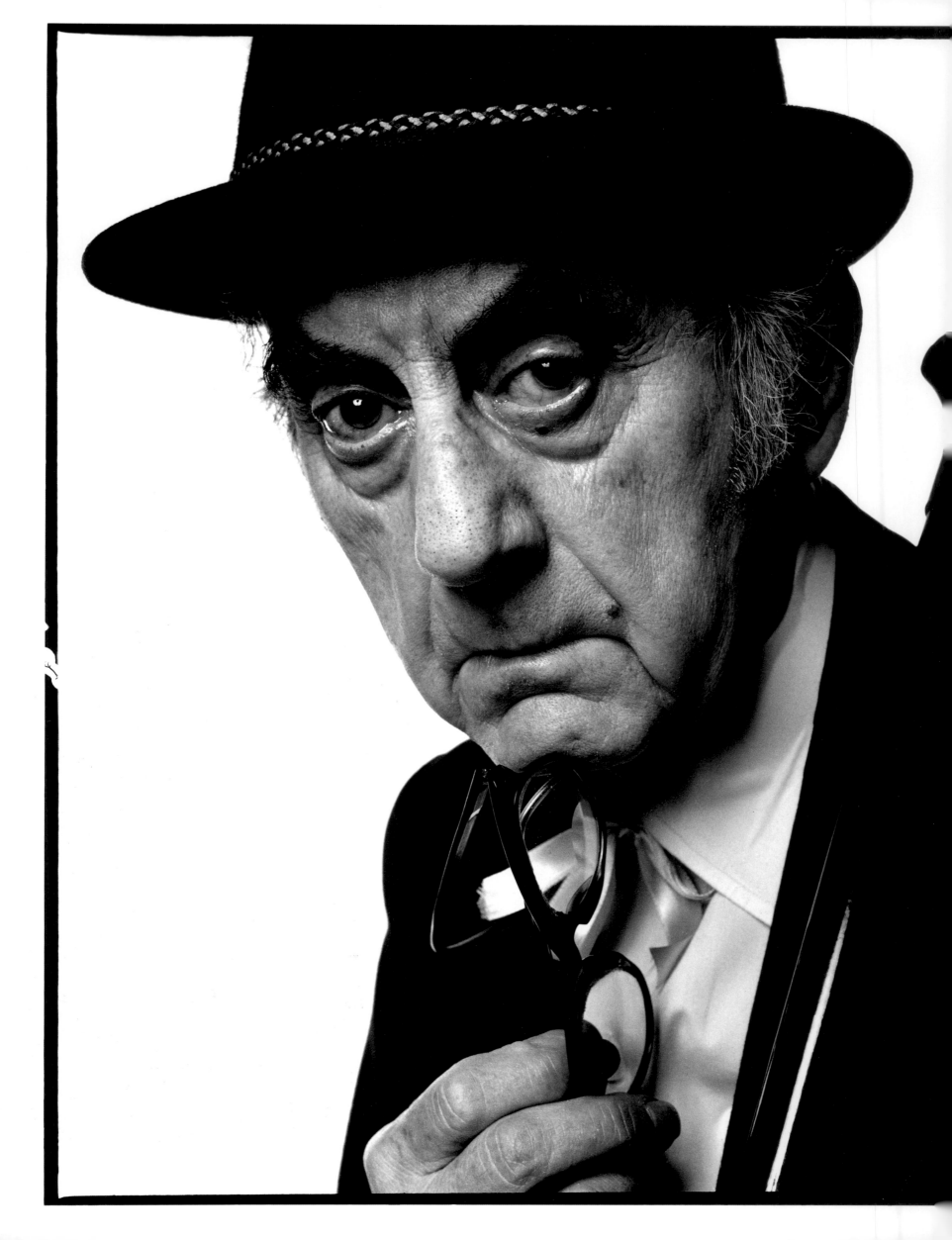

Man Ray 1968

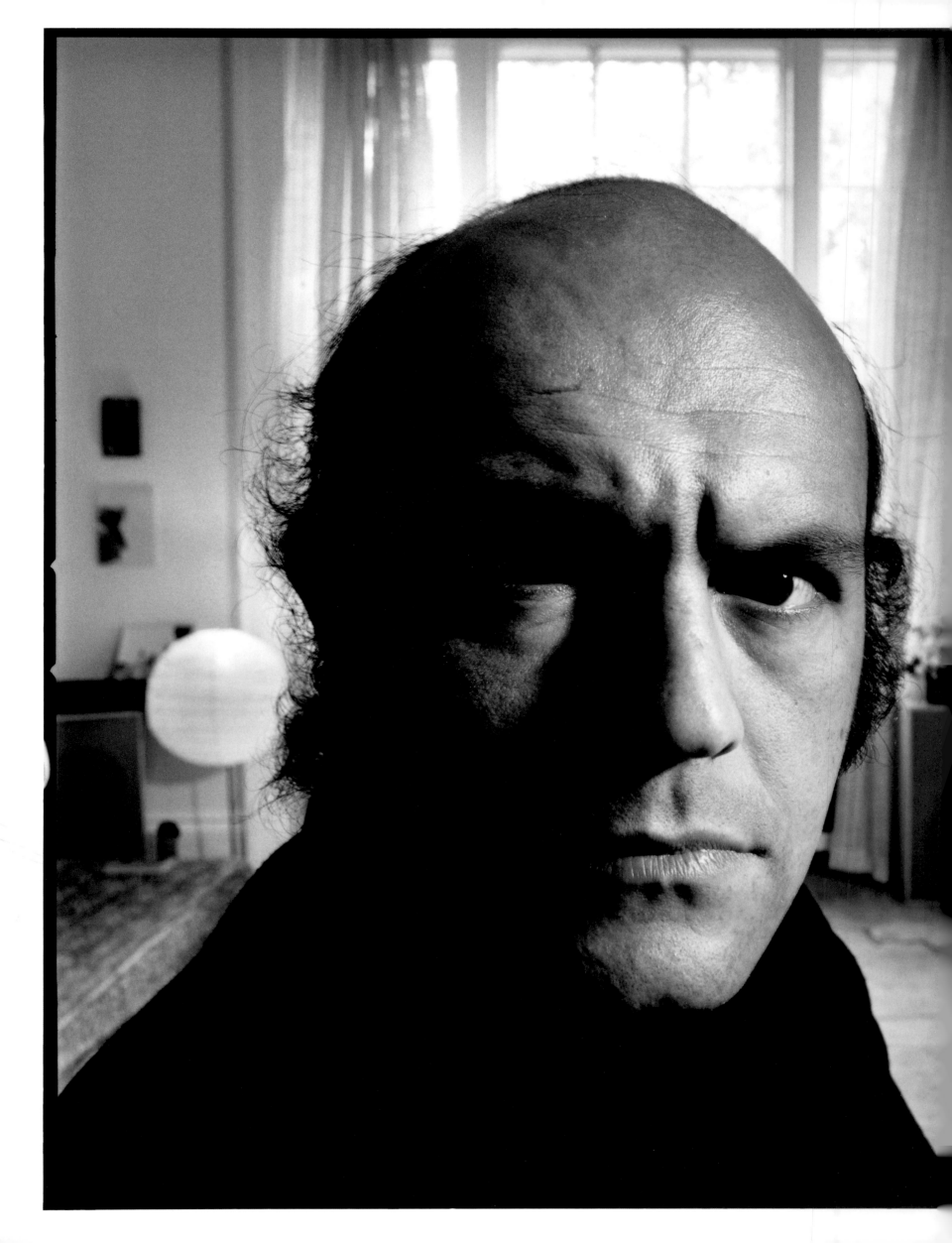

Jim Dine 1968

Joseph Beuys 1985

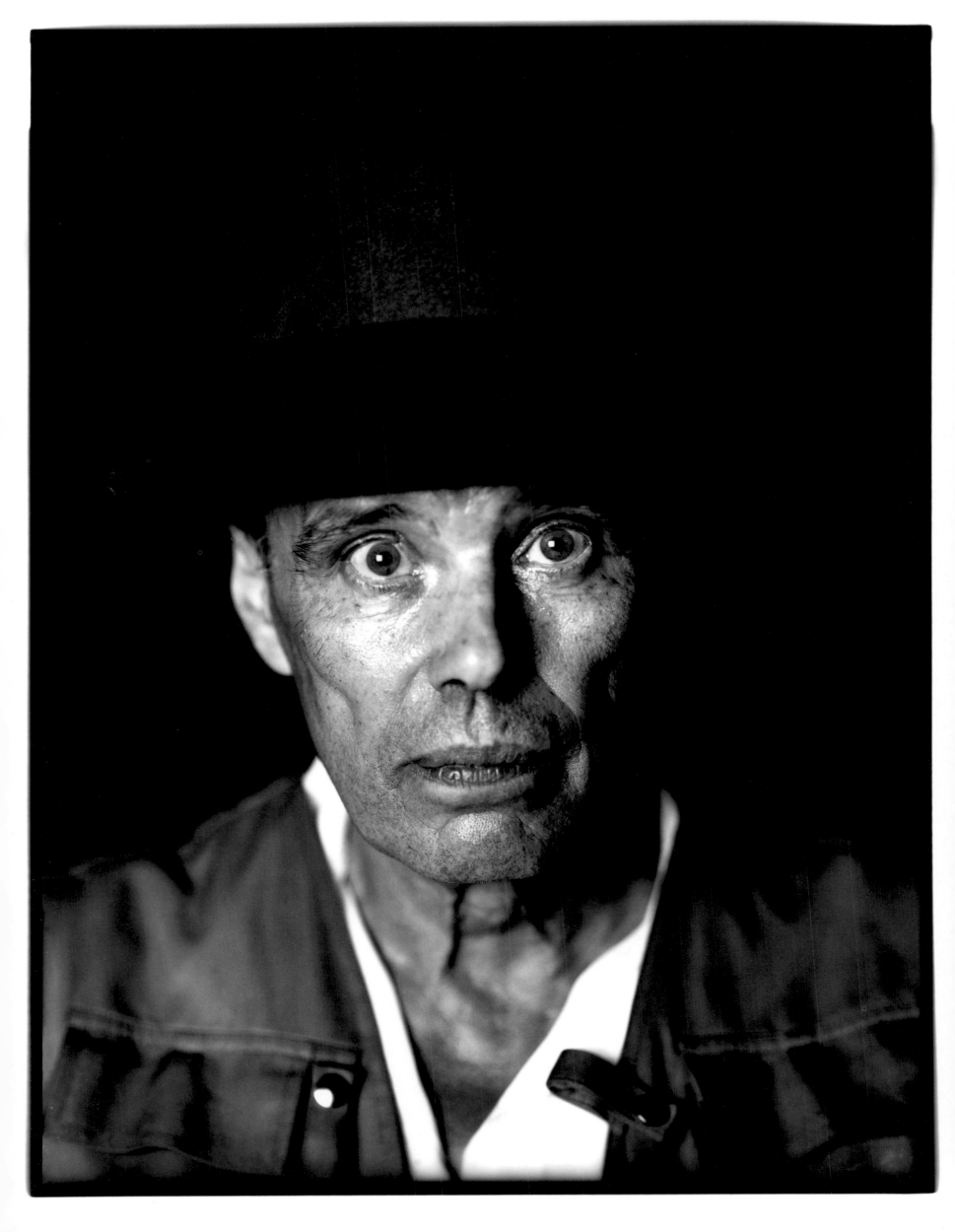

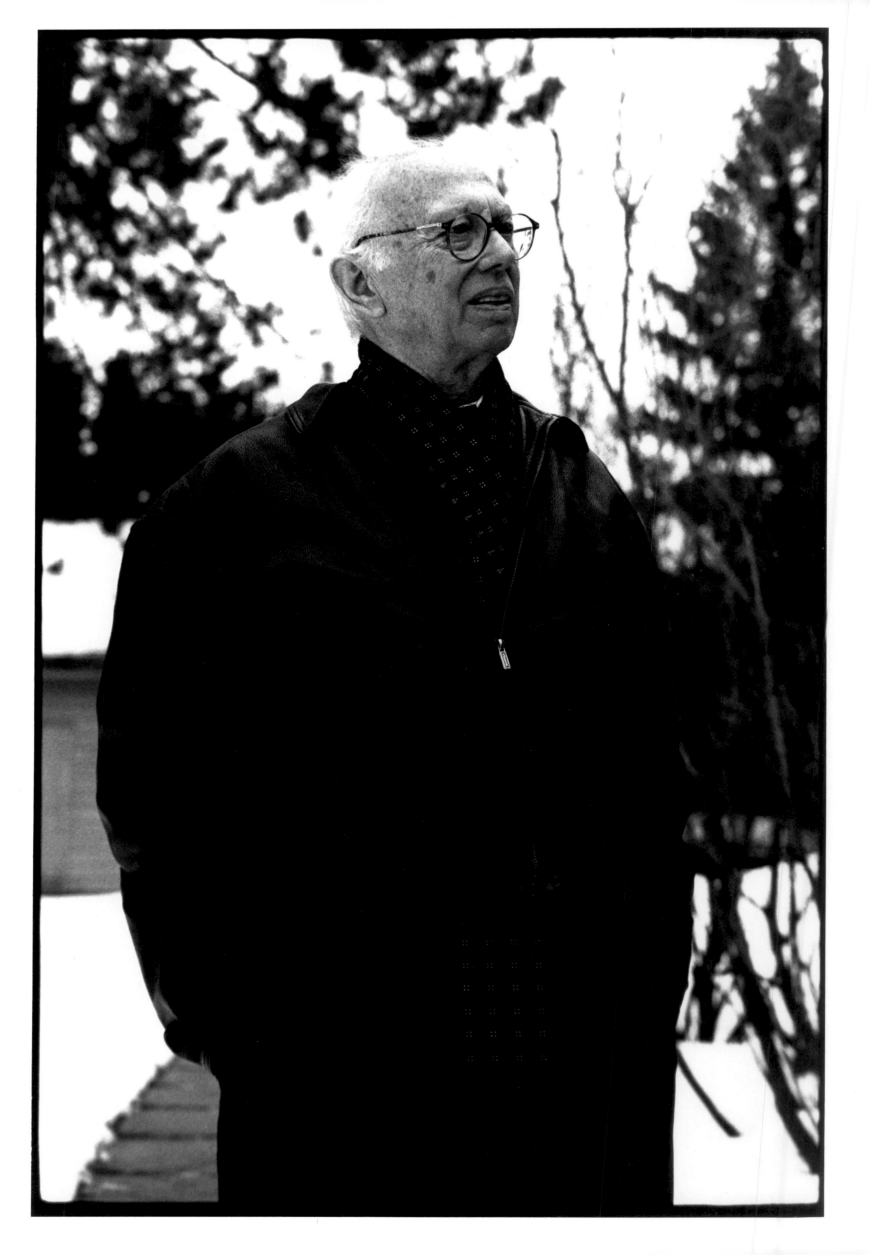

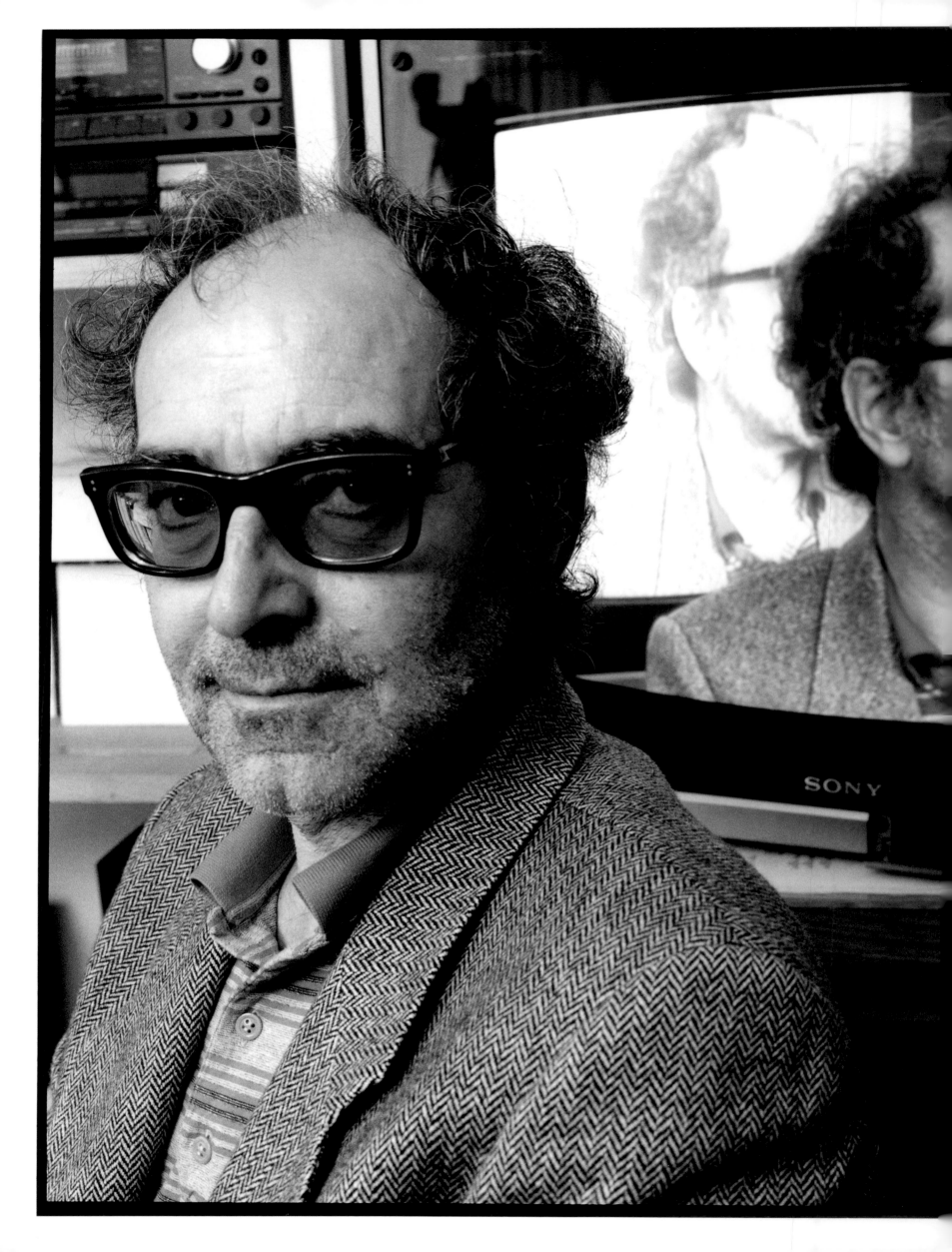

Jean-Luc Godard 1986

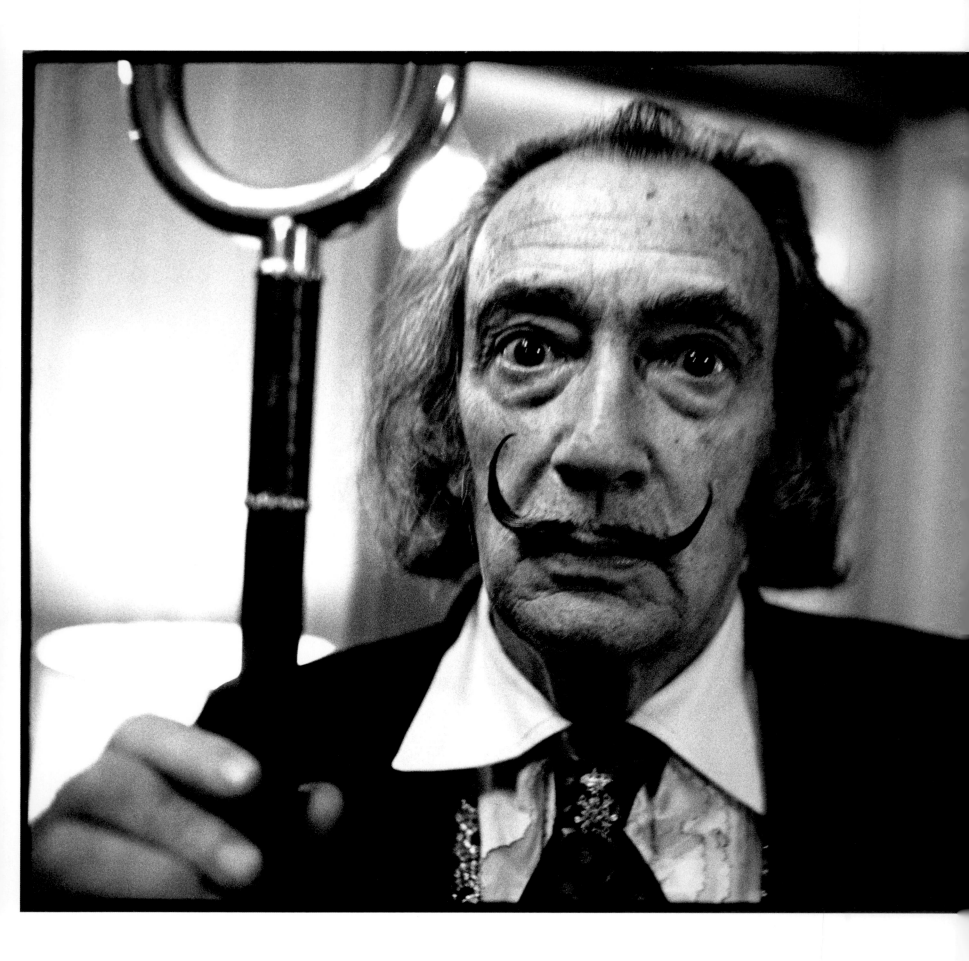

Salvador Dalí 1972

Henri Cartier-Bresson 1965

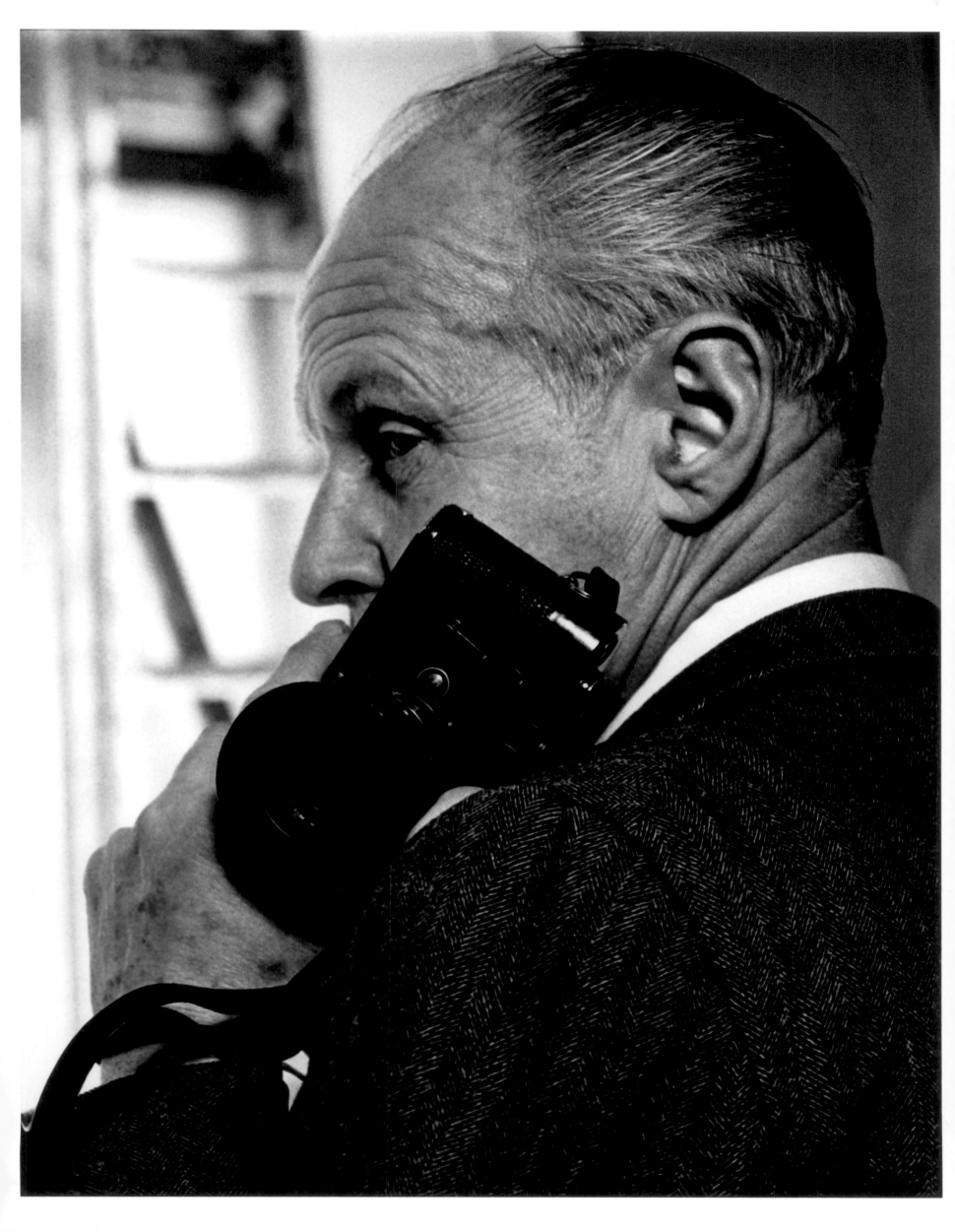

Michael Powell 1985

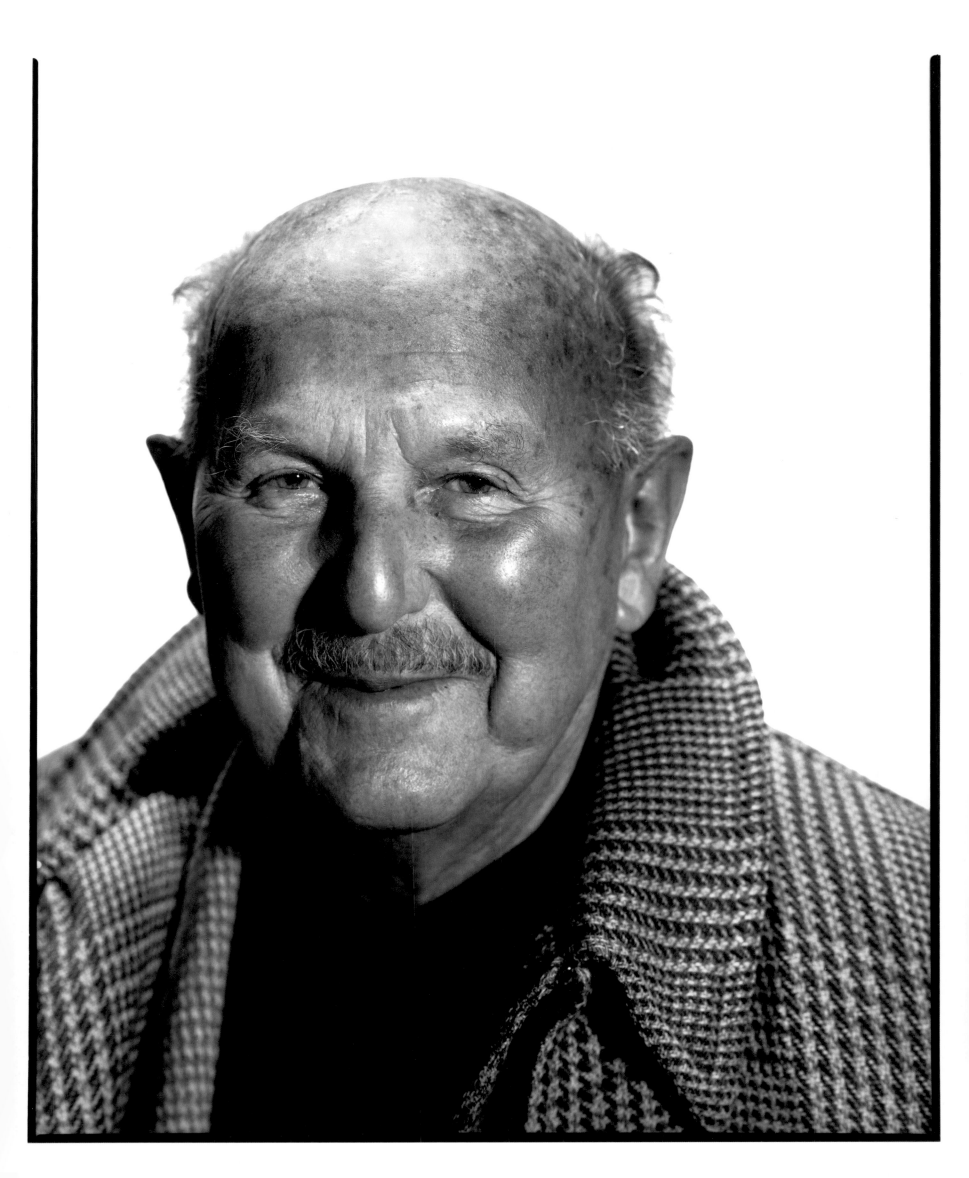

Achille Castiglioni 2000

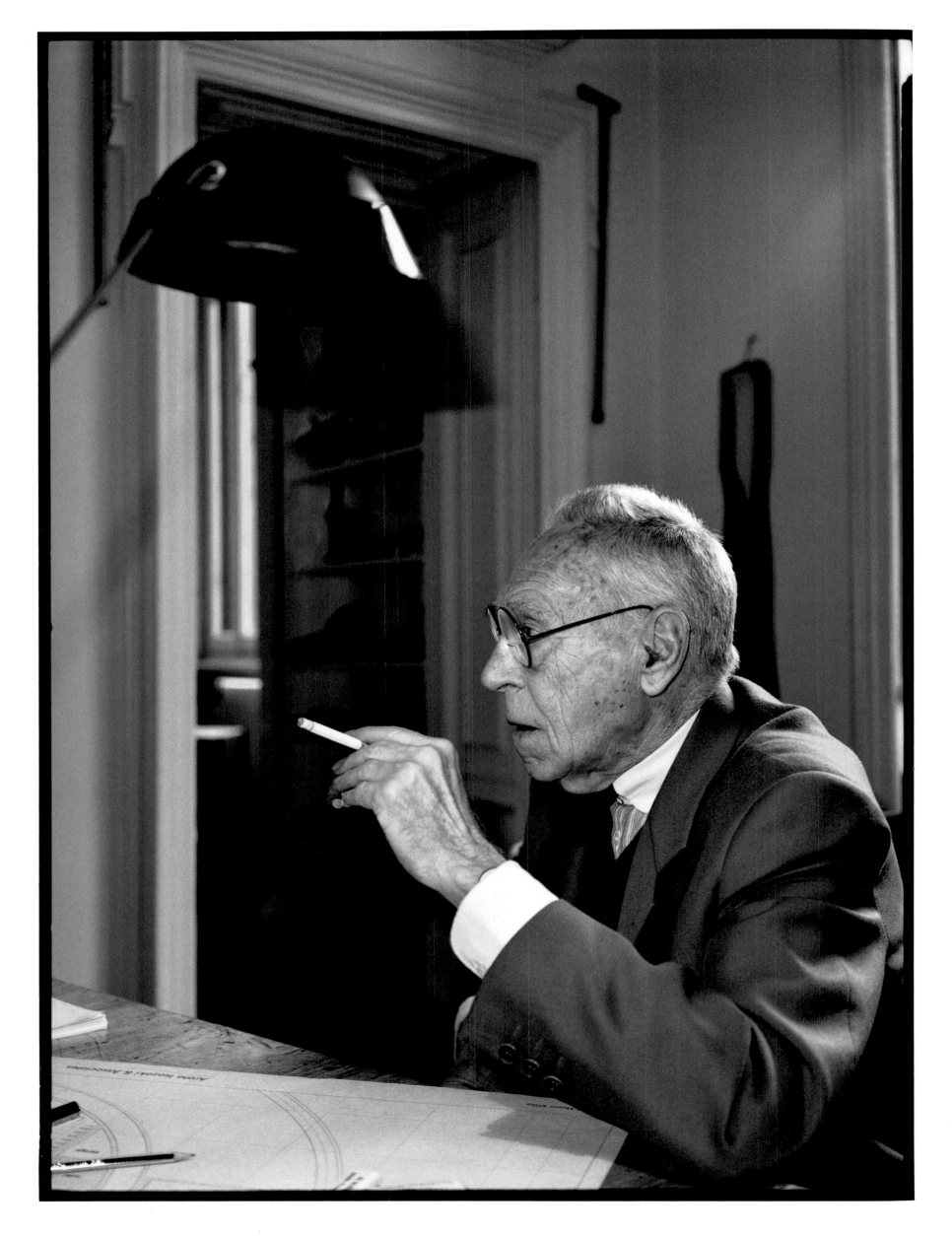

Manuel Alvarez Bravo 1989

Roman Polanski 1965 (following page)

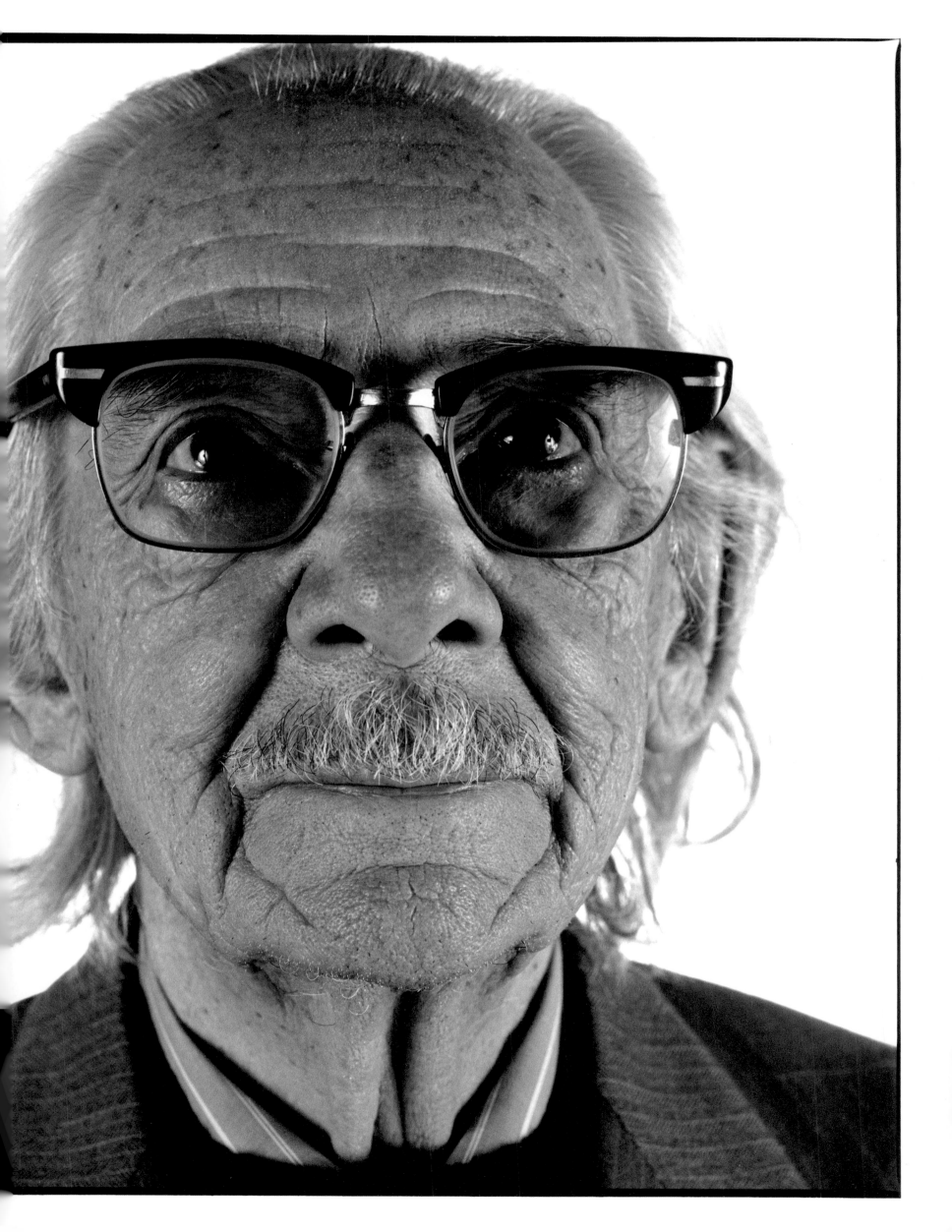

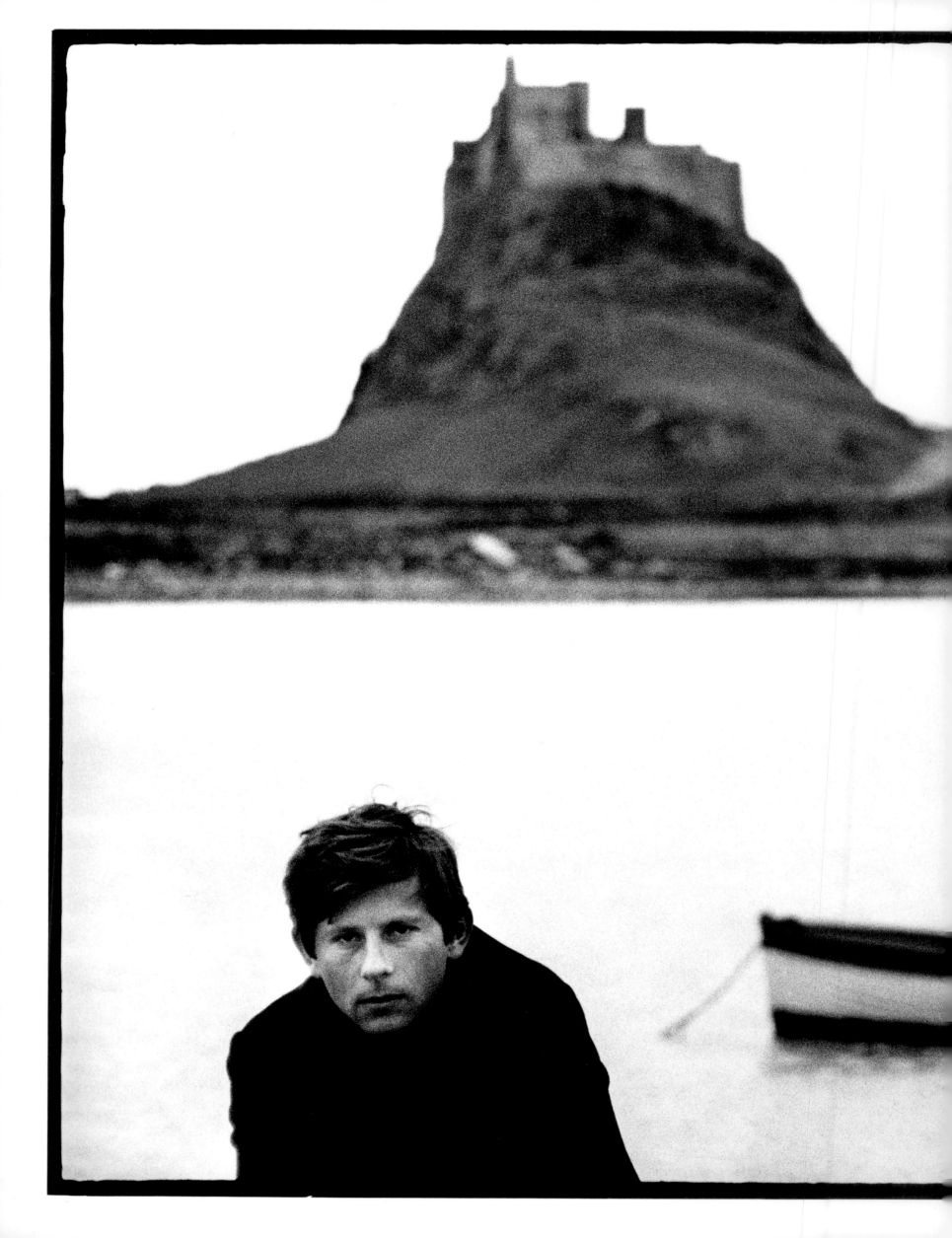

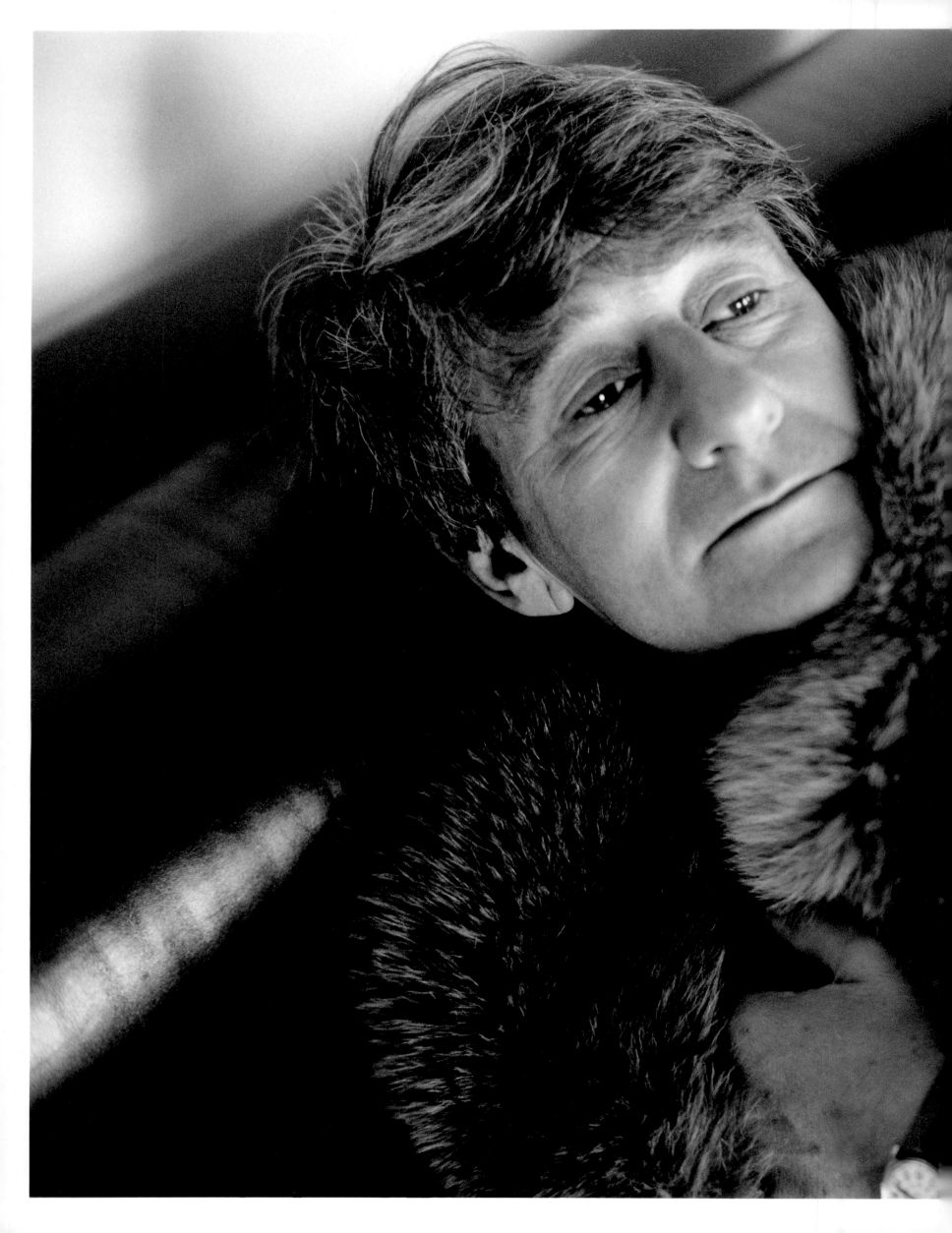

Helmut Newton 1981 (previous page)

Cecil Beaton 1965

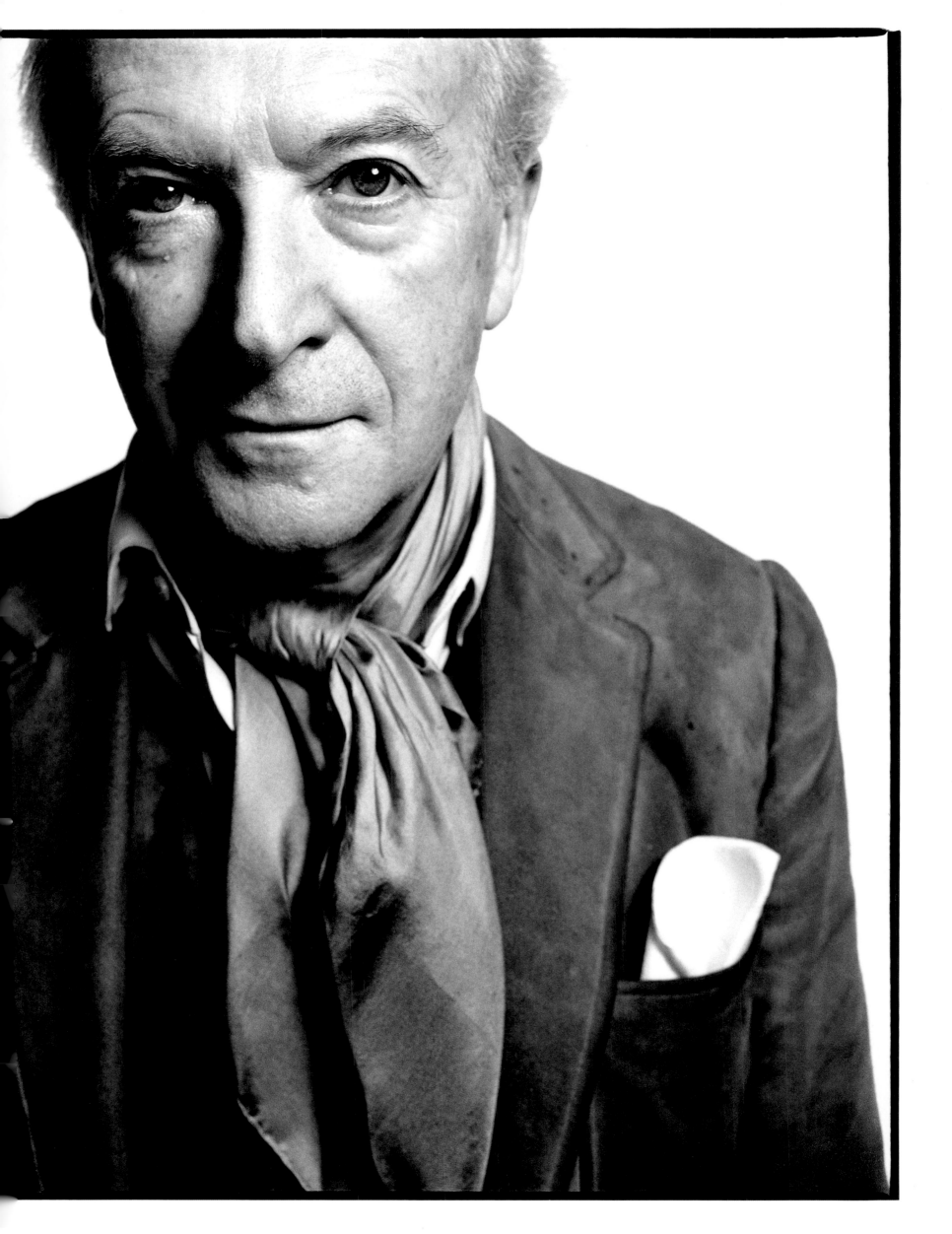

Tim Burton 1999

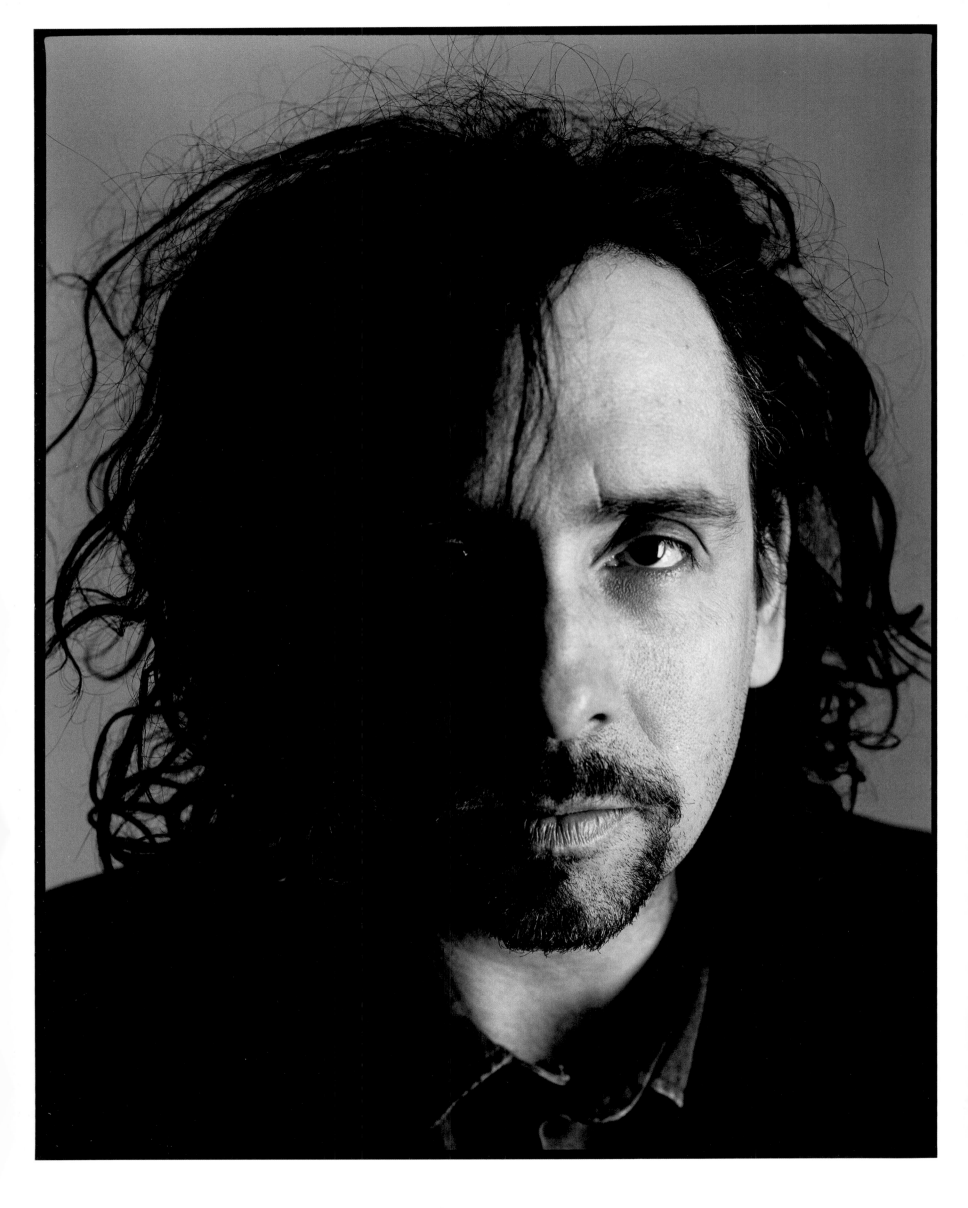

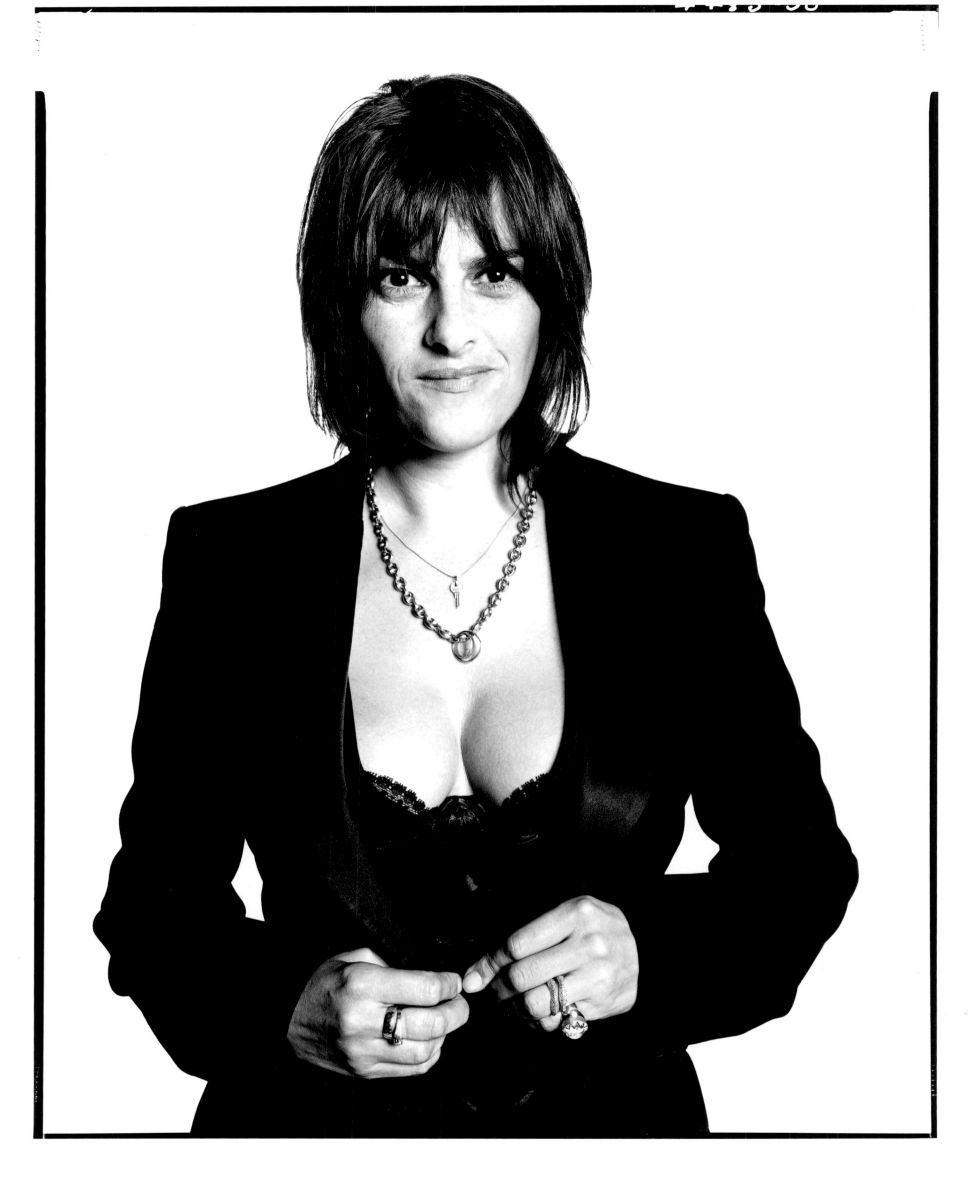

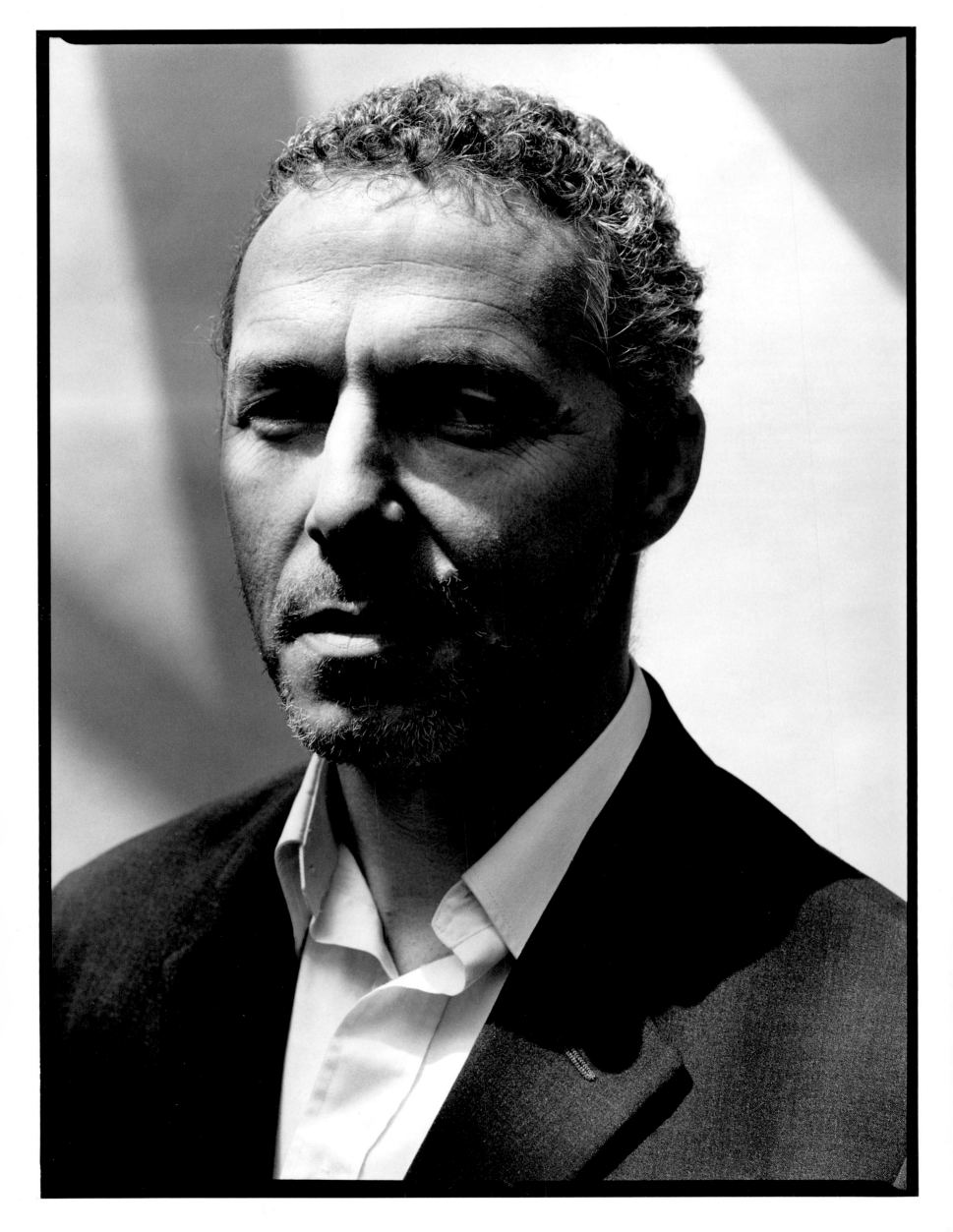

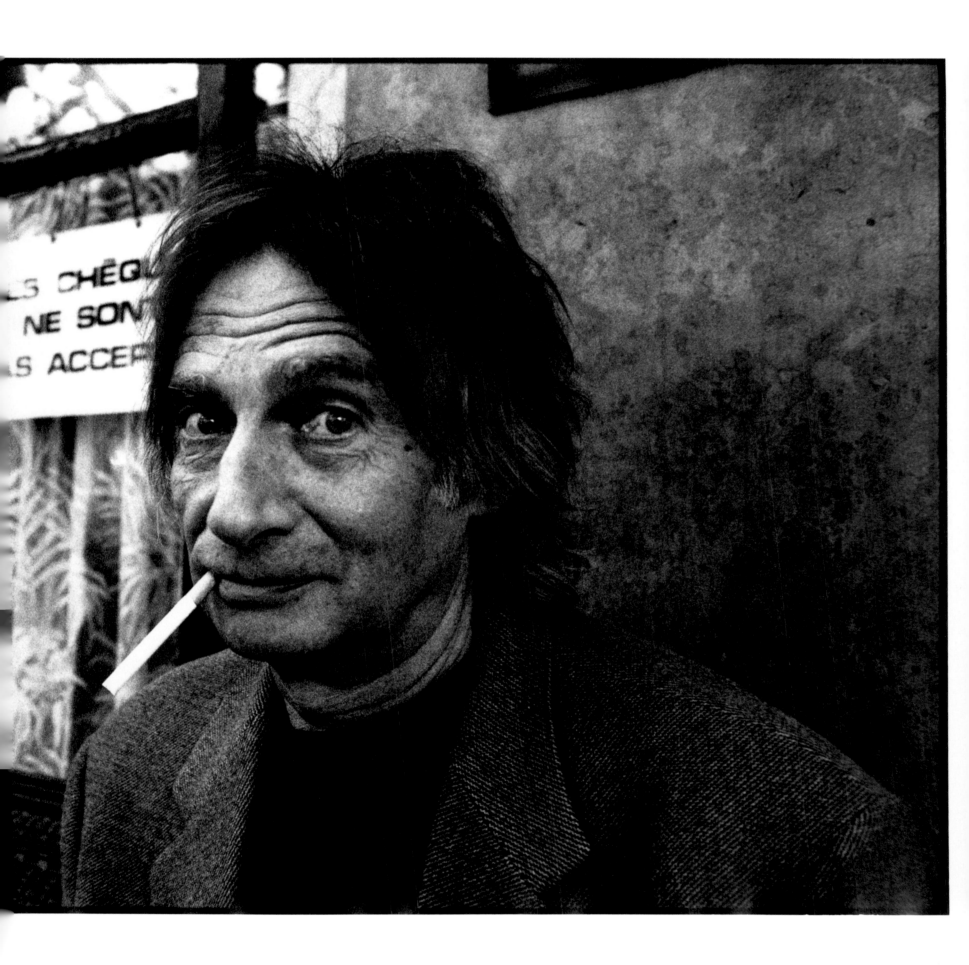

Rufino Tamayo 1962

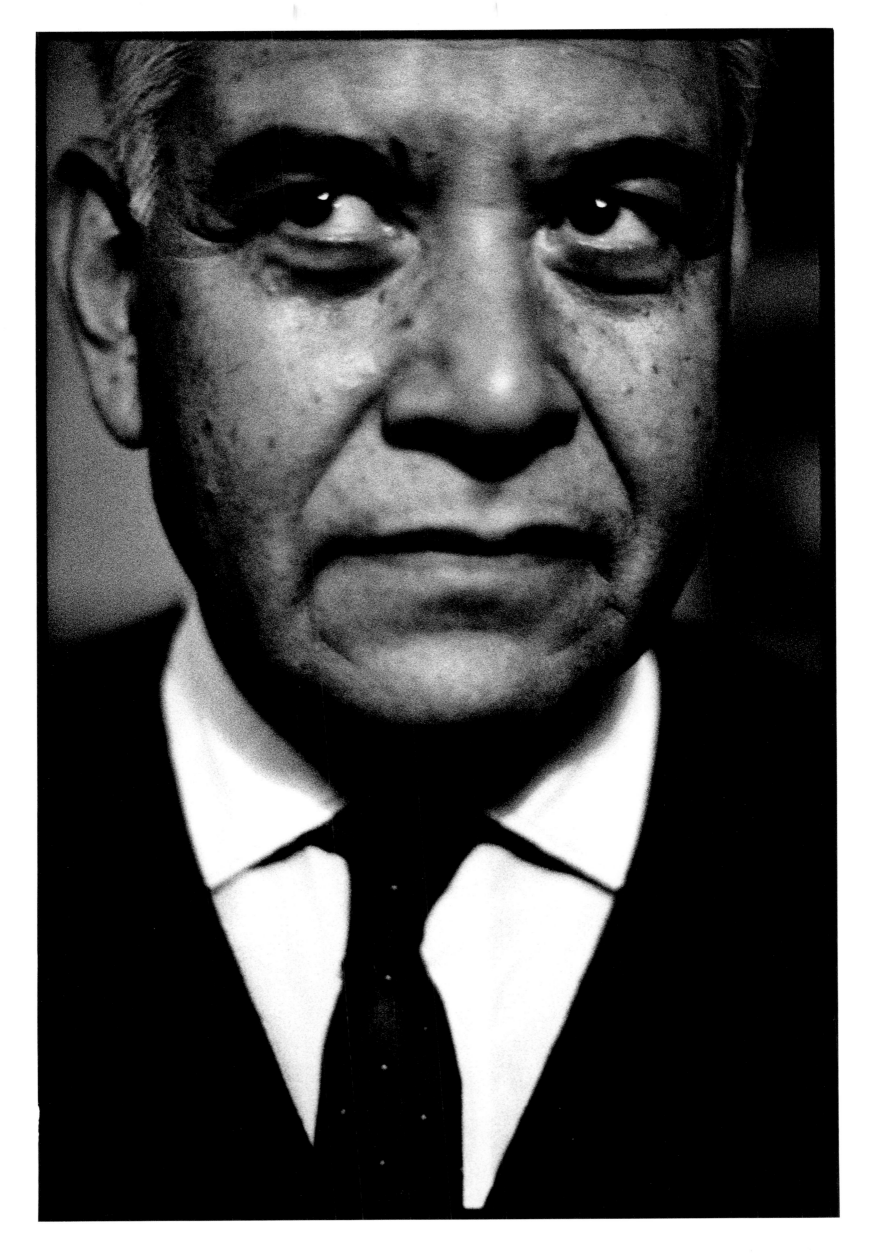

Philip Johnson 2001

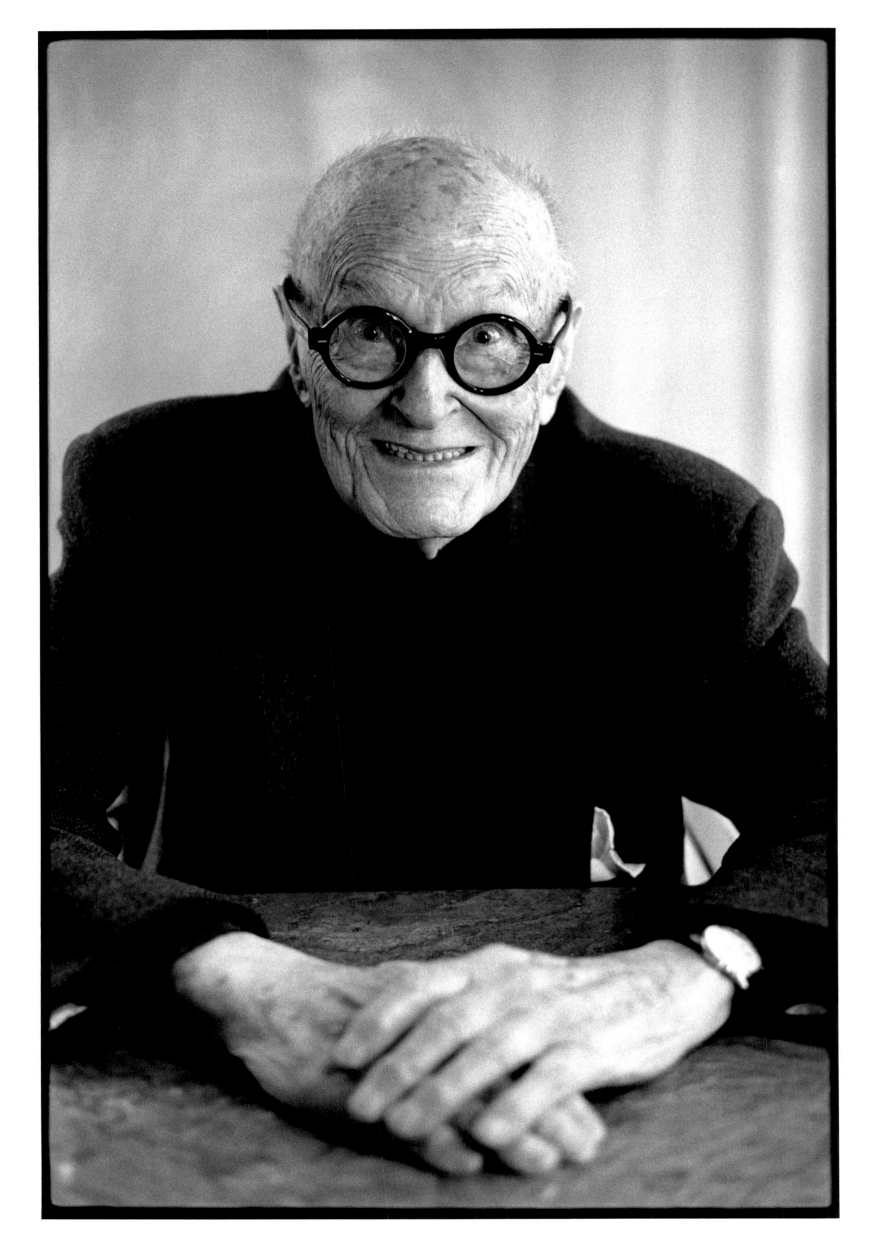

Yoko Ono 1974

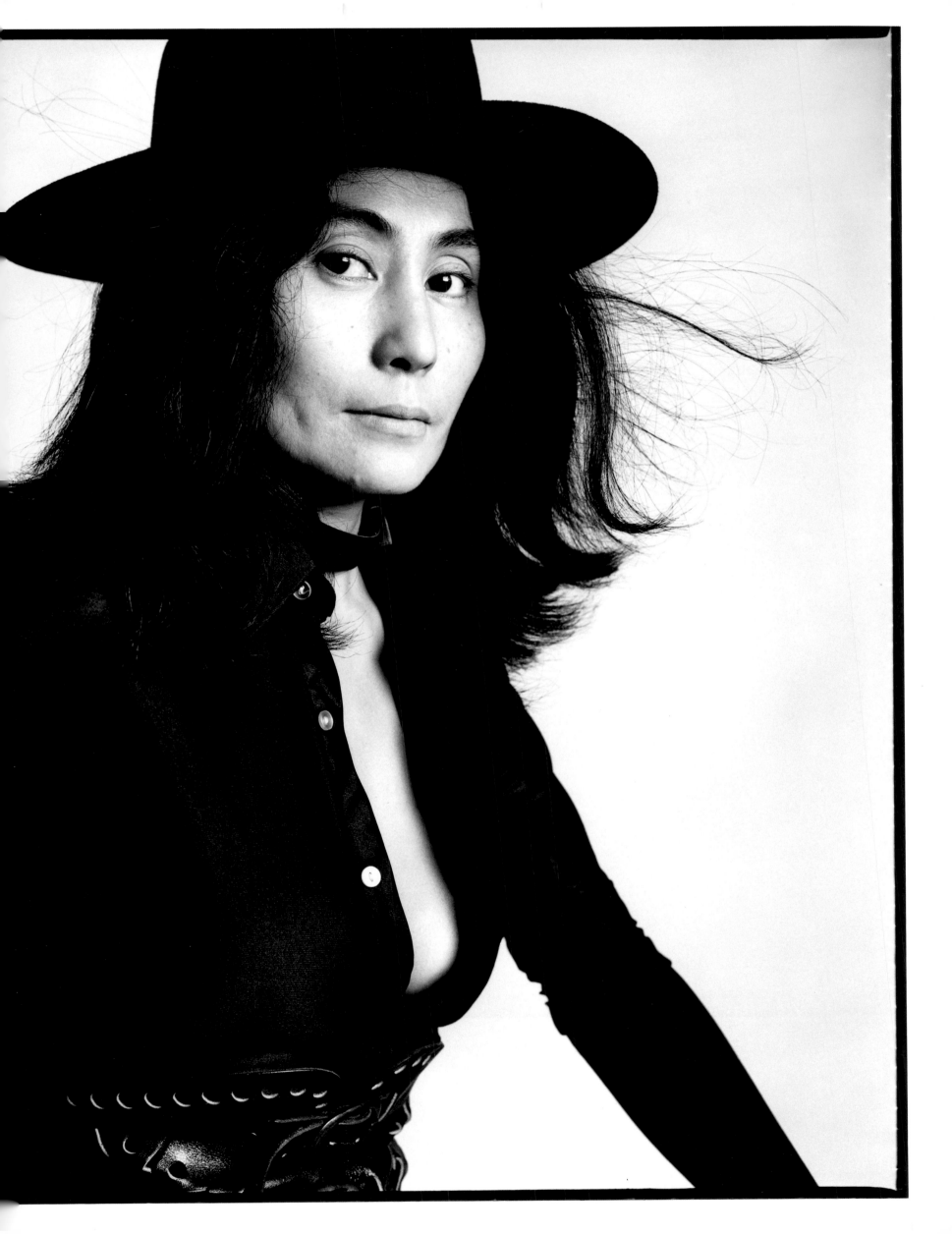

Rem Koolhaas 2001

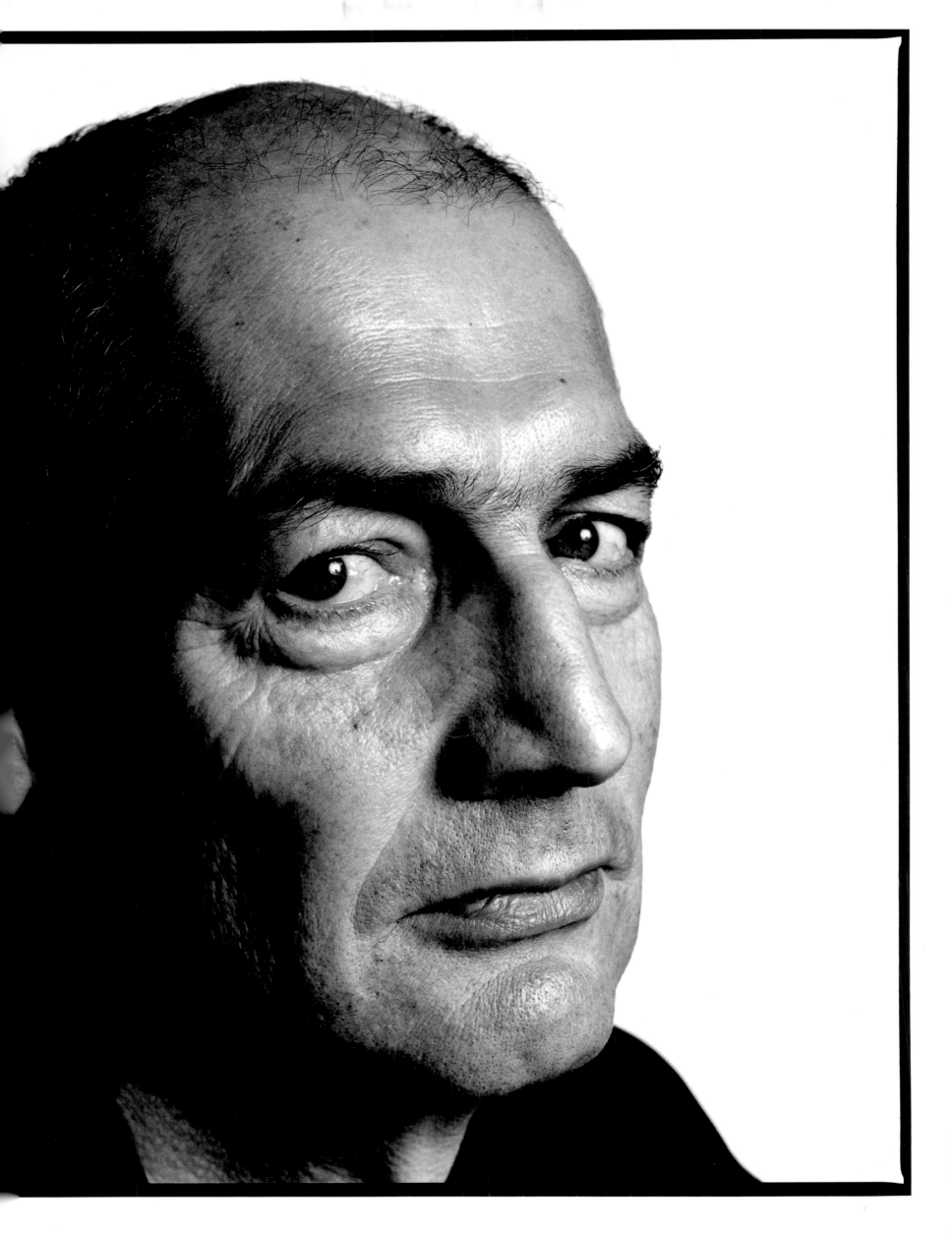

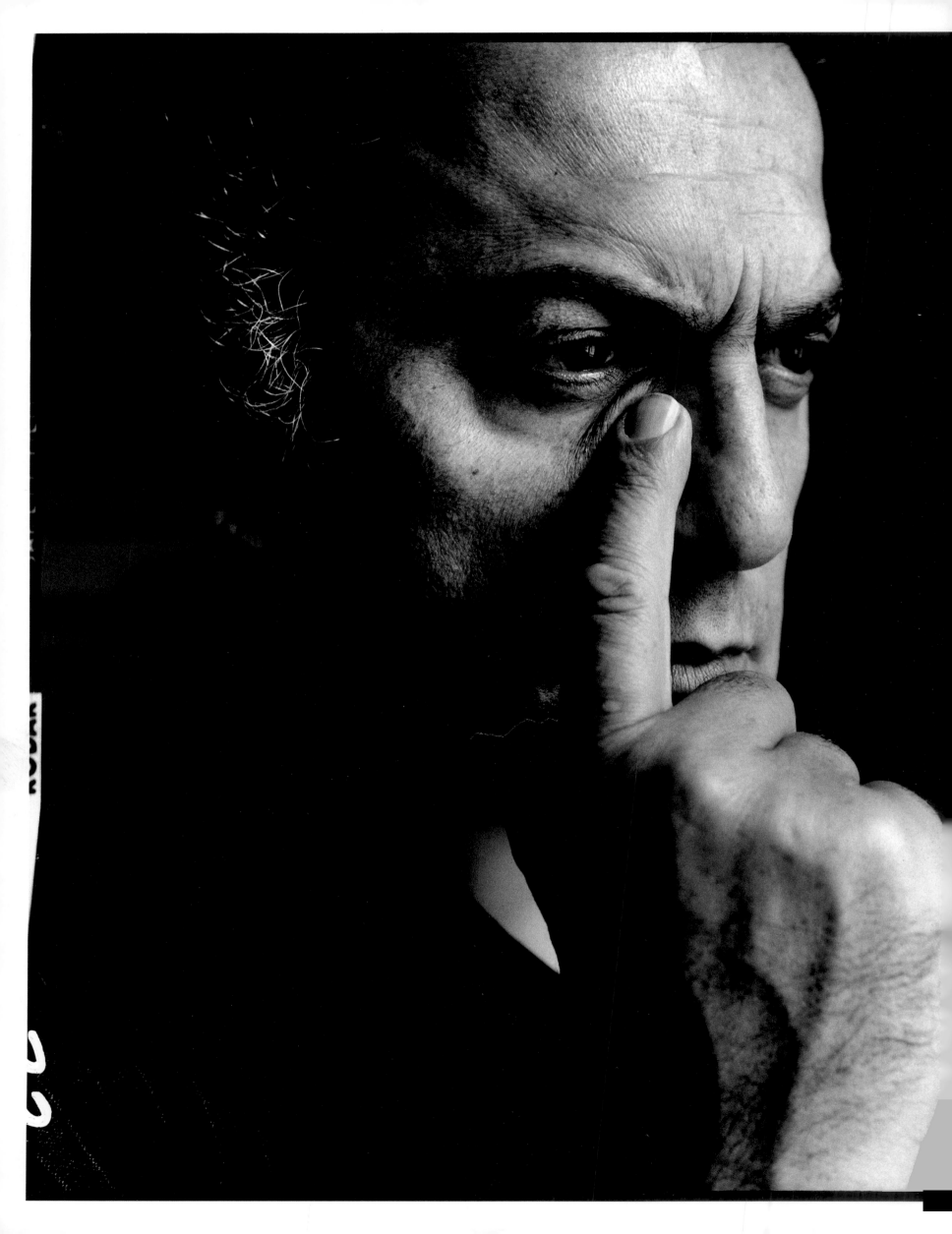

Federico Fellini 1965

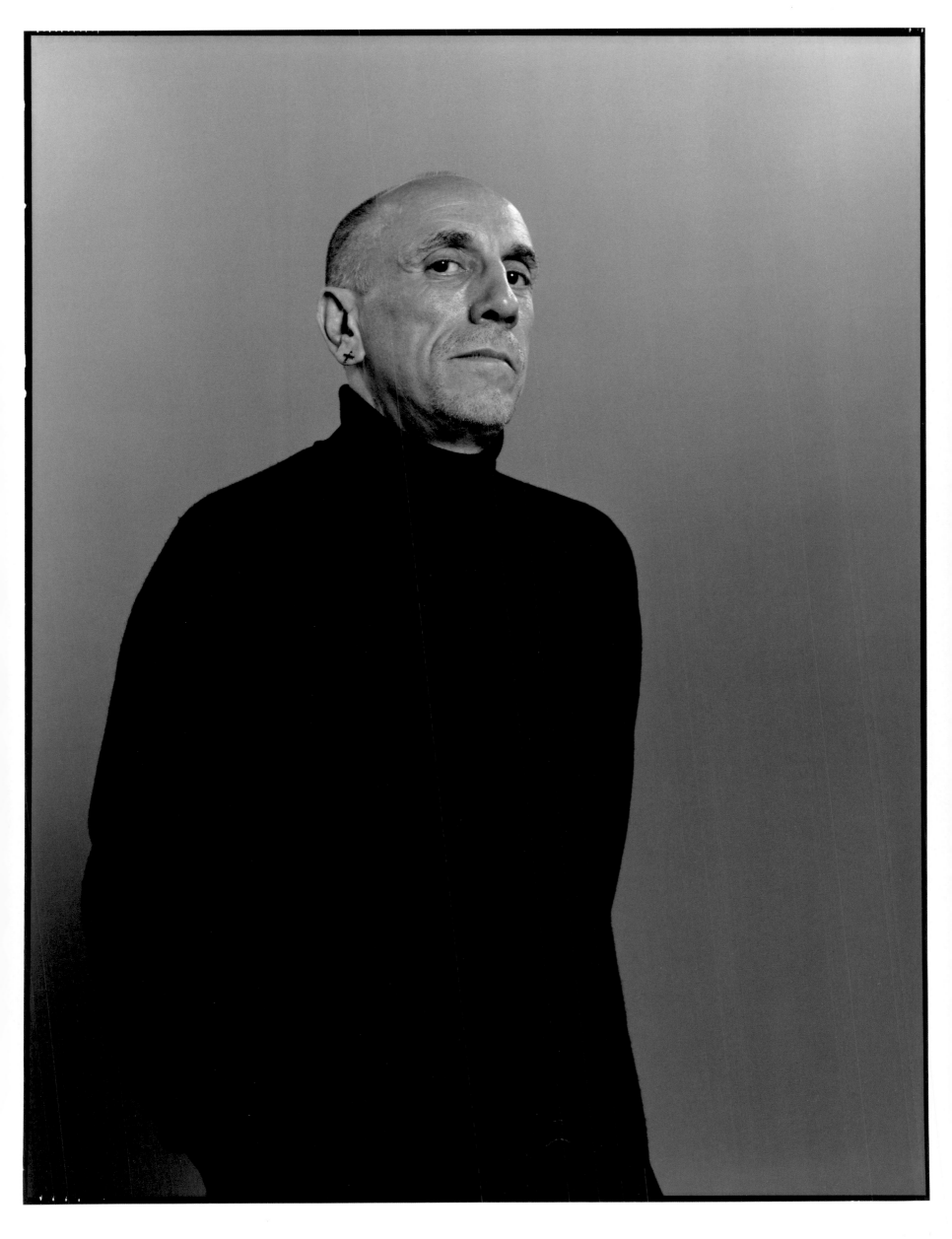

Richard Hamilton 2003

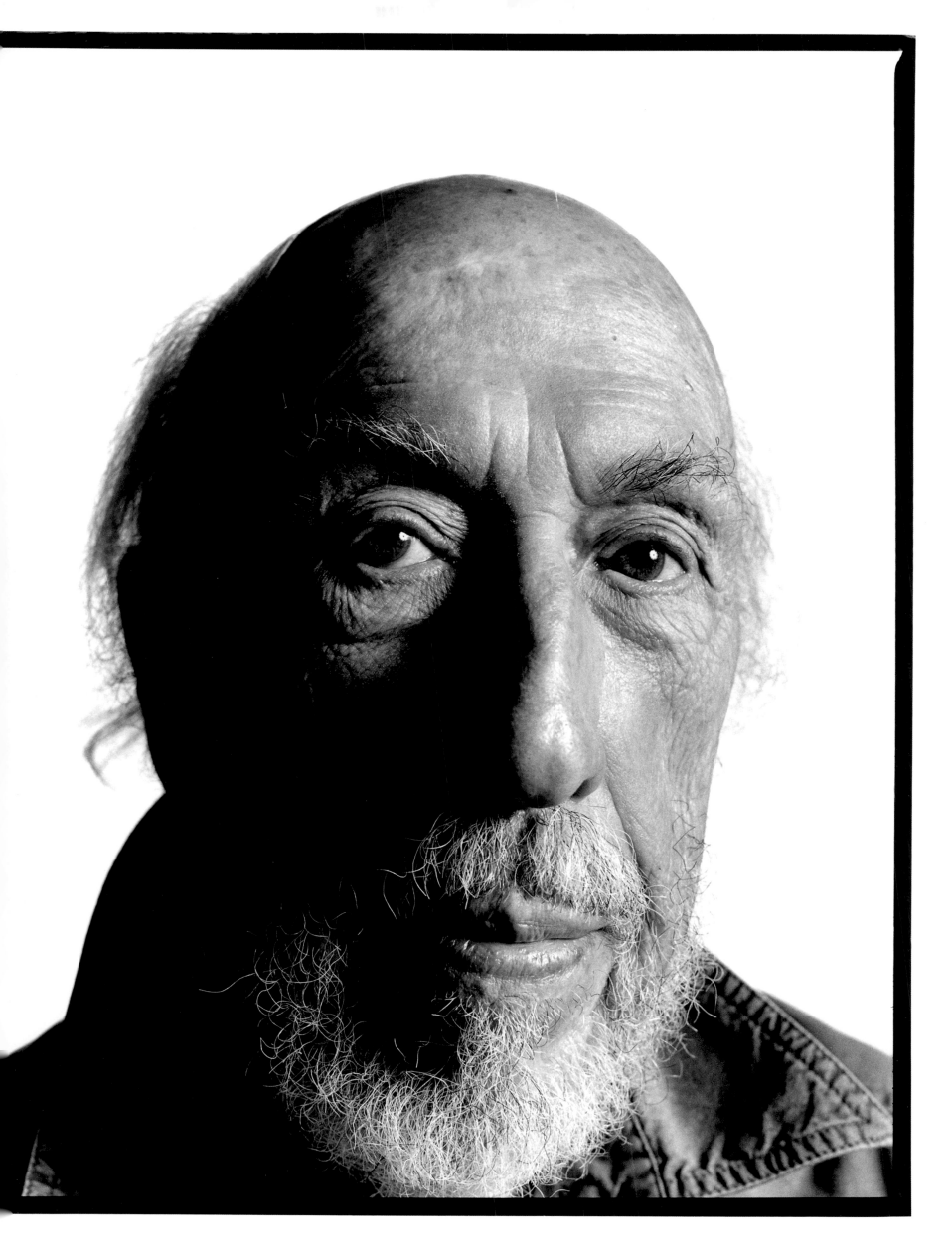

Pauline Boty 1964

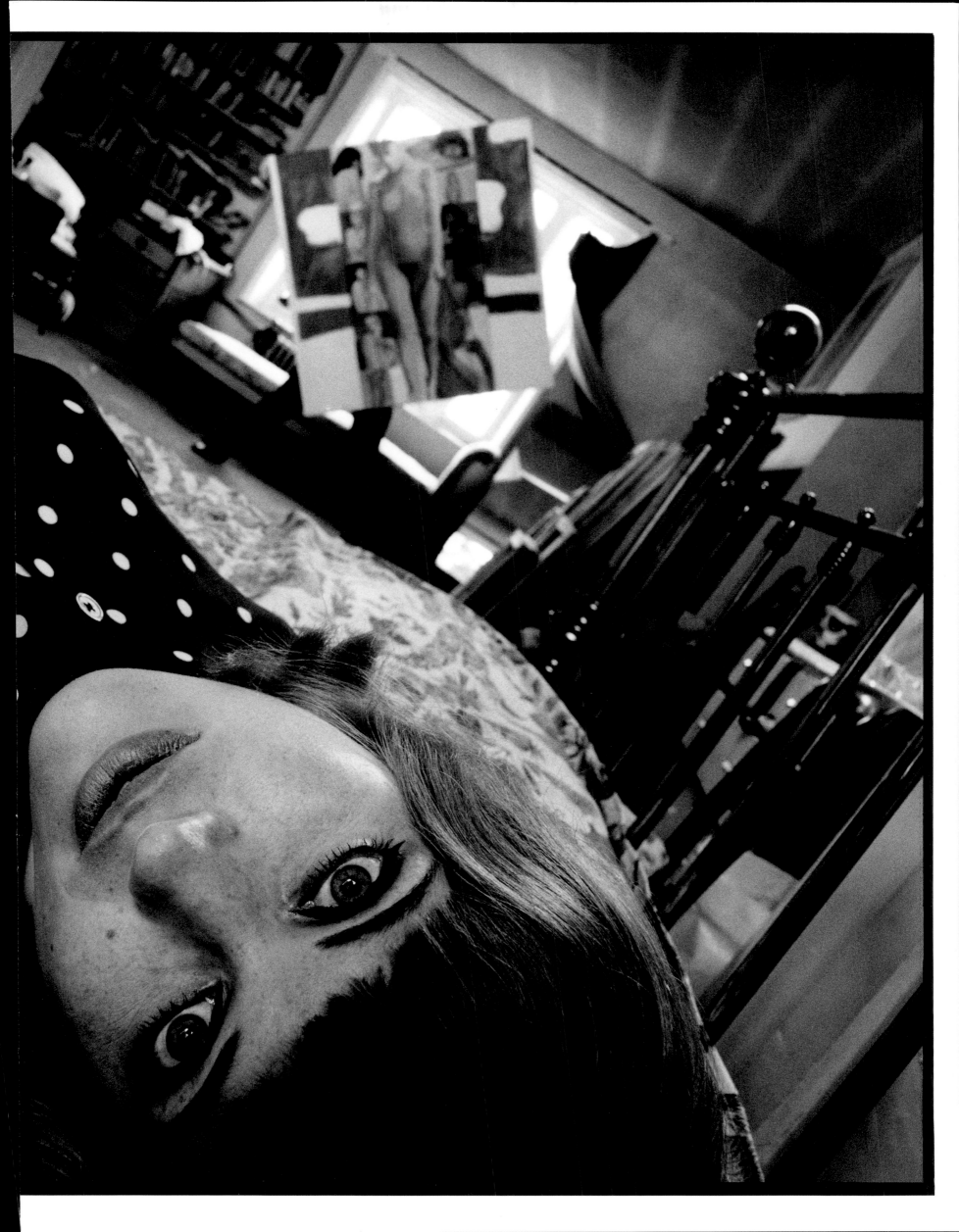

Zaha Hadid 2005

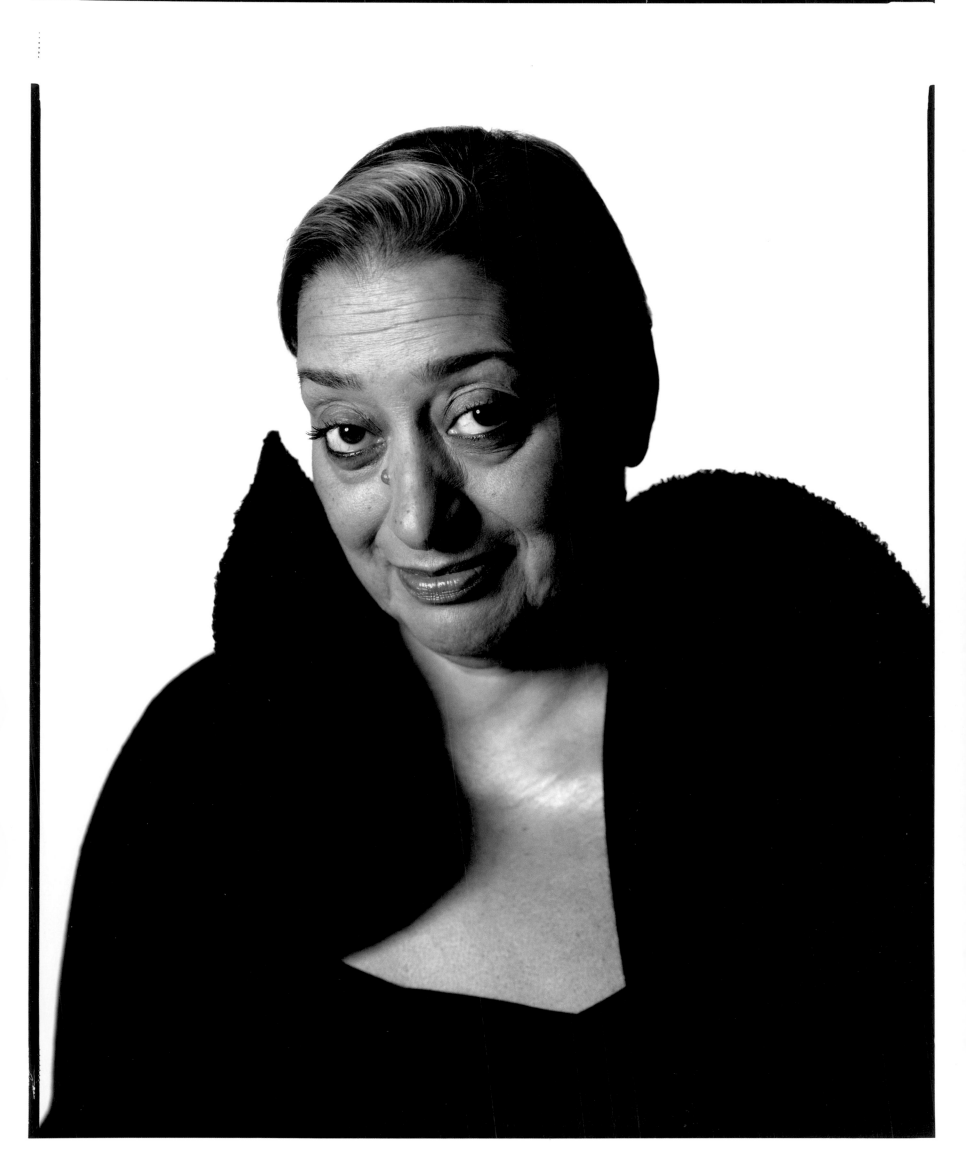

Antoni Tàpies 2000

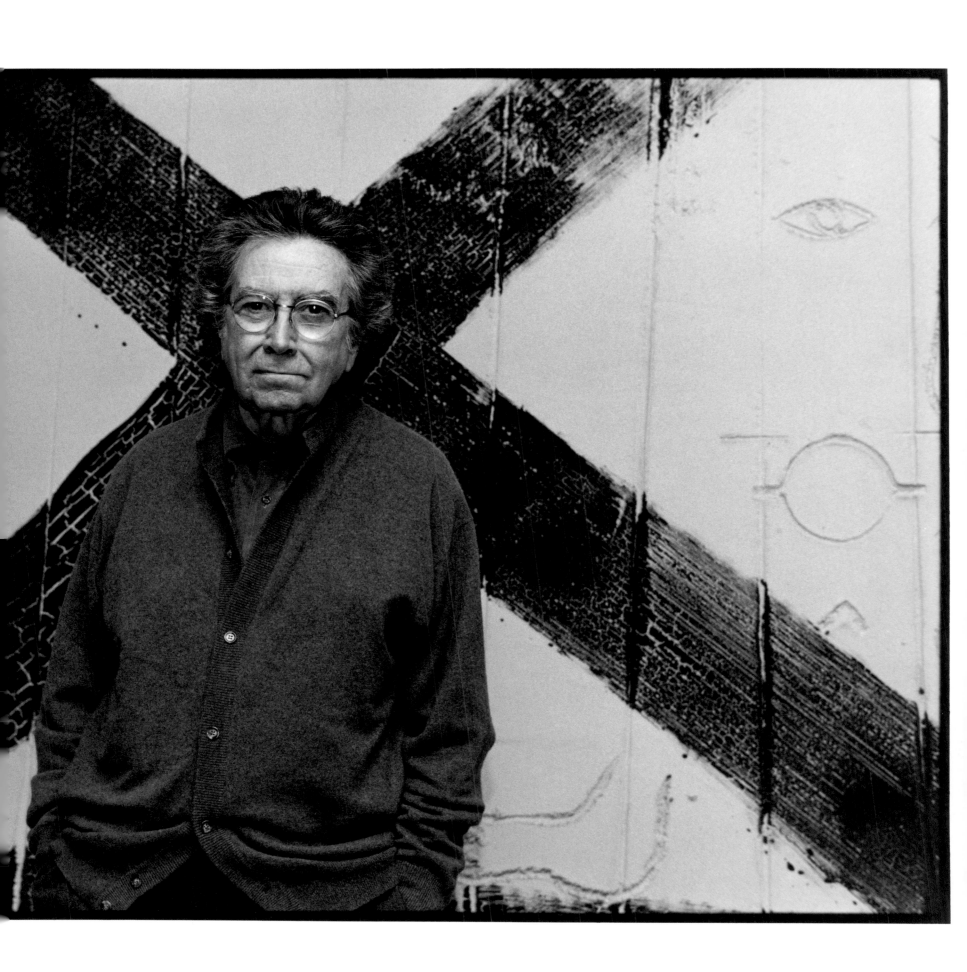

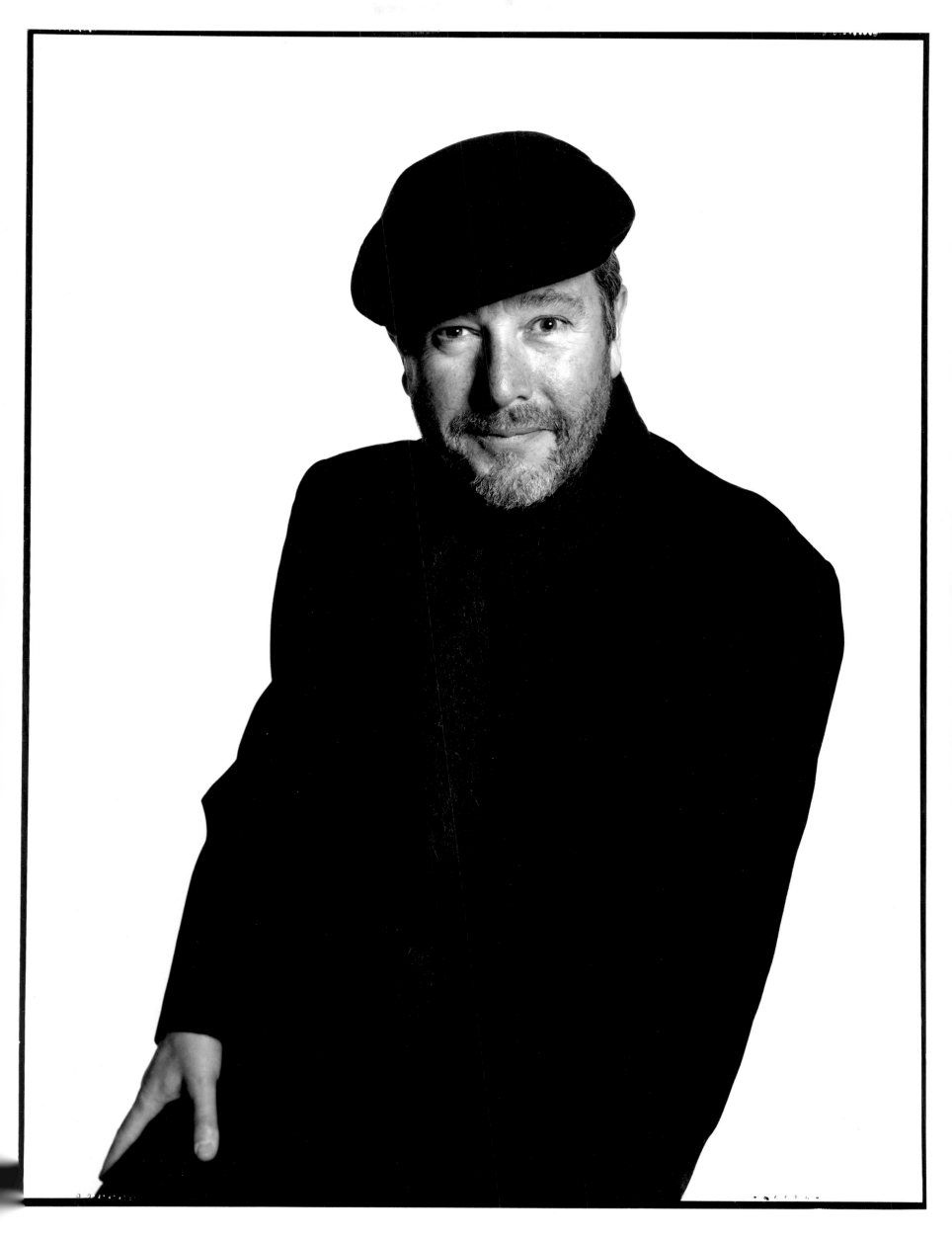

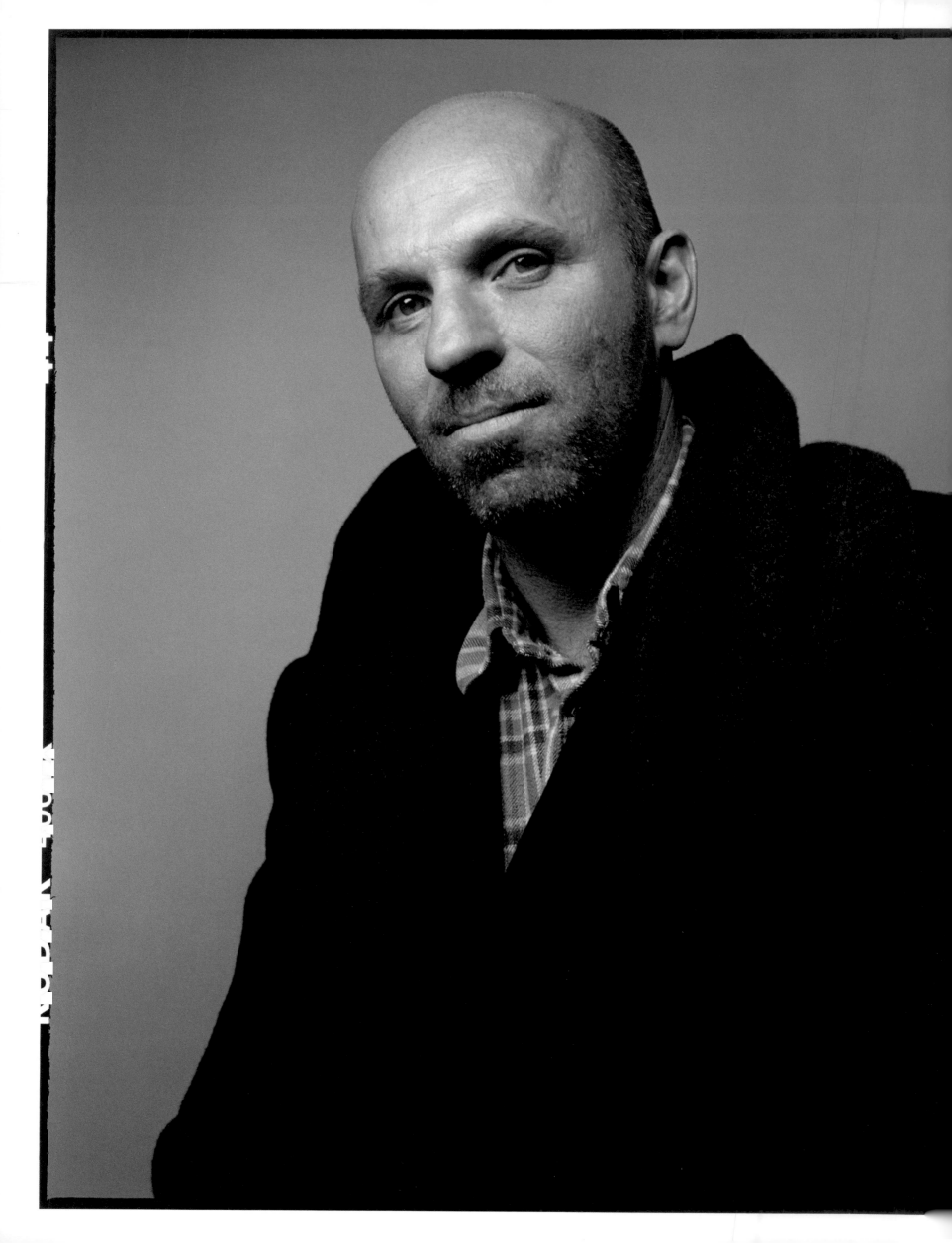

Peter Doig 2006

Chapman Brothers 2008

Bruce Weber 2000

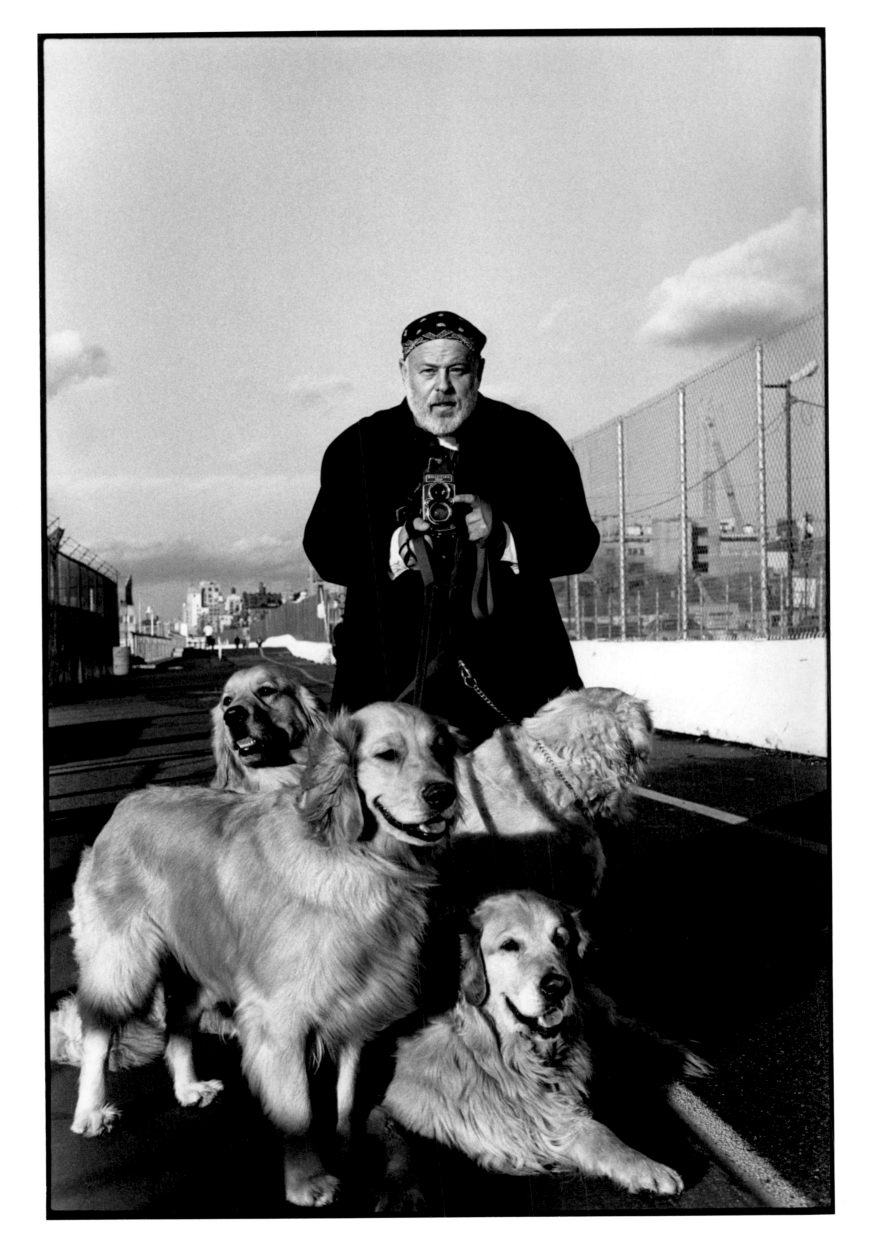

Norman Foster 1988

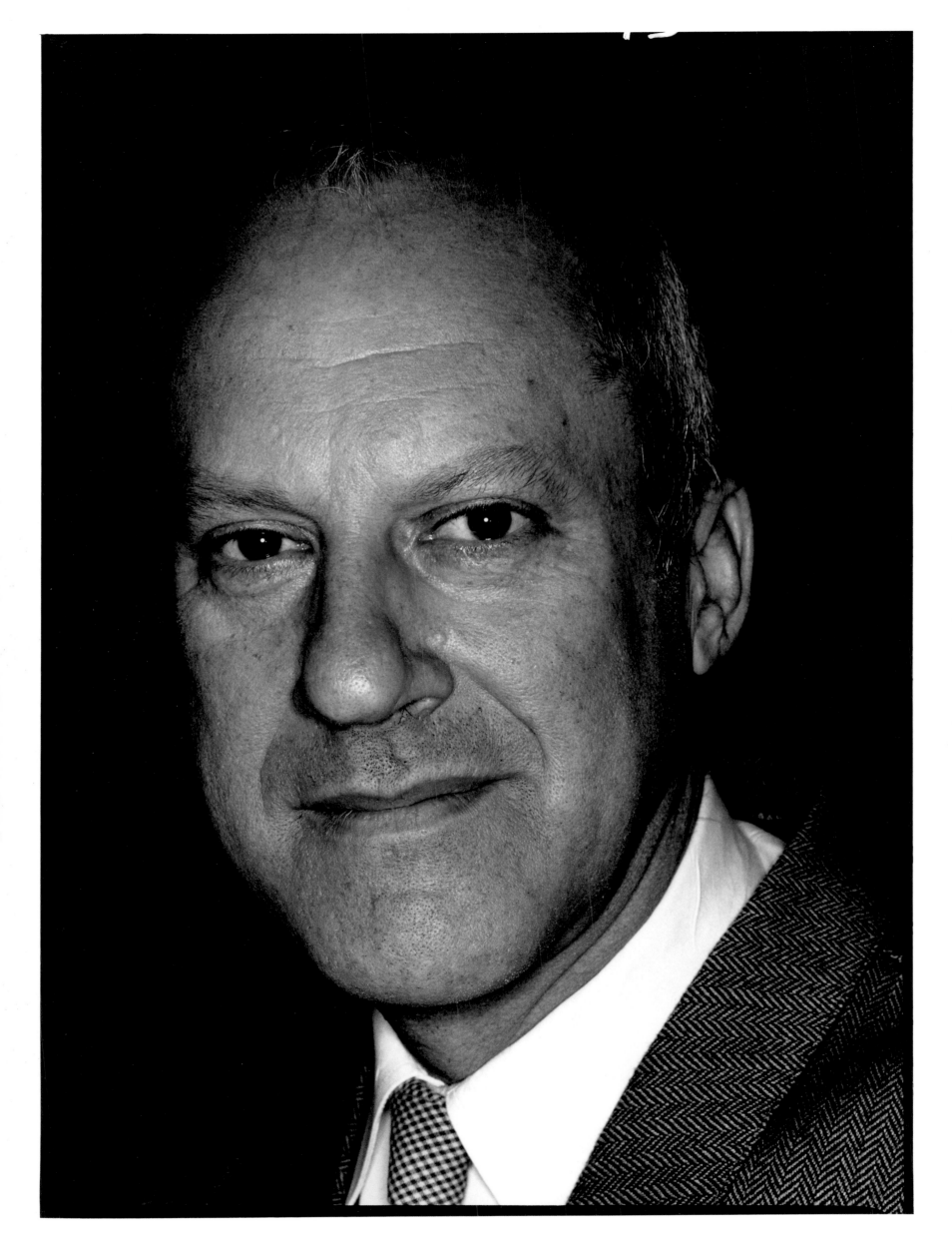

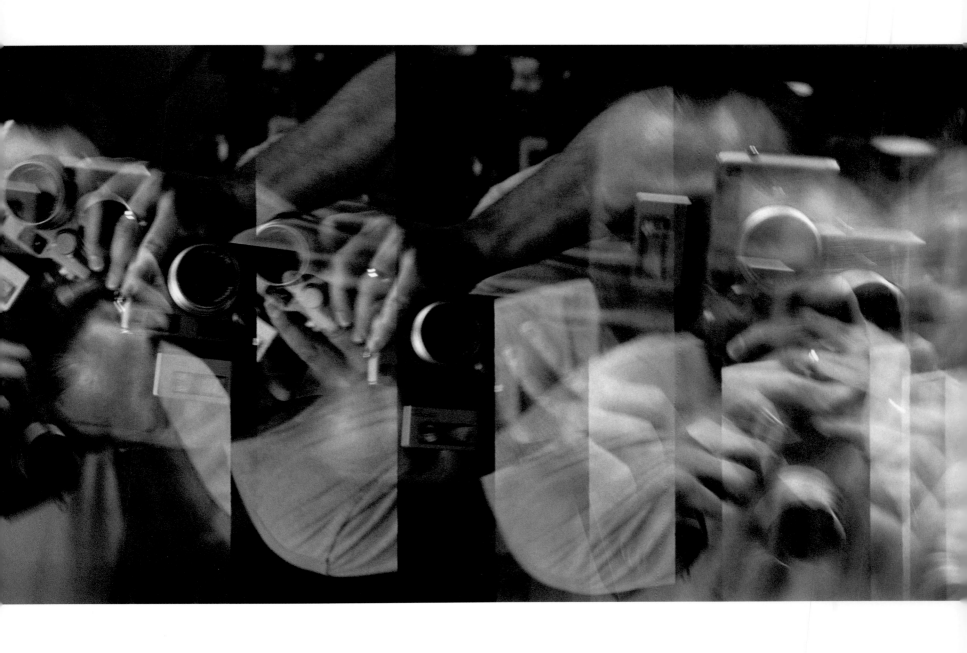

Juergen Teller 2006

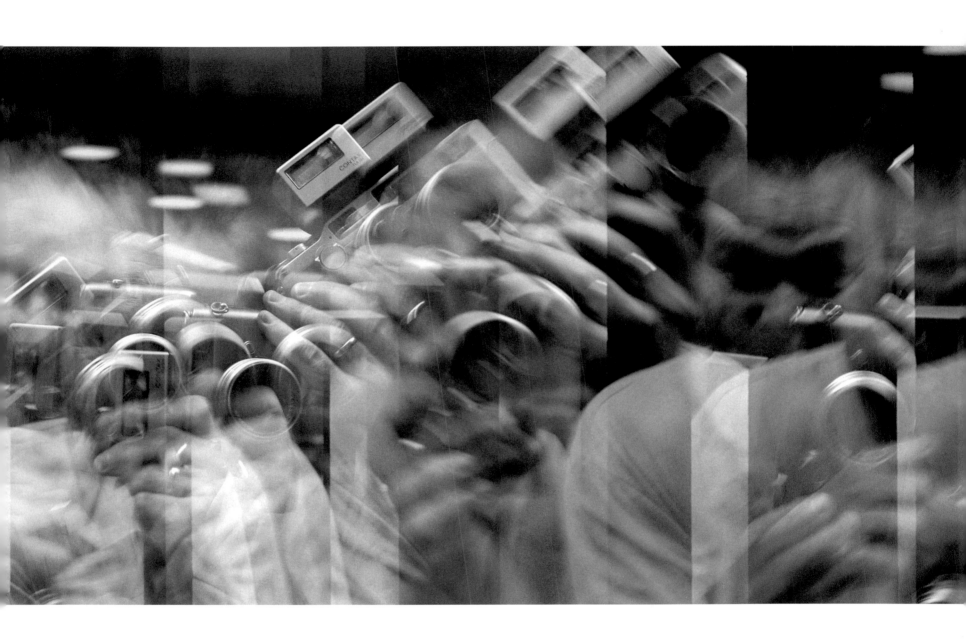

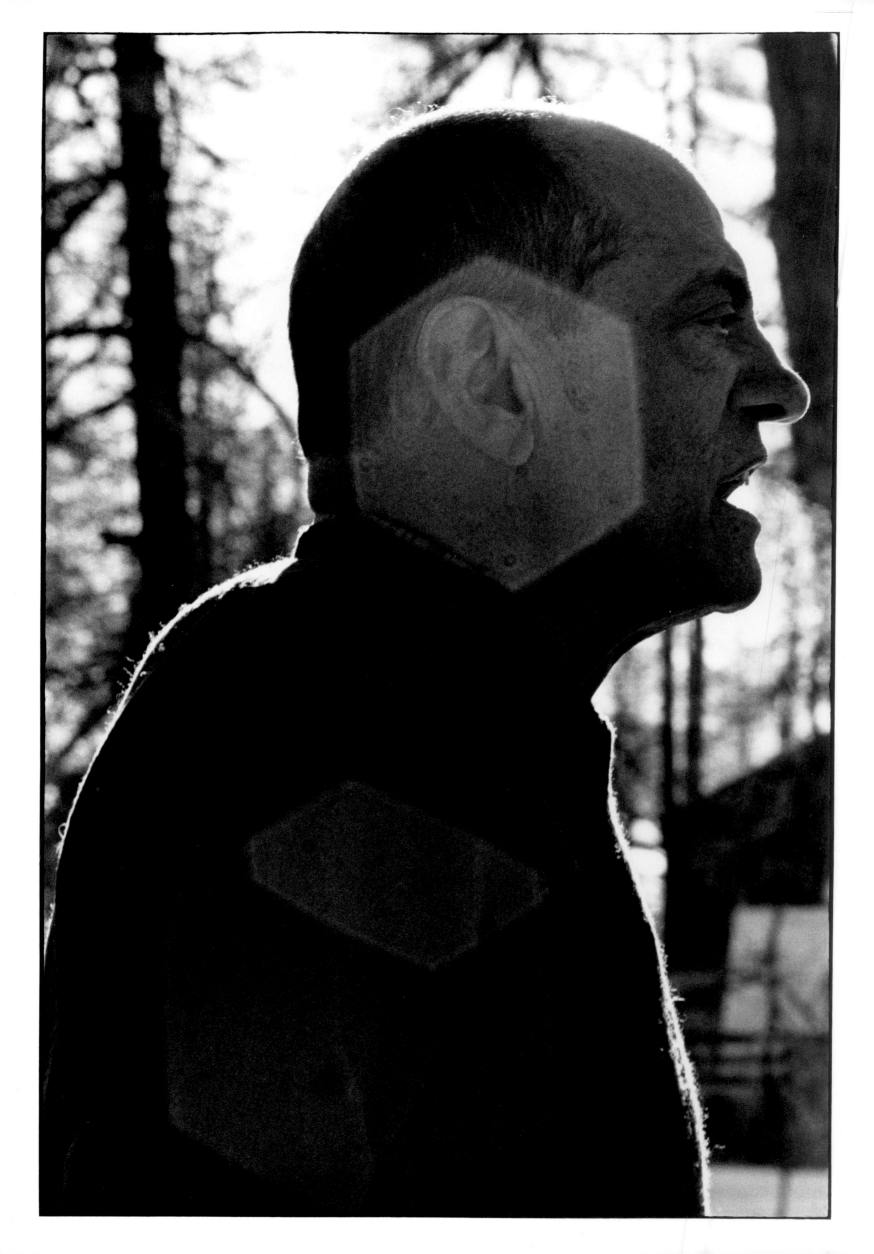

Luis Buñuel 1962

Sarah Moon 1972

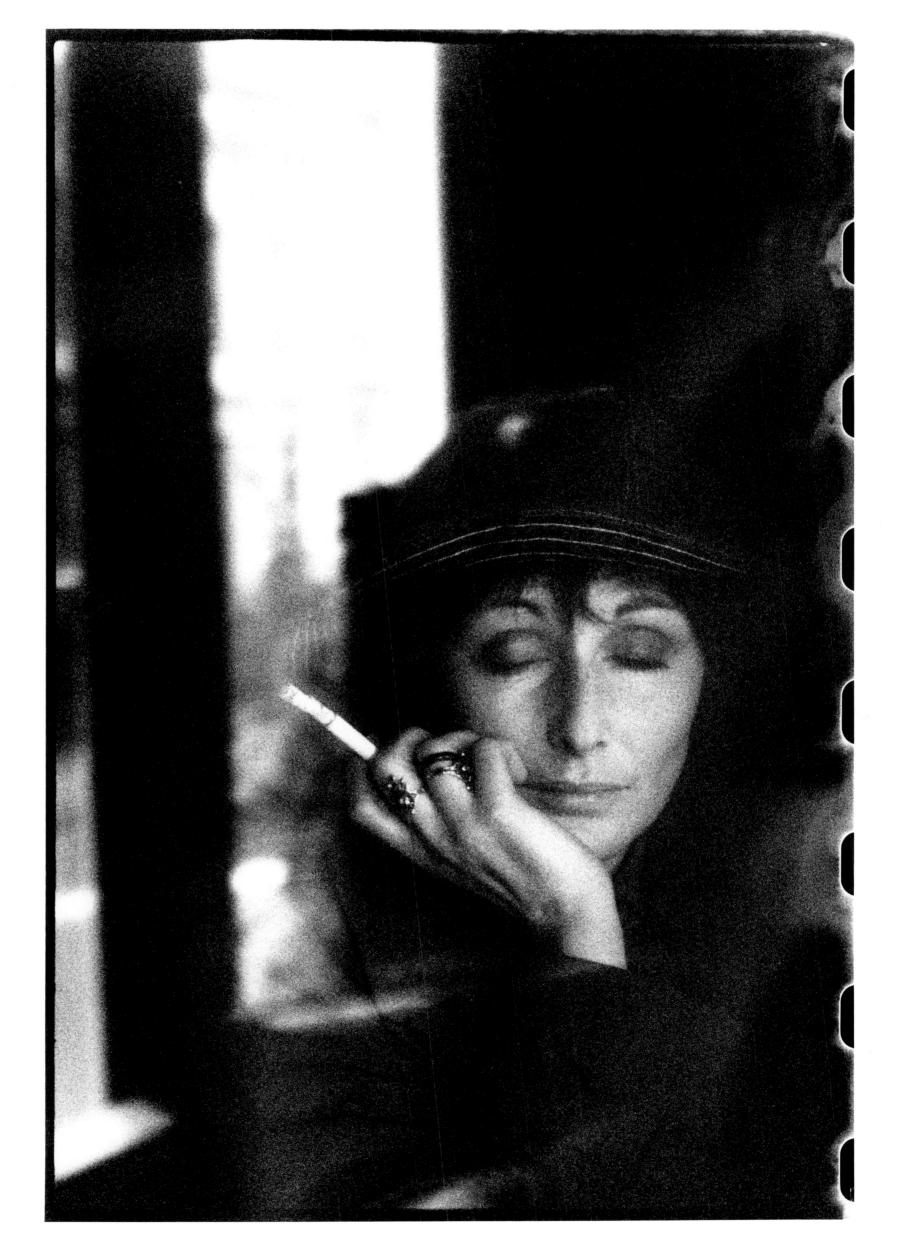

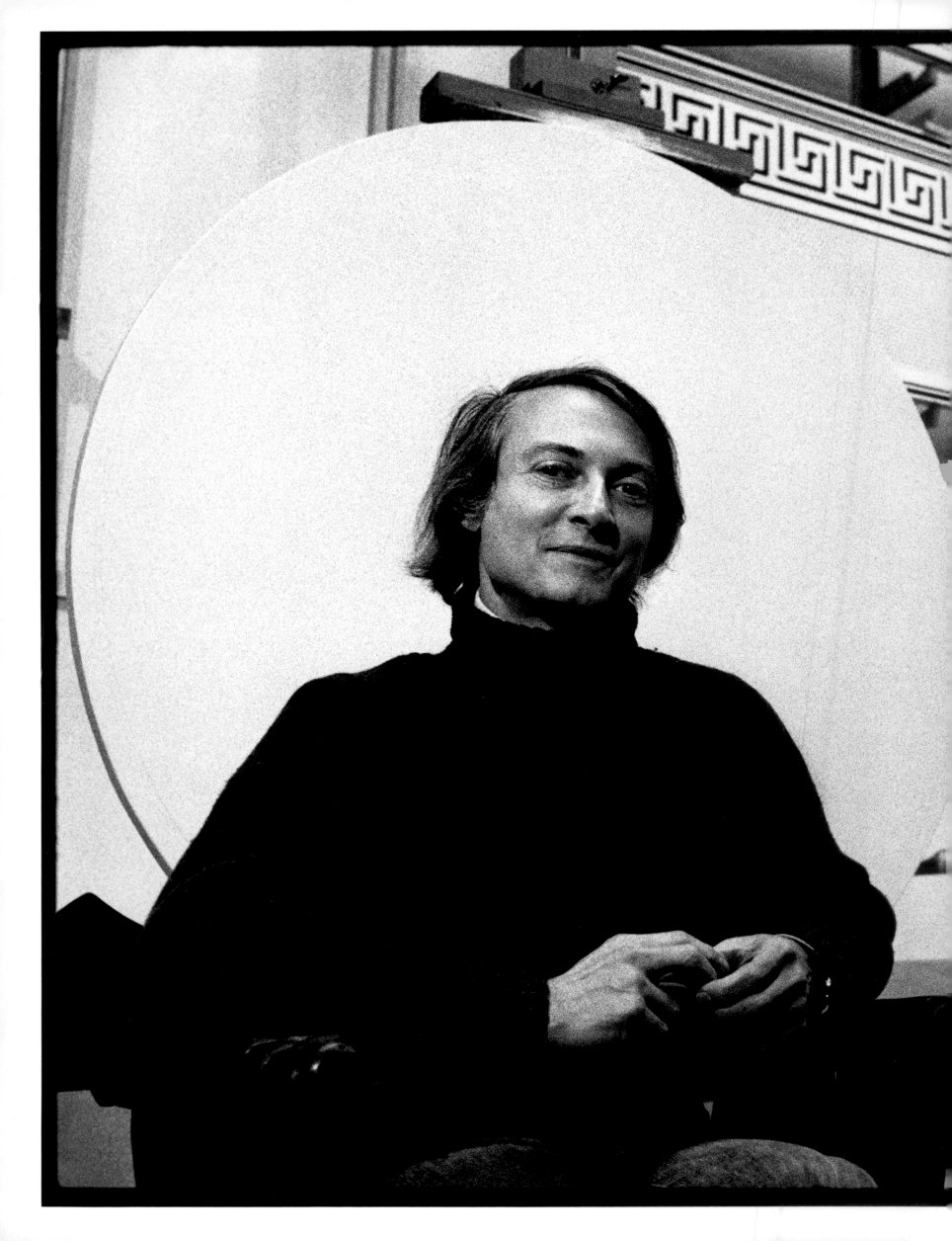

Roy Lichtenstein 1972 (previous page)

Francesco Clemente 1984

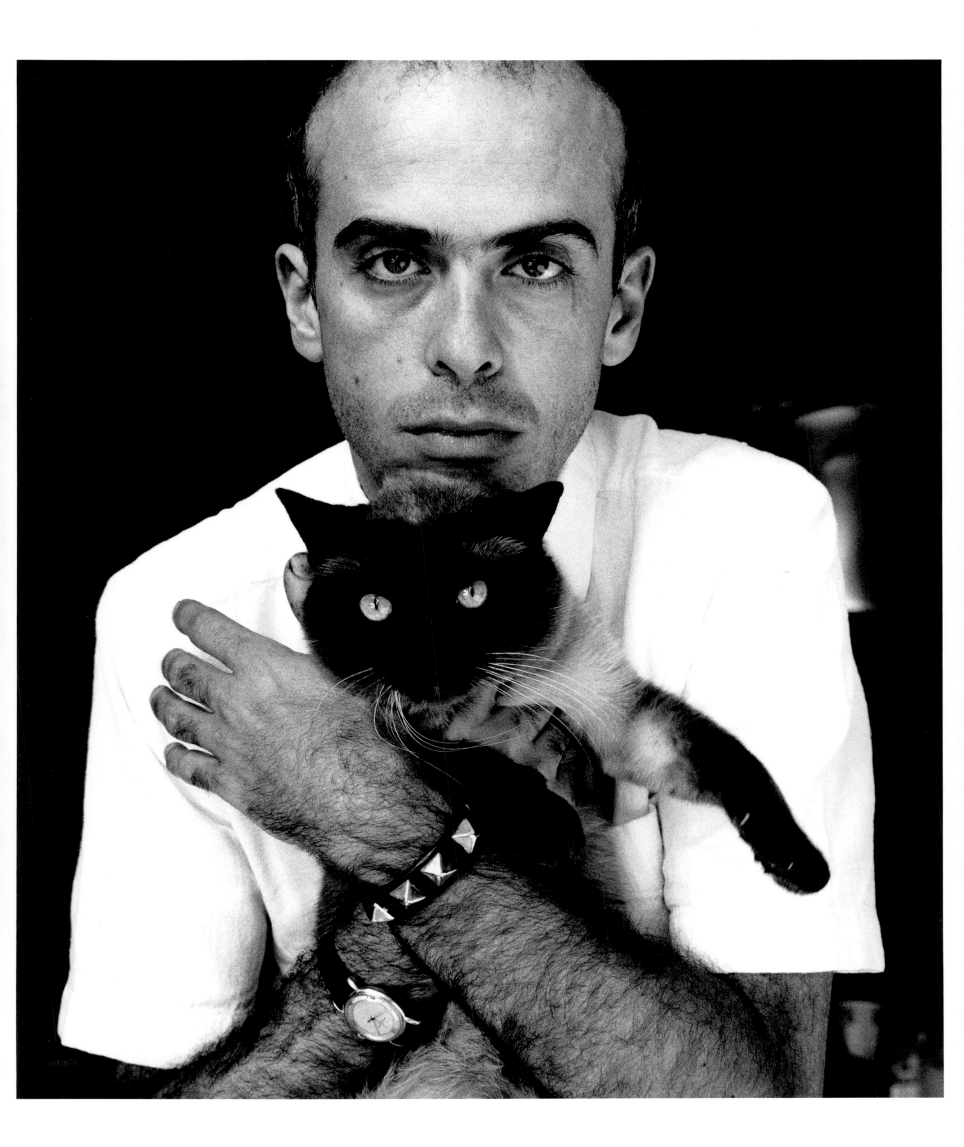

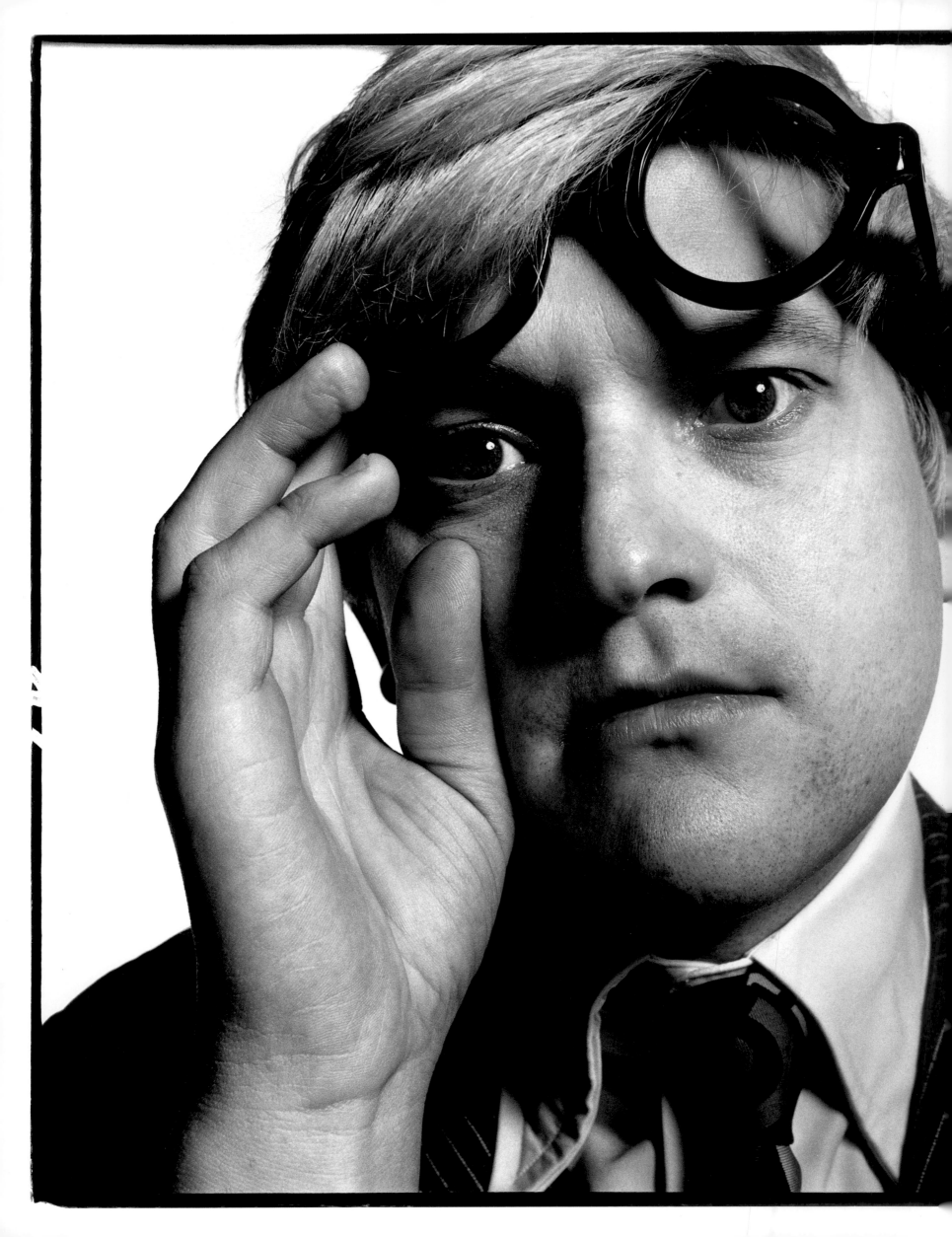

David Hockney 1969

Don McCullin 2007

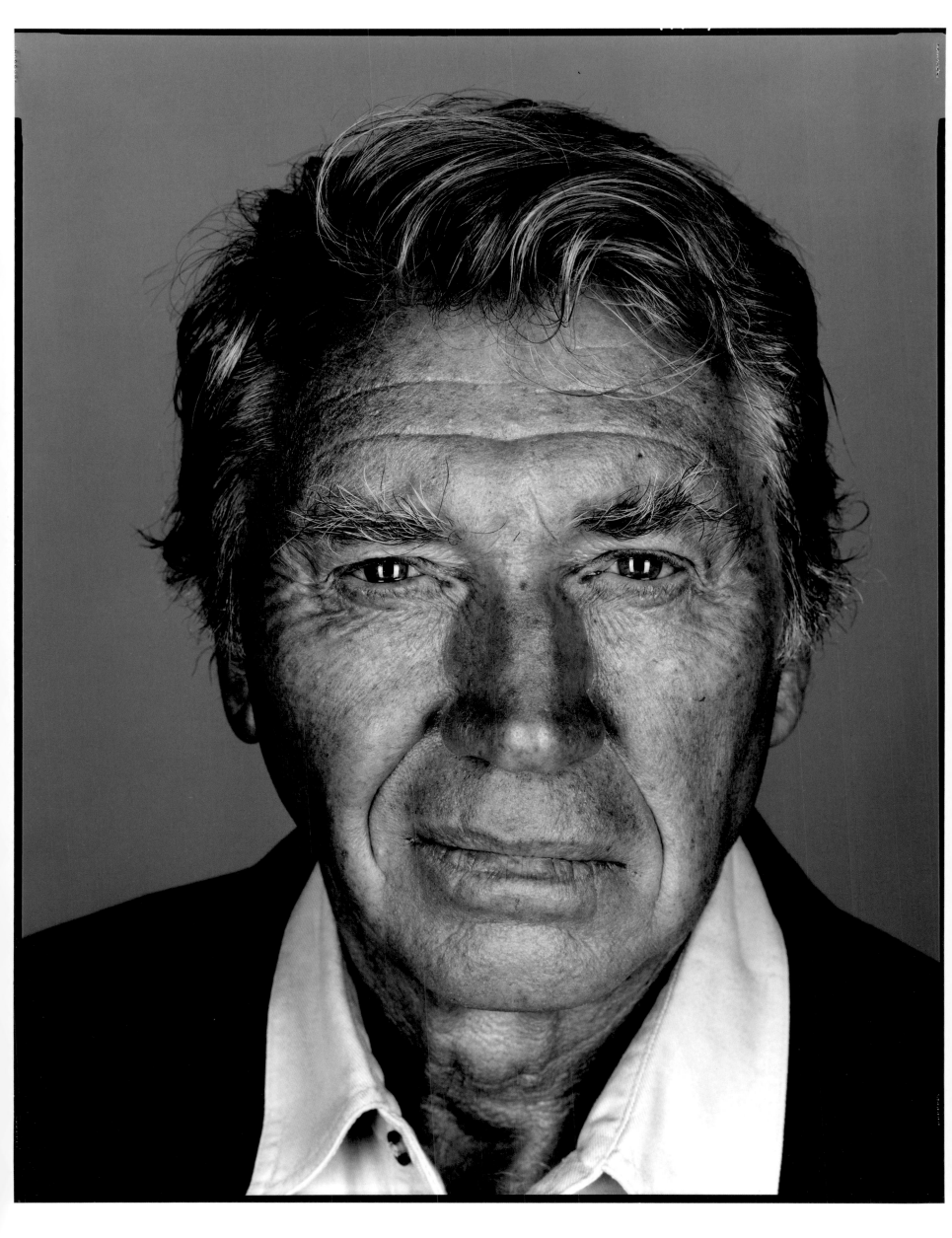

Luis Barragàn and Jean Shrimpton 1962

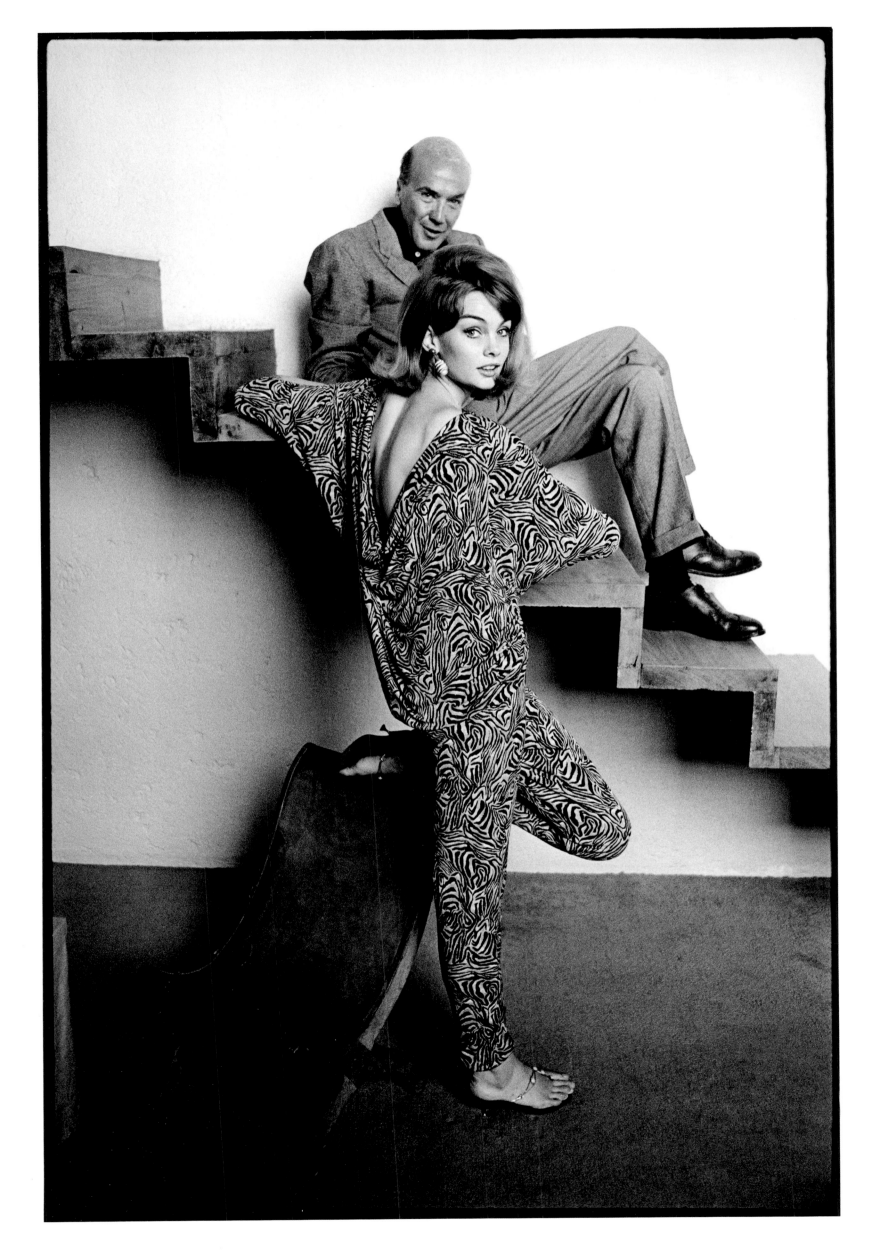

Robert Altman 1986

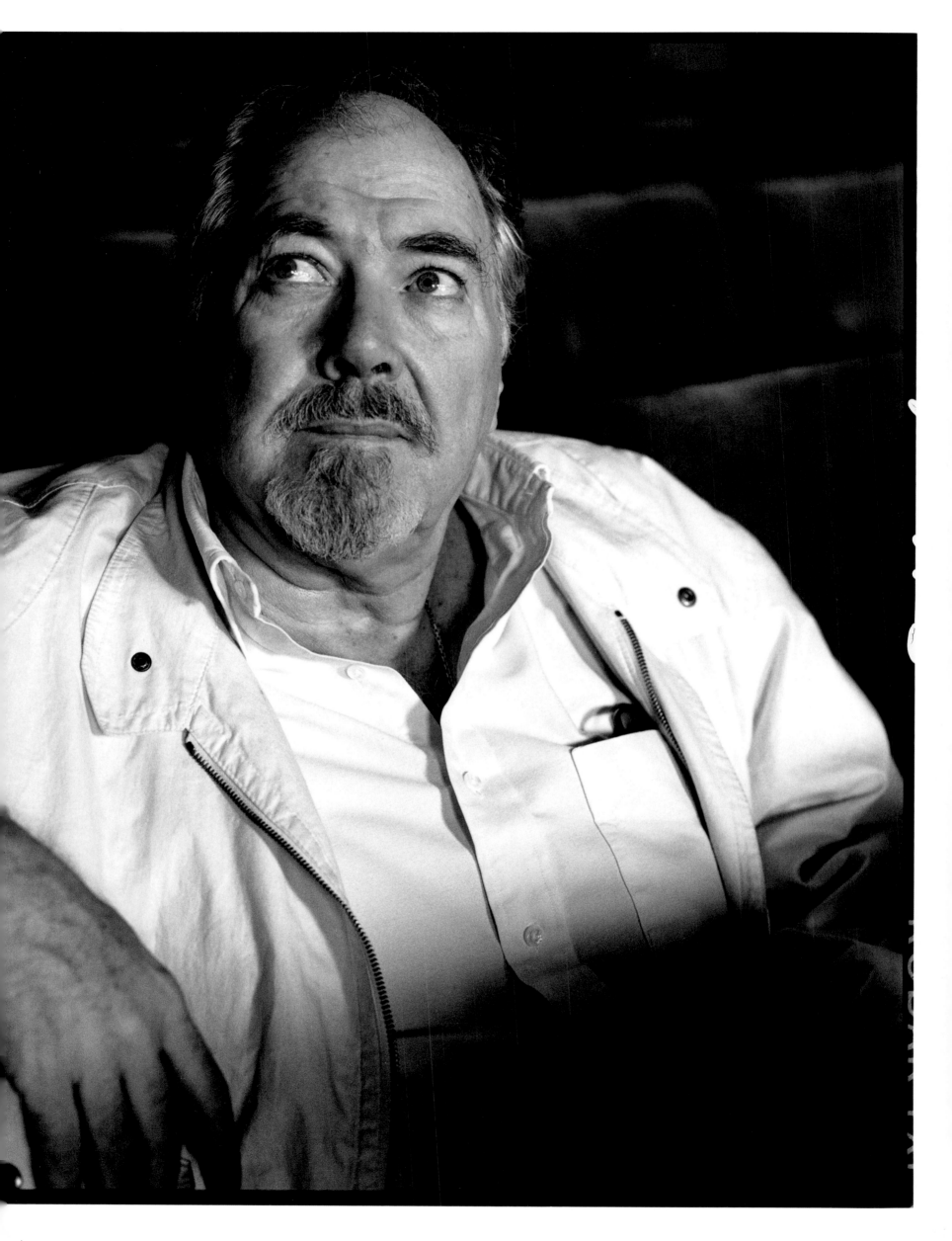

David Salle 1984

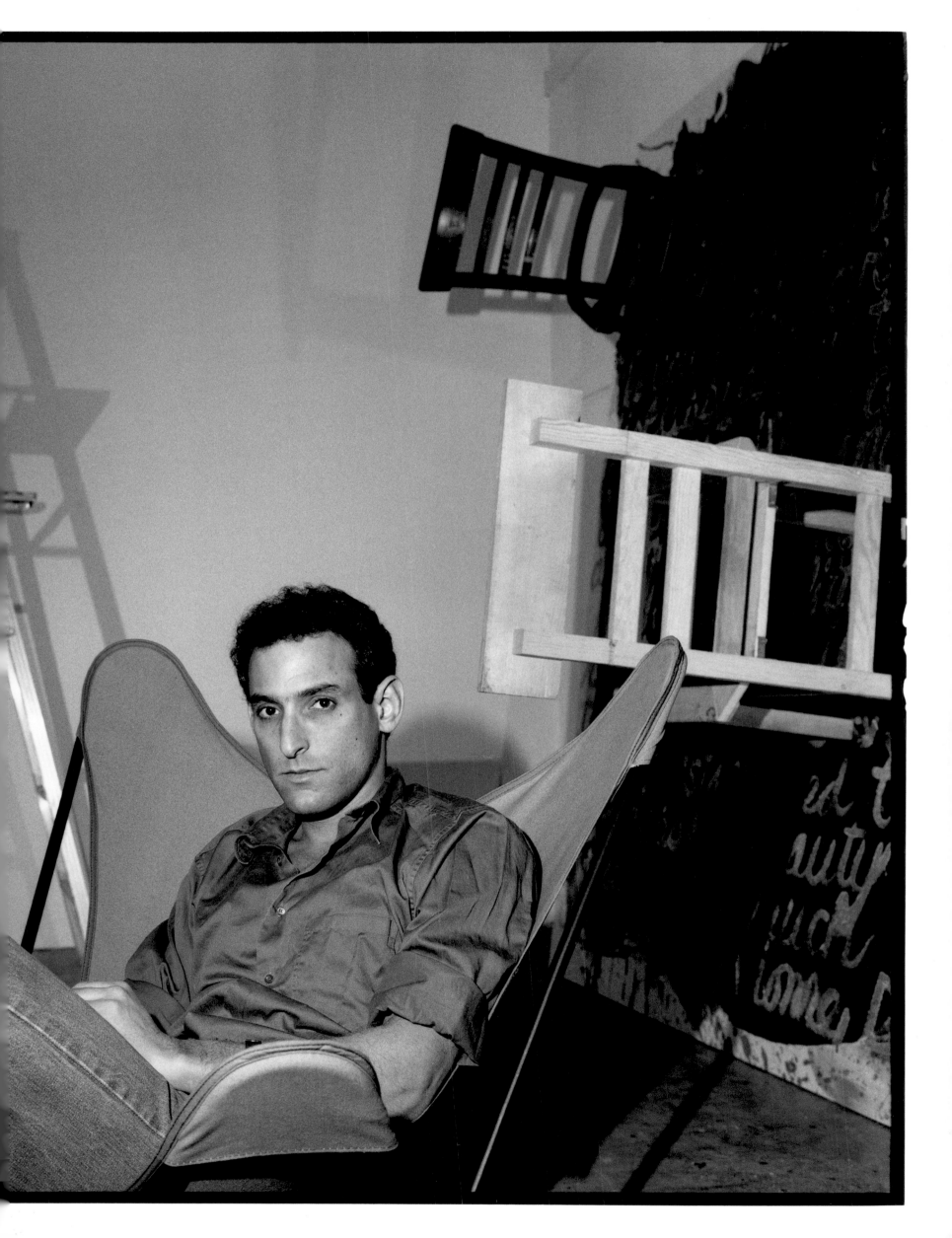

Dennis Hopper 1991

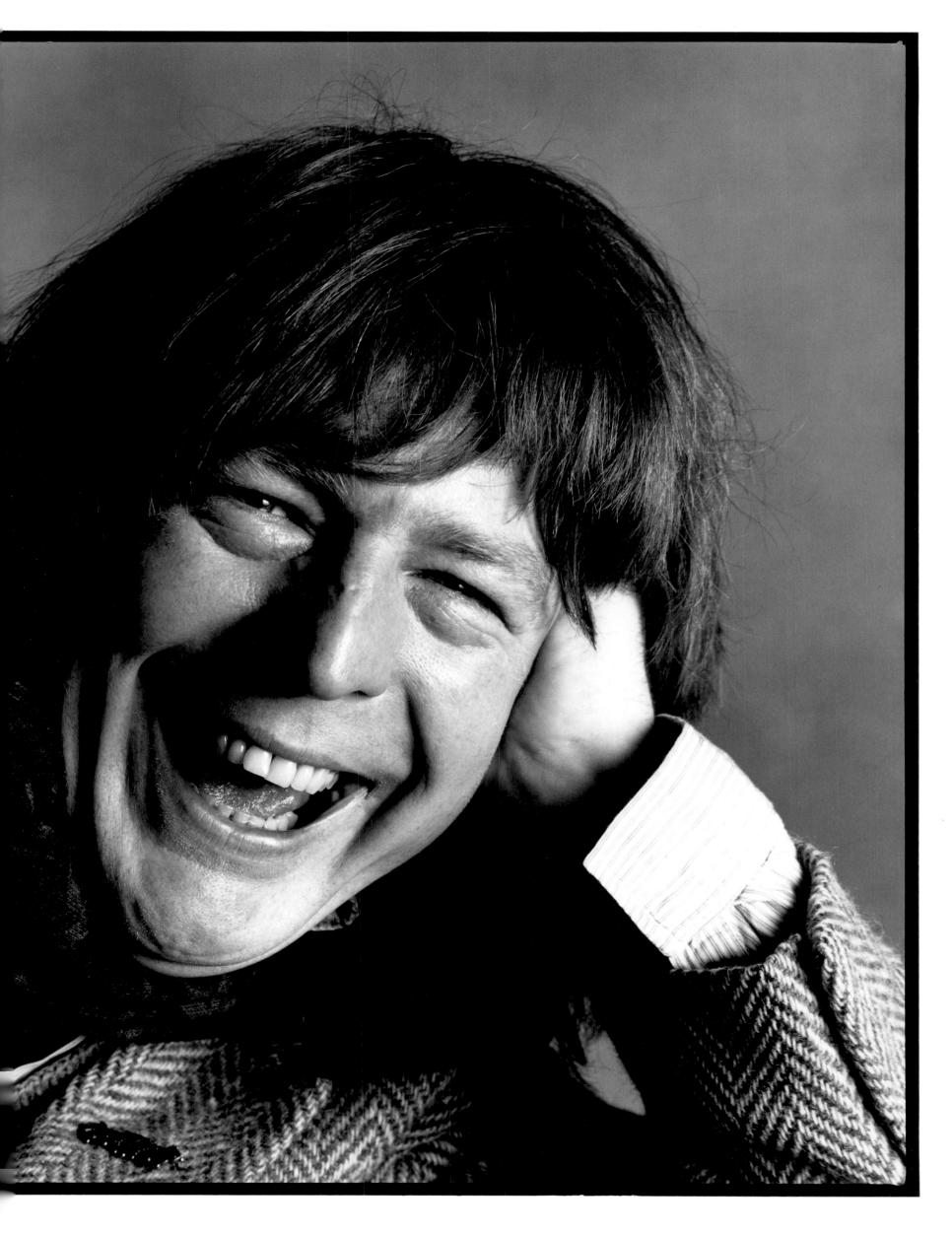

Alan Parker 1979 (previous page)

Gavin Turk 2008

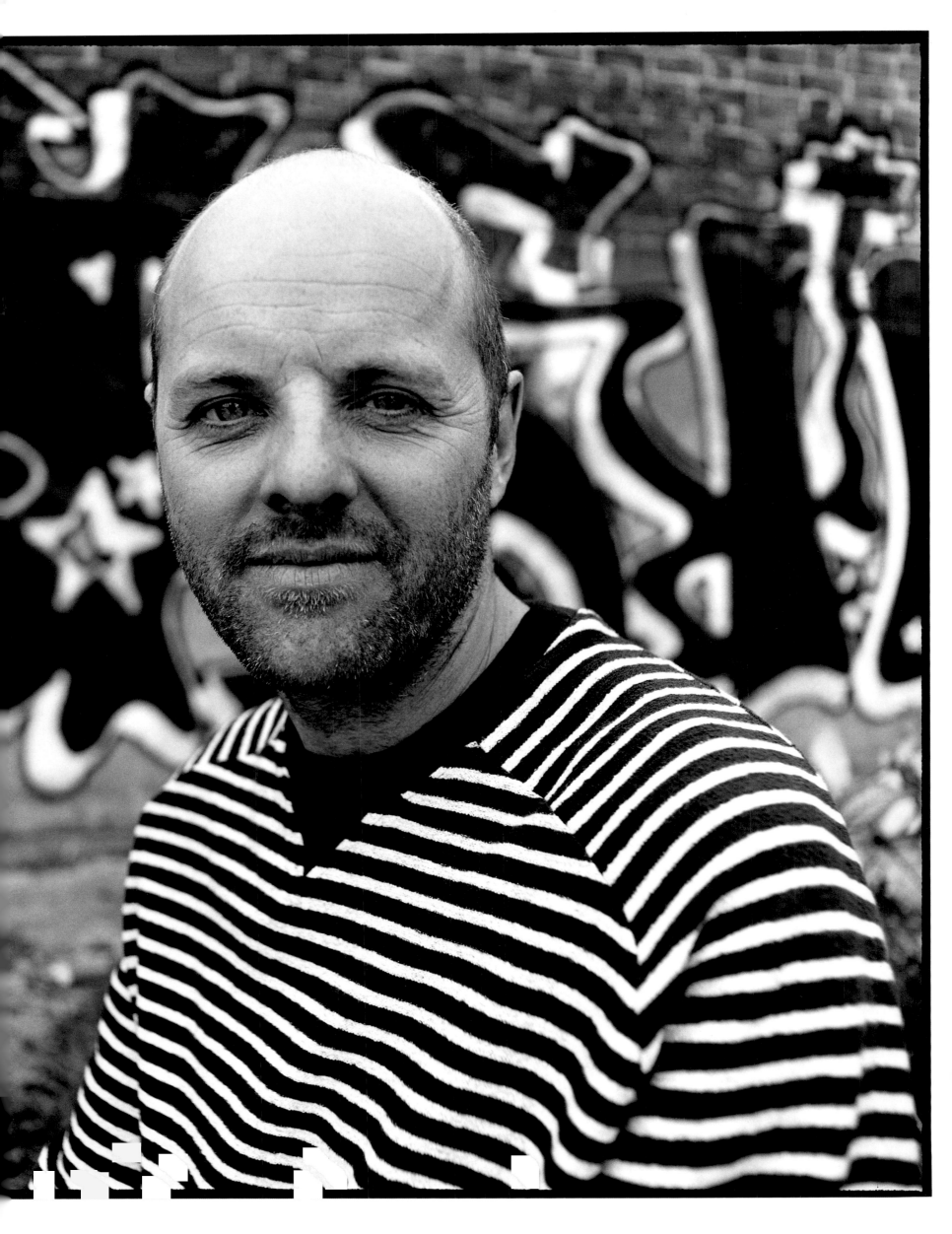

Peter Ustinov 1965

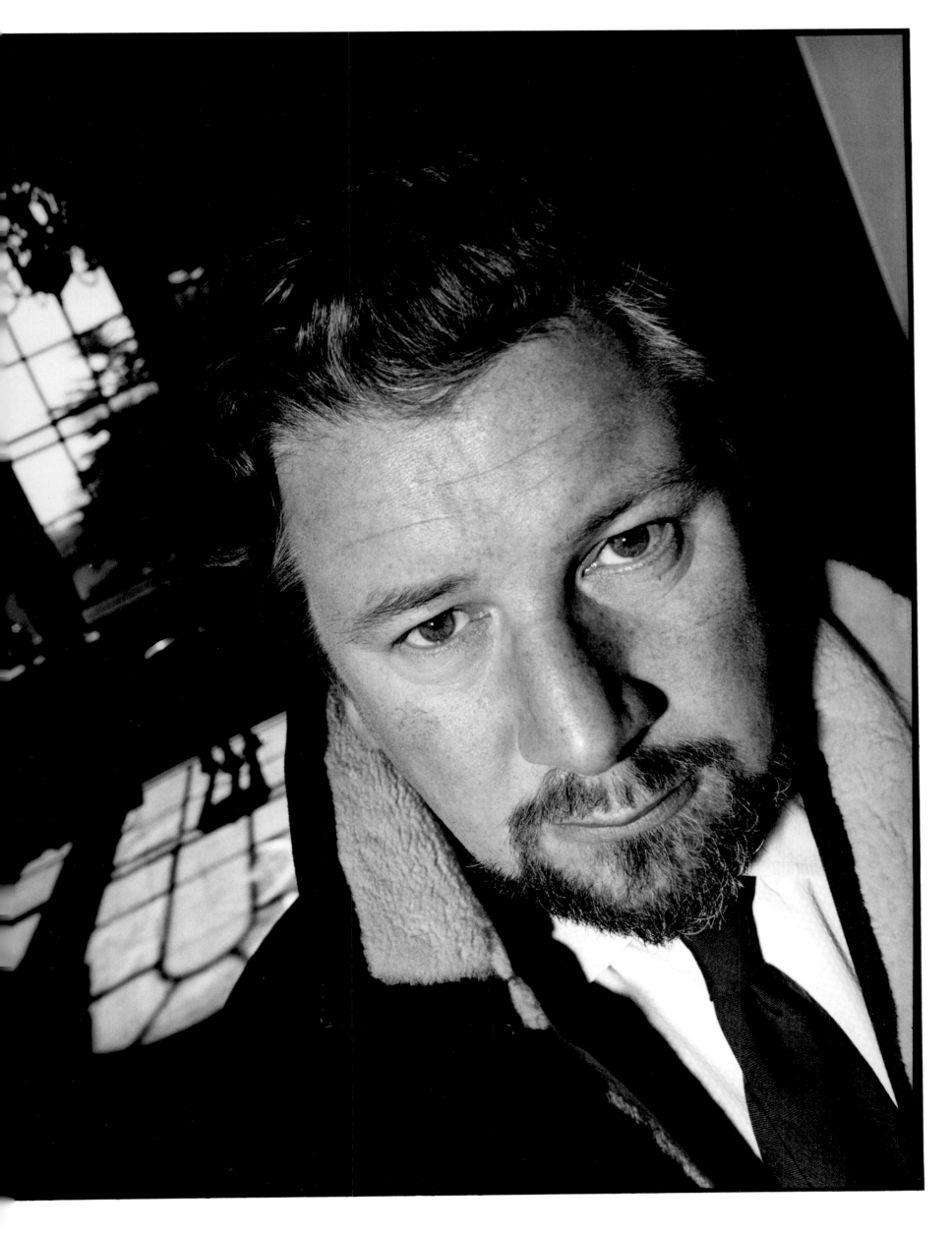

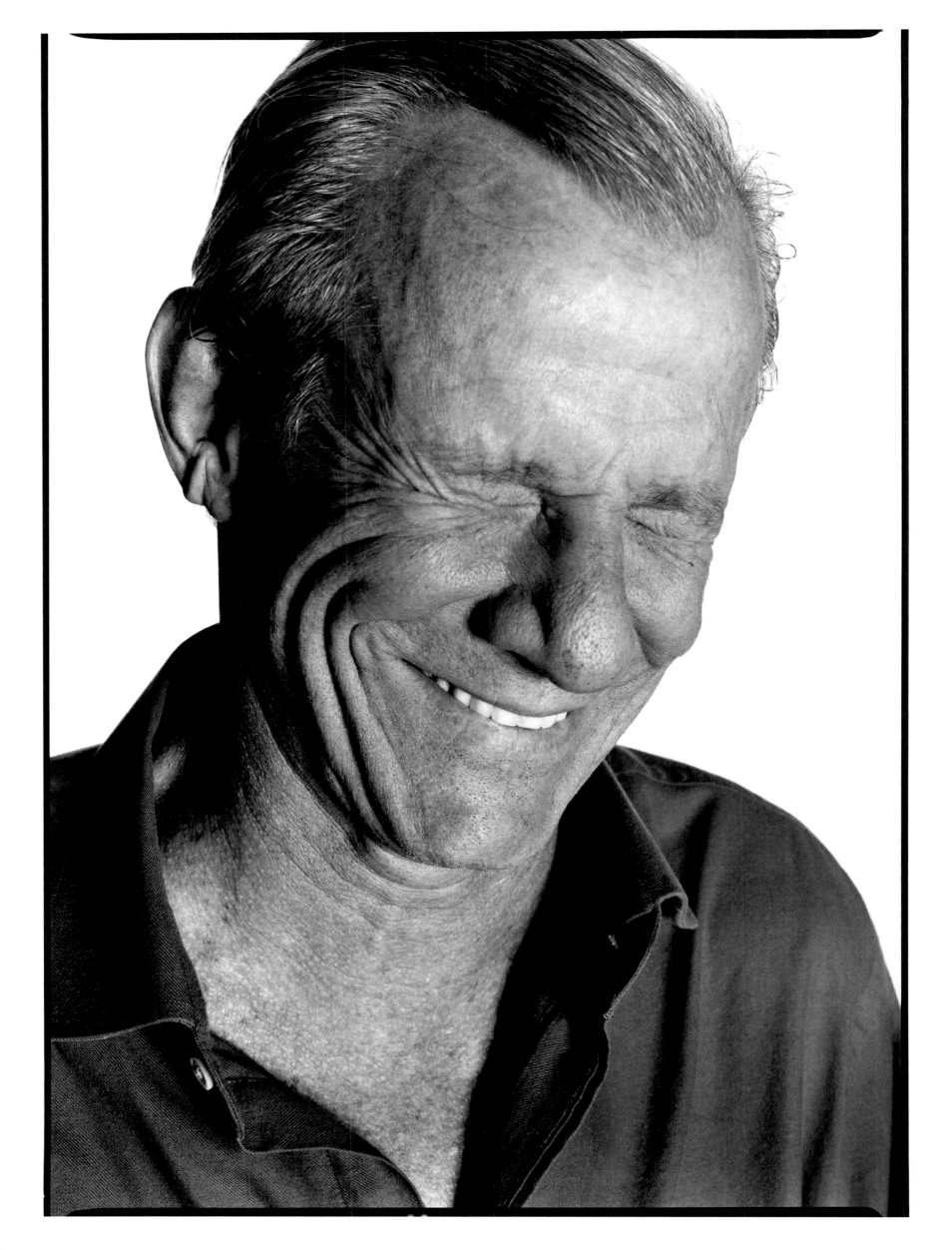

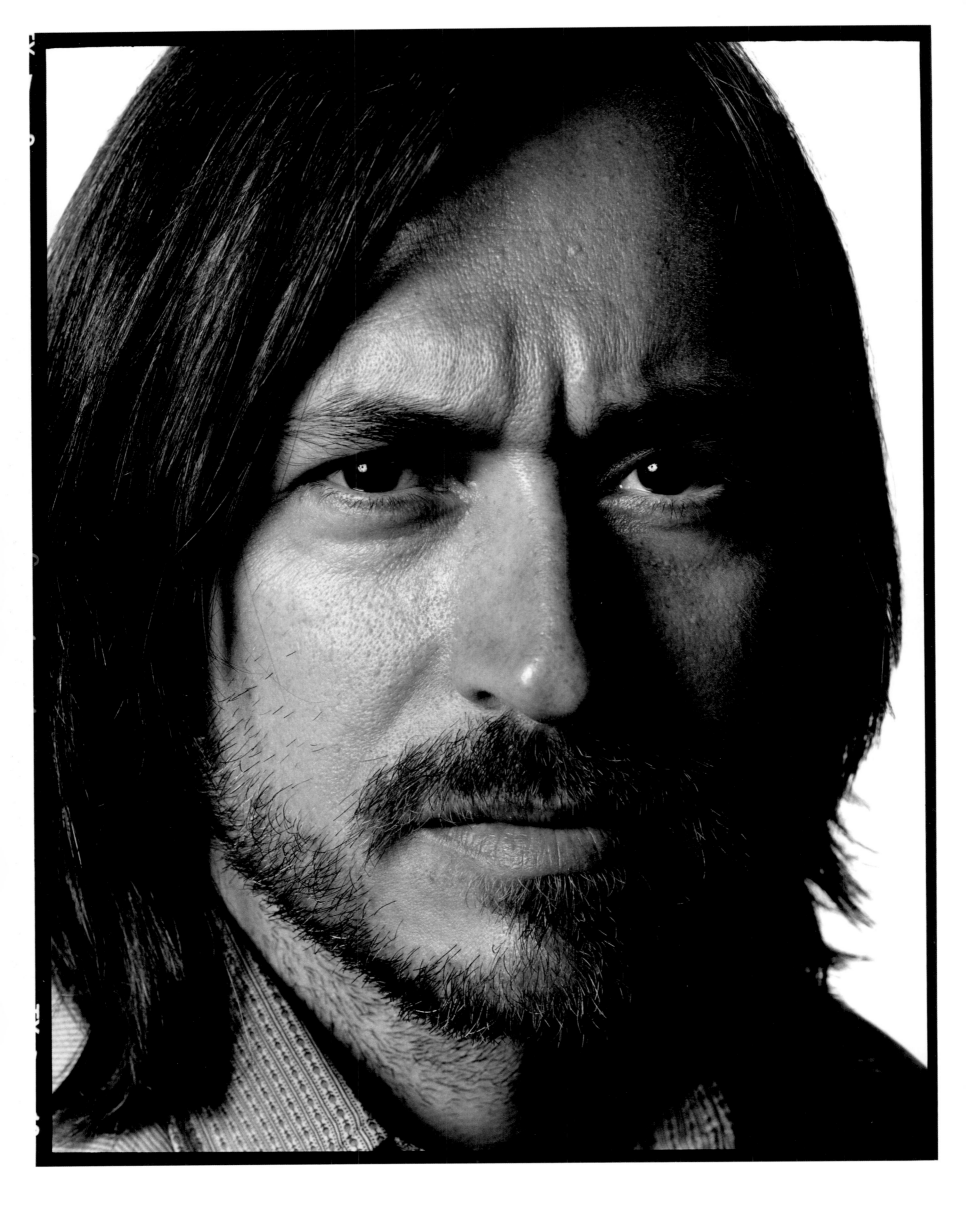

Brassaï 1983

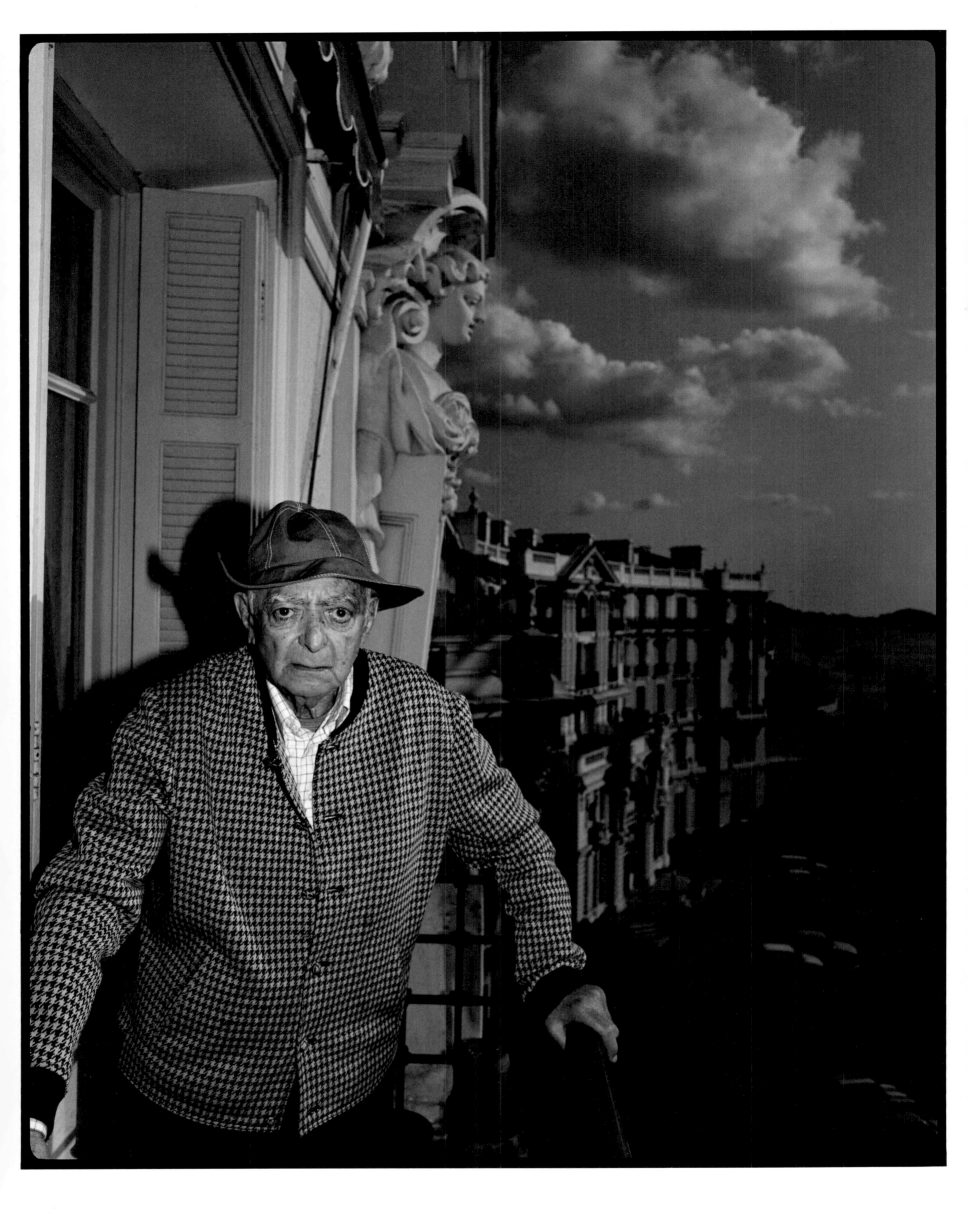

Tim Noble and Sue Webster 2005

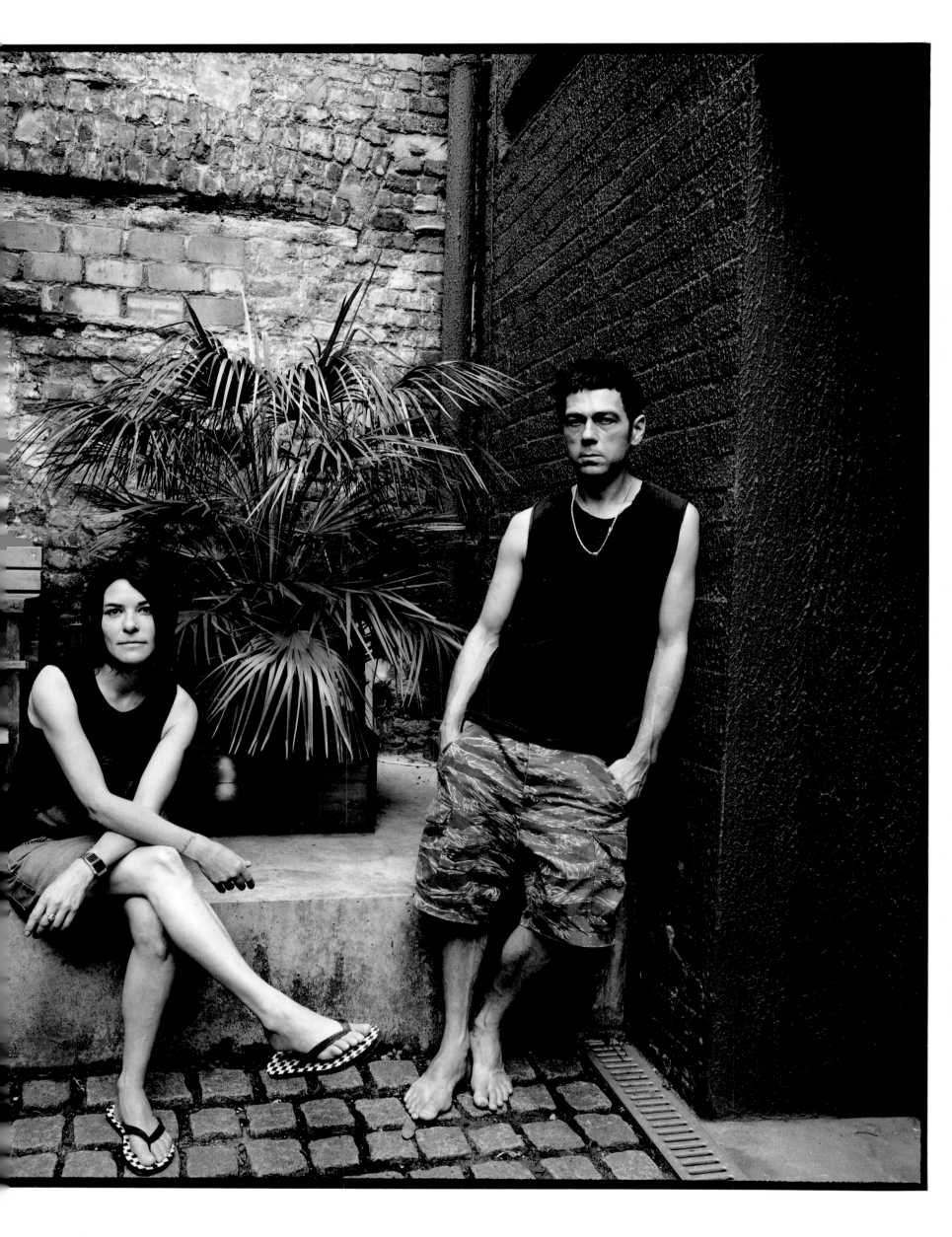

Francis Bacon 1983

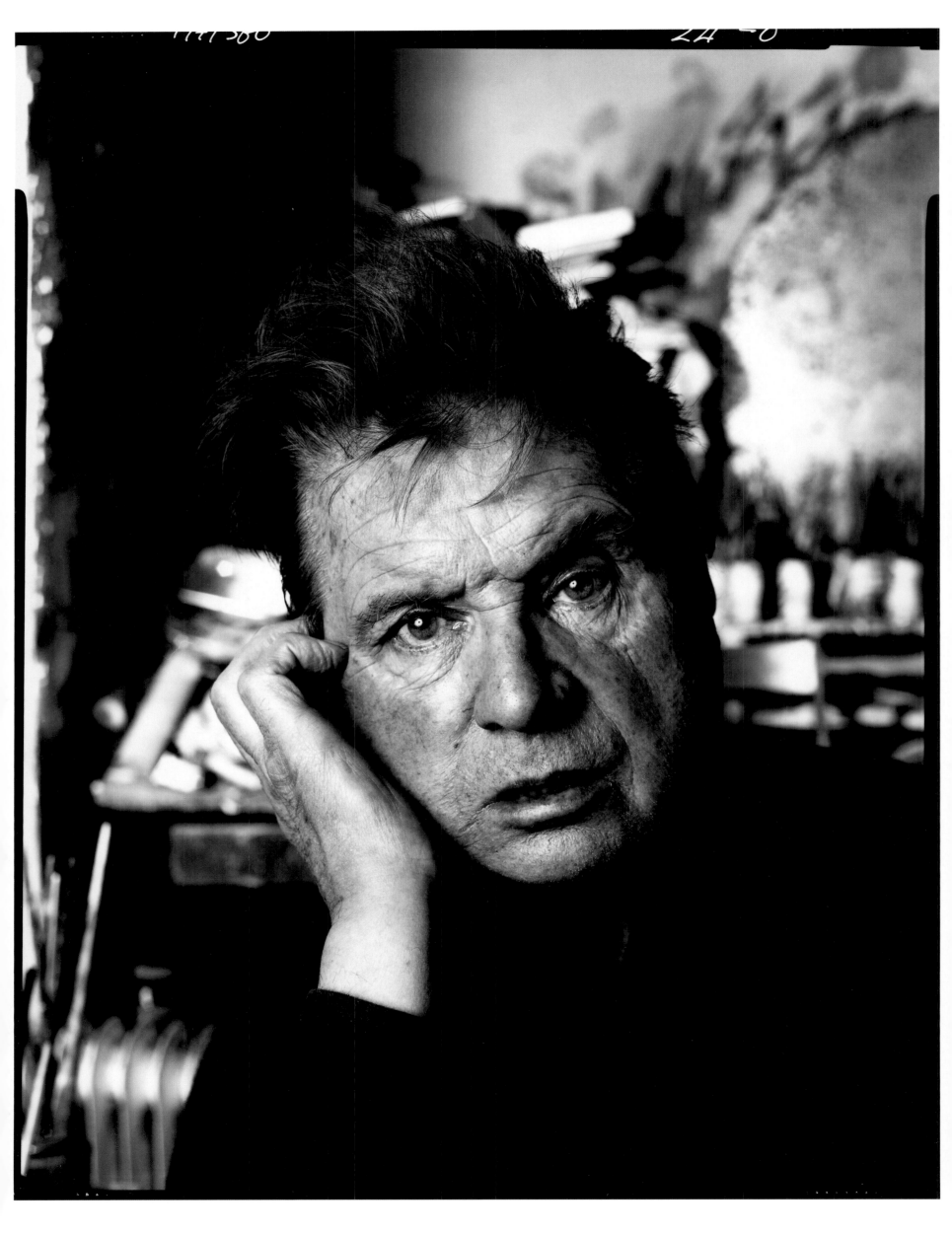

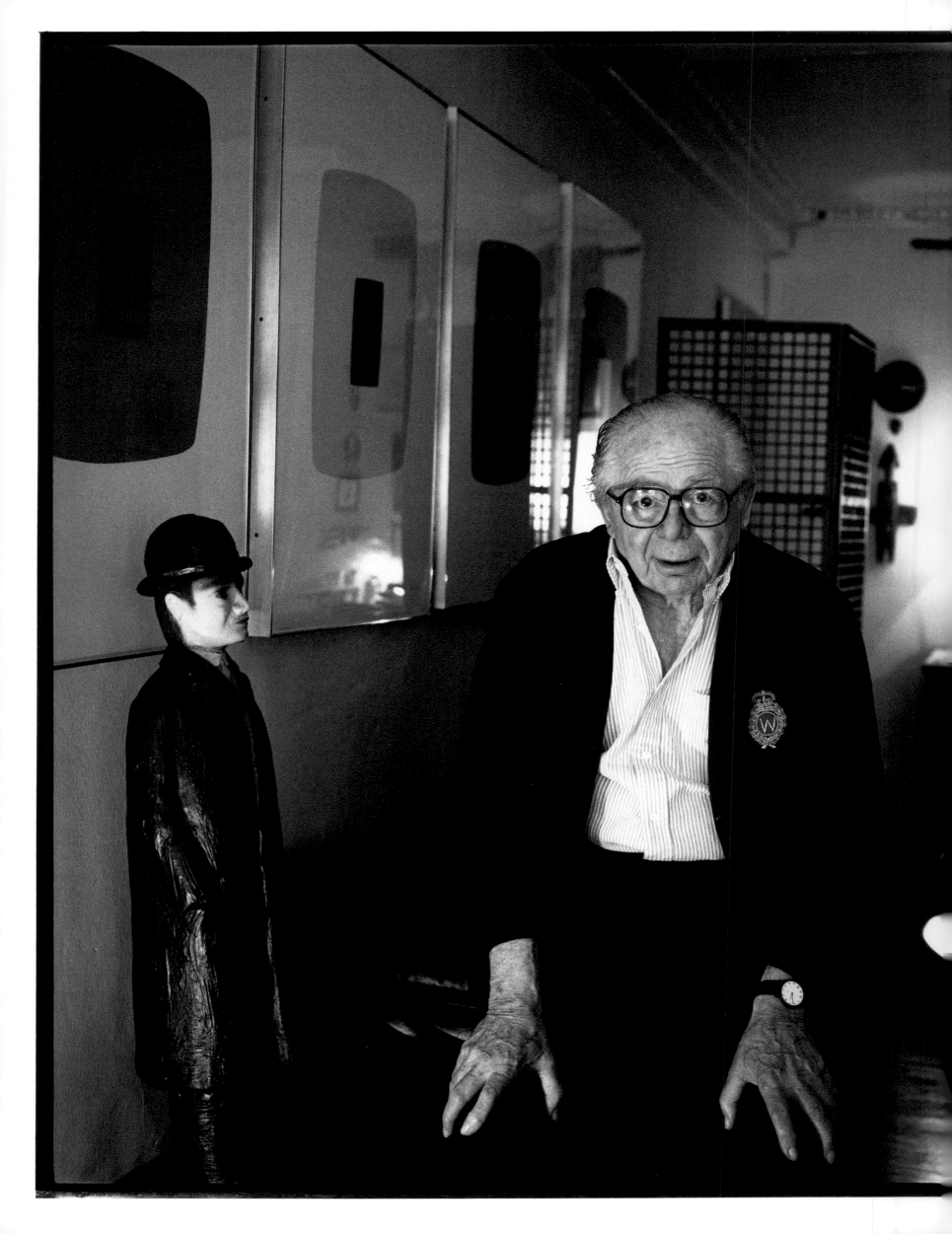

Gilbert and George 1976 (previous page)

Billy Wilder 1989

Bill Brandt 1982

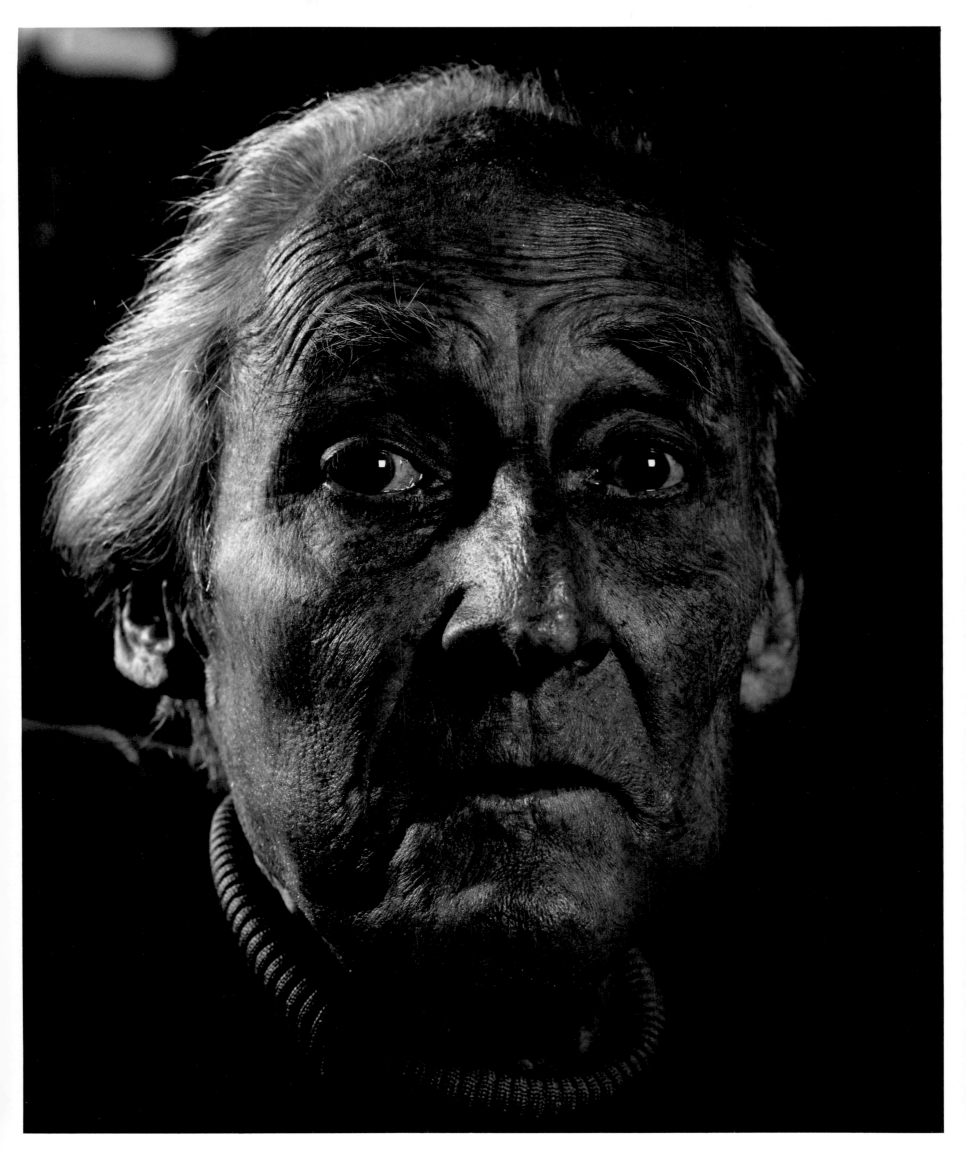

Juan O'Gorman 1963

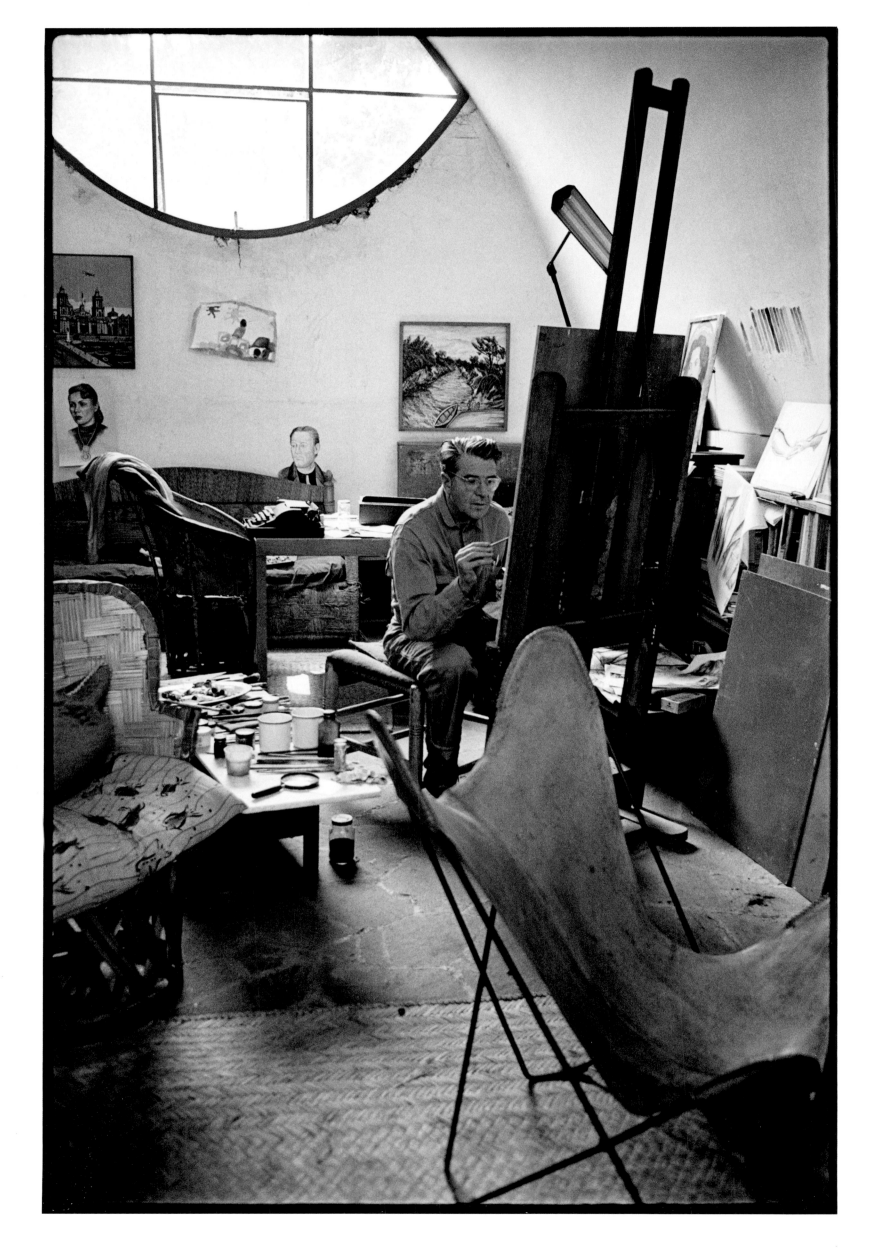

Julian Schnabel 2005

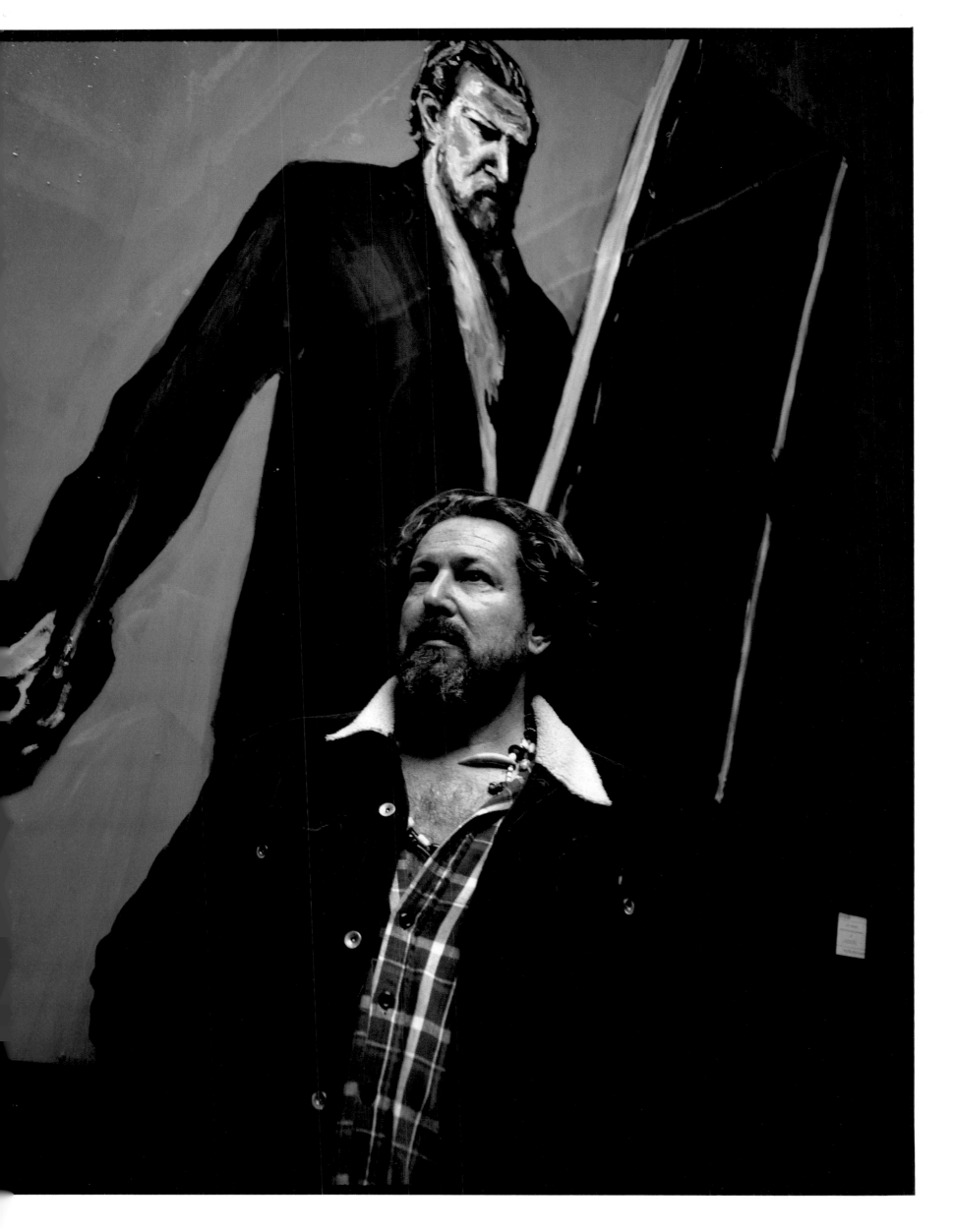

The Robert Fraser Gallery 1968

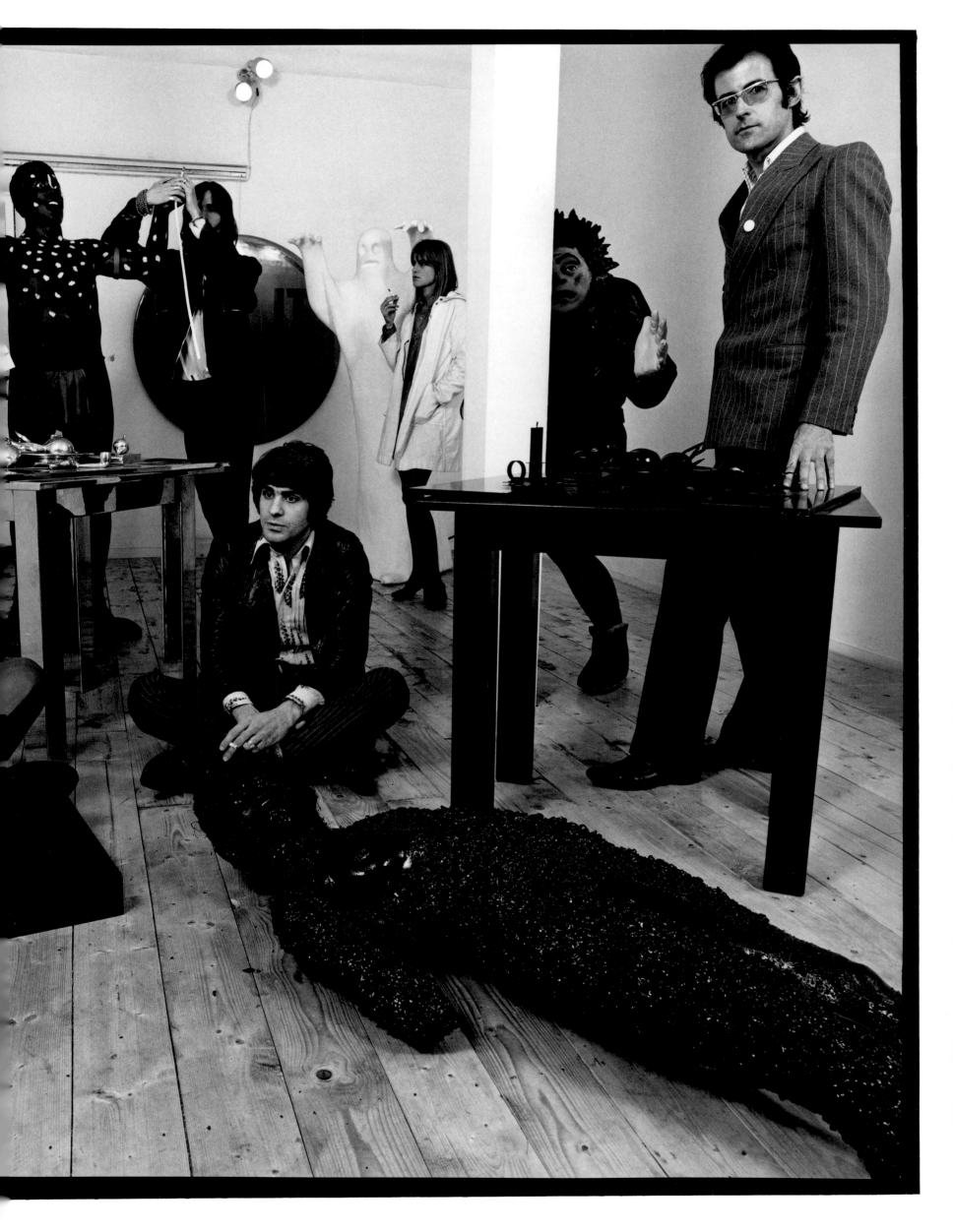

André Kertész 1980

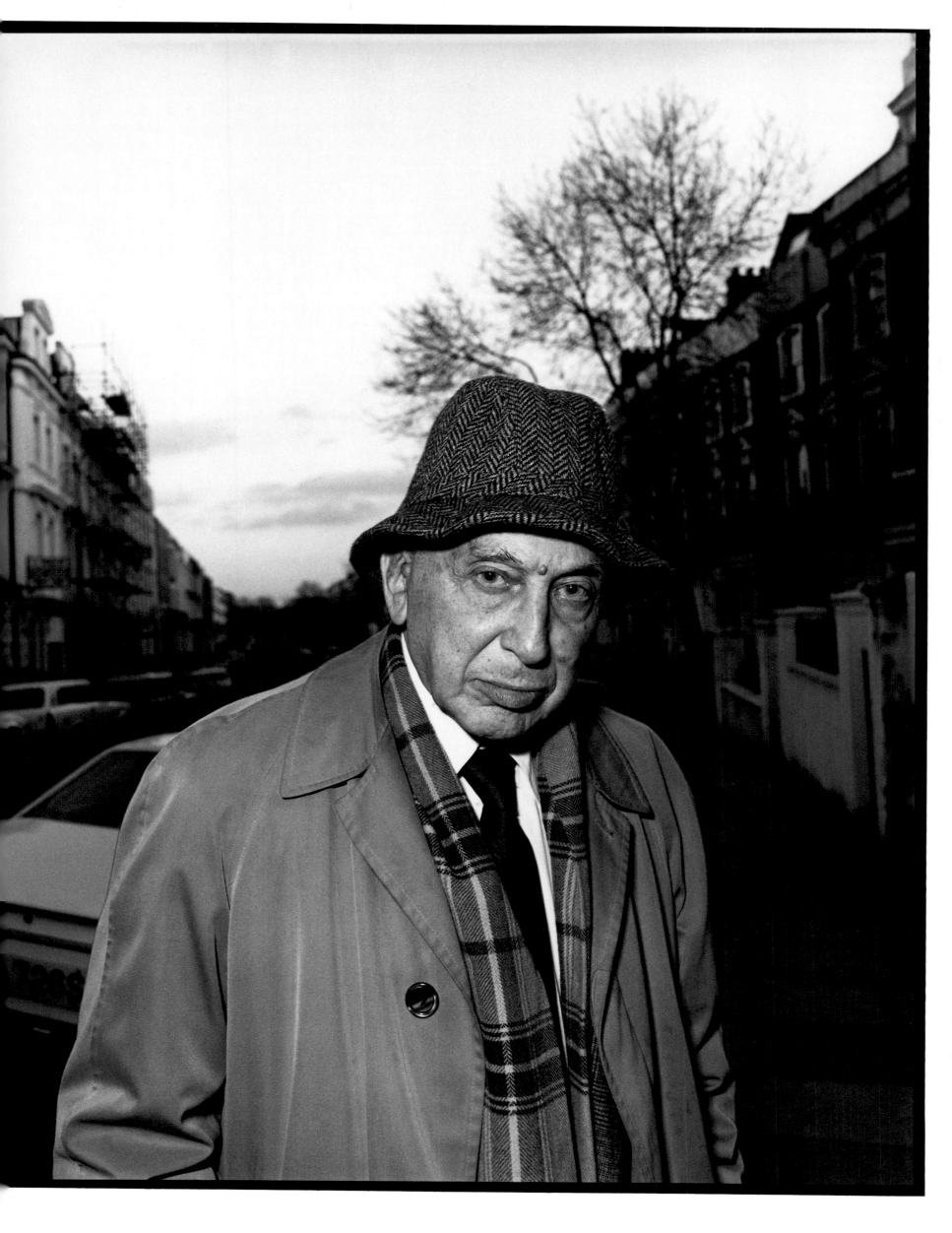

Terry Frost 2001

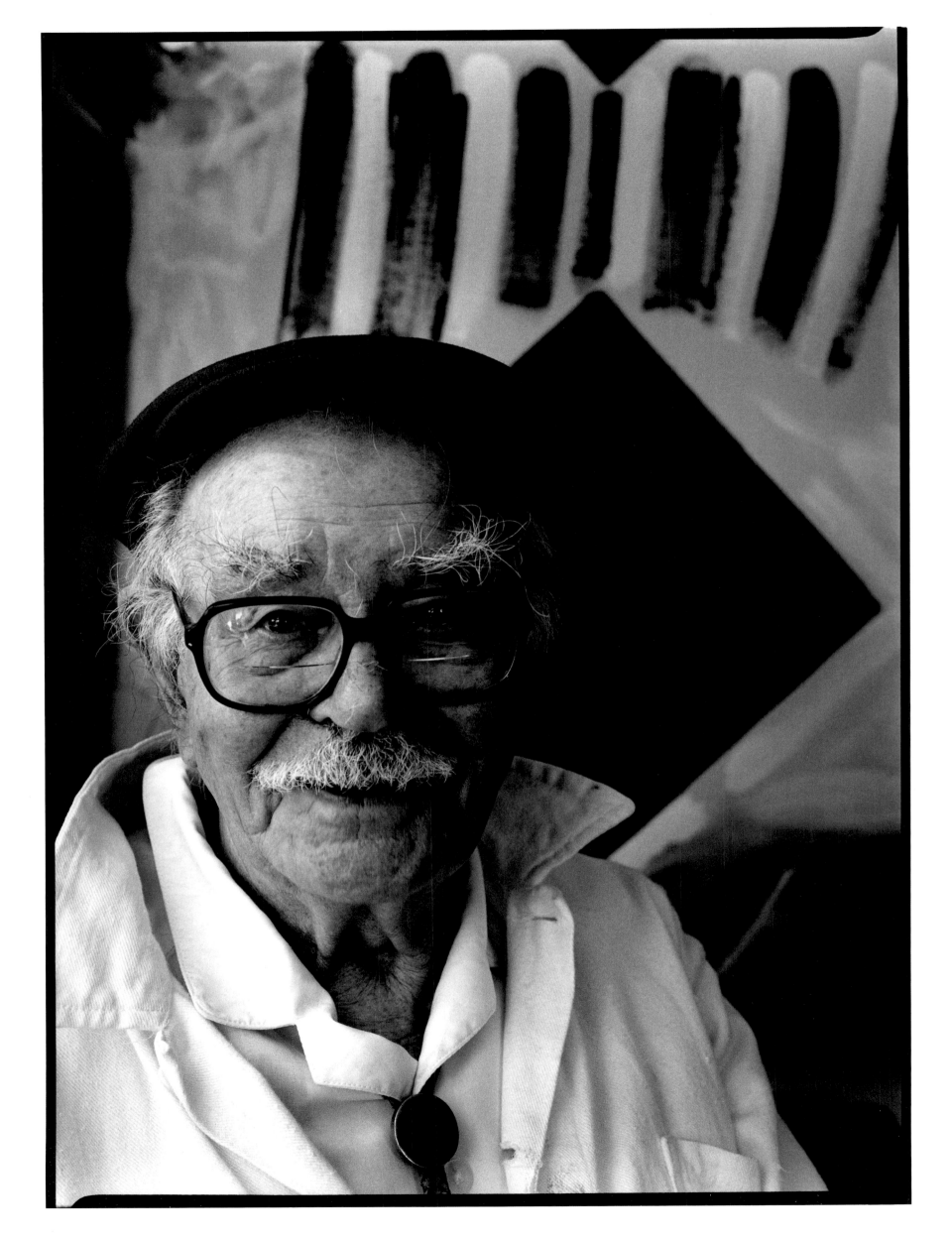

Ken Russell 1991

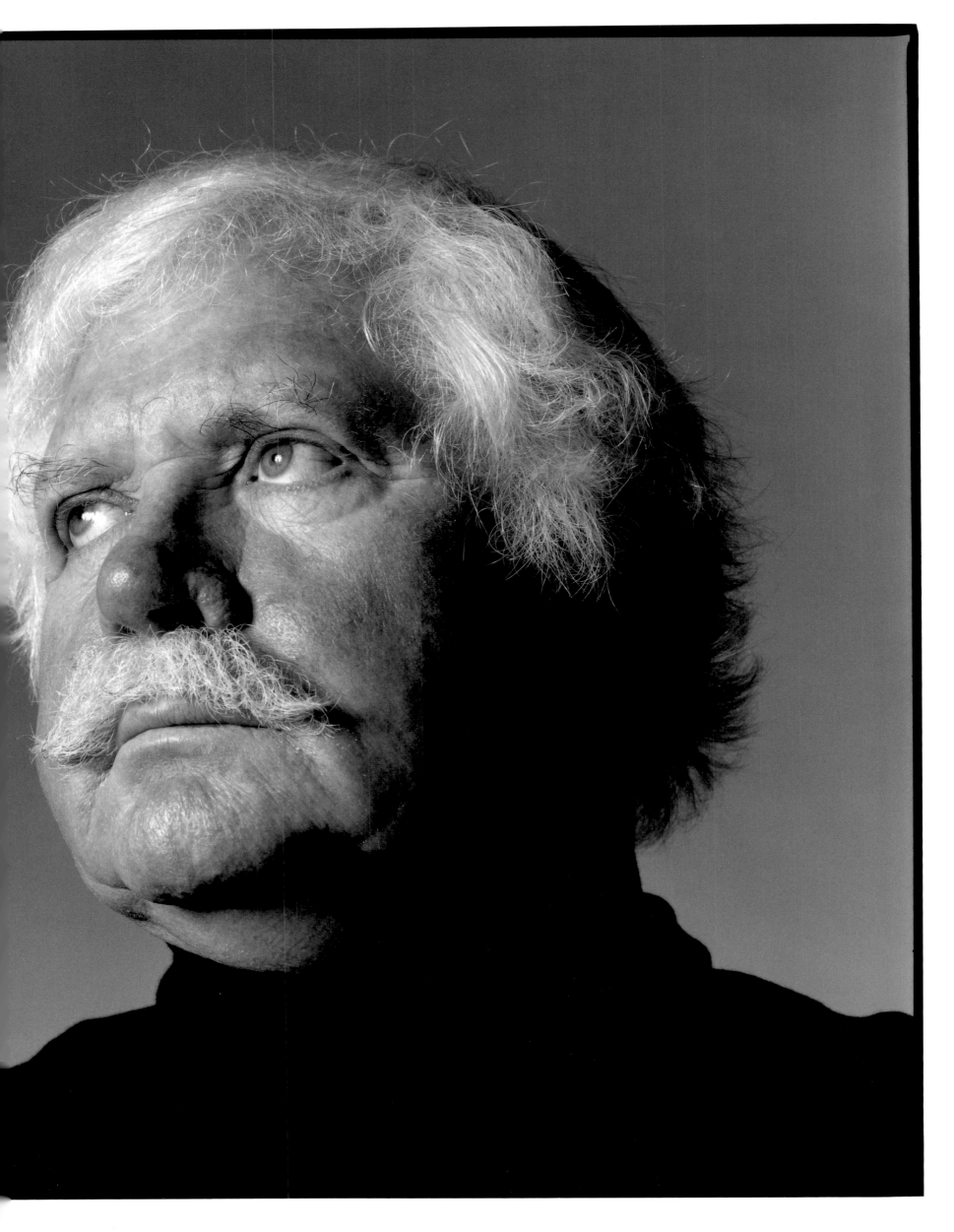

Karl Lagerfeld 1984

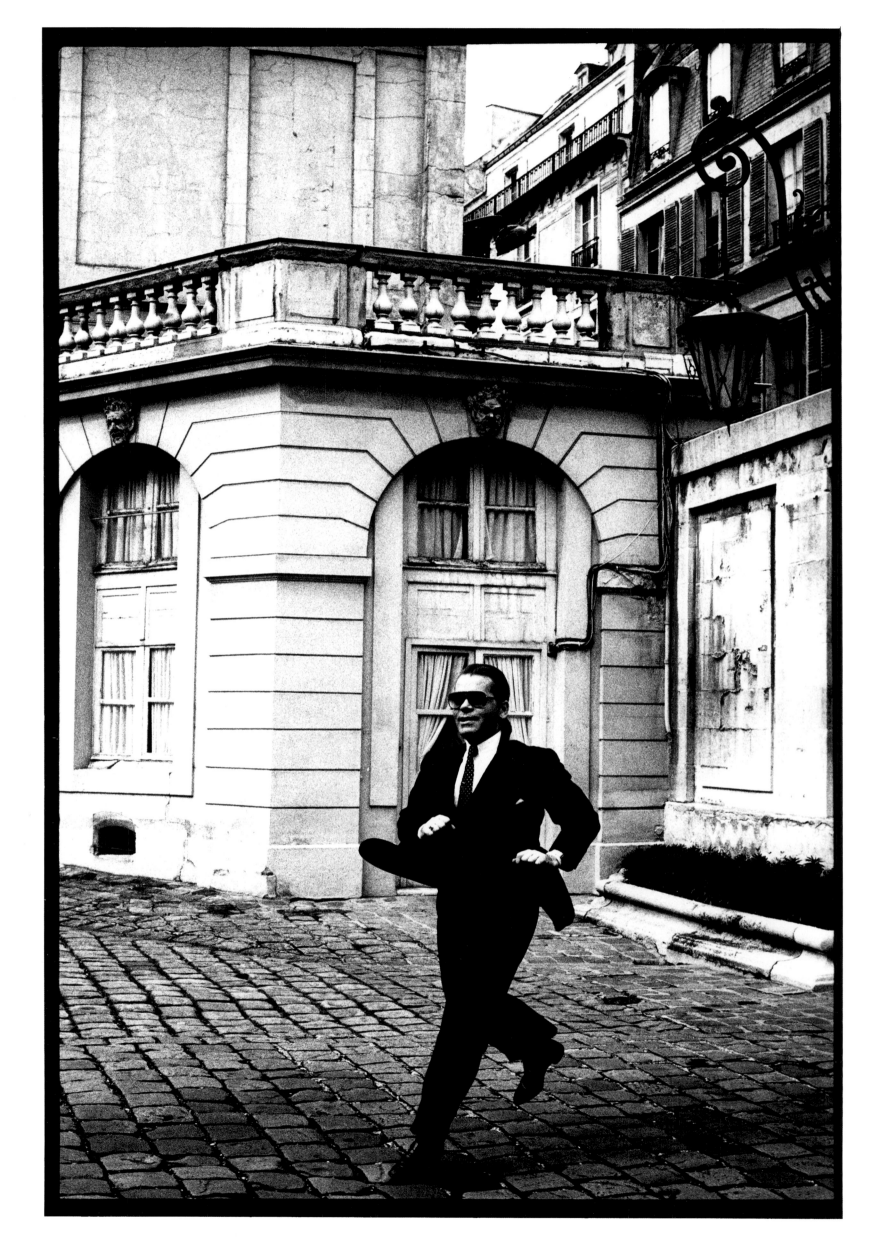

Maurizio Cattelan 2000

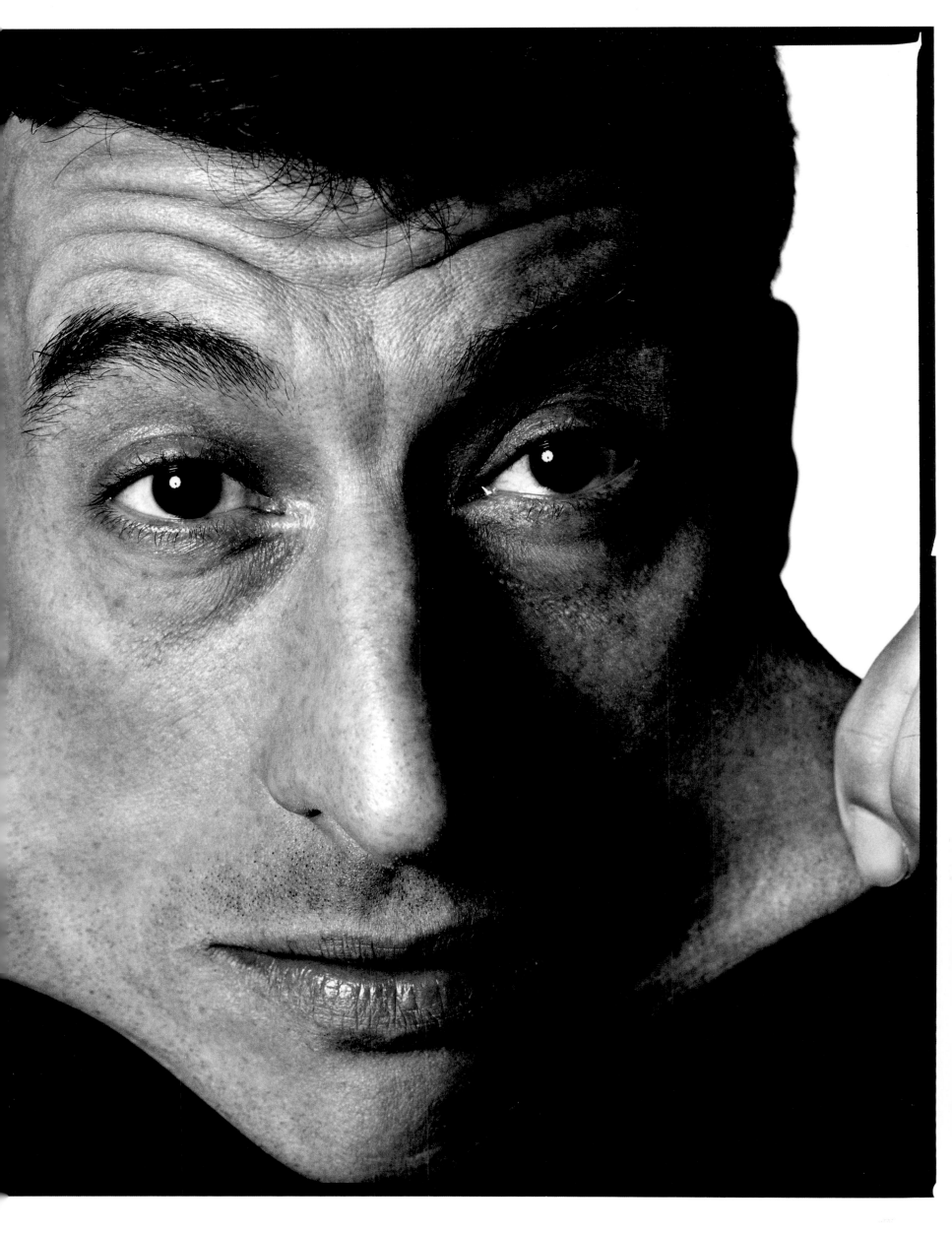

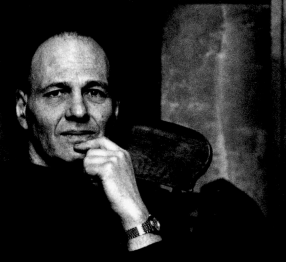

Frank Auerbach 1988

Luchino Visconti 1970